A YEAR OF TATTOOS

WELCOME

The

TATTOO

CHRONICLES

by

KAT VON D

WITH SANDRA BARK

PHOTOGRAPHY BY KAT VON D

COLLINS DESIGN

An Imprint of HarperCollinsPublishers

The Tattoo Chronicles
Text copyright © Kat Von D
Photography and illustrations copyright © Kat Von D

HarperCollins books may be purchased for educational, business,
or sales promotional use. For information, please write:
Special Markets Department, HarperCollins*Publishers*,
10 East 53rd Street, New York, NY 10022.

First published in 2010 by
Collins Design
An Imprint of HarperCollins*Publishers*
10 East 53rd Street
New York, NY 10022
Tel: (212) 207-7000
Fax: (212) 207-7654
collinsdesign@harpercollins.com

Distributed throughout the world by
HarperCollins*Publishers*
10 East 53rd Street
New York, NY 10022
Fax: (212) 207-7654

Library of Congress Control Number: 2010926554

ISBN 978-0-06-195336-1

Book design by Lonewolfblacksheep

Printed in China
First printing, 2010

Additional photography credits:
Front jacket: Ramon Felix; page 64, left © Paul Brown; page 74 © Nikki
Sixx; page 102, top © Shannon Brooke; page 180–81 © Nikki Sixx.

Model credits:
Page 14, Miss Spring: Nika Tomazincic; page 34, Miss Summer:
Zoe Minx; page 88, Miss Fall: Eden Lamour; page 138, Miss Winter:
Lacey Valentine.

For the heart is an organ of fire...

THIS BOOK IS

DEDICATED

TO

Ludwig Von Drachenberg

I miss you every day.

R. d. P.

FOREWORD

I.

MY DEAREST KATHERINE,

I told you I had a letter to write to you, and I would try to do it by Christmas. It is no small honor for you to have asked me to write the foreword to your new, beautiful book. You are an incredible artist.

"Trust life," someone said to me many years ago. I'm just starting to learn that (insert smiley face icon if you dare).

A year ago last summer I was in Hollywood for a week for a class and, as you know, I love Hollywood, my hometown. Although I don't live here anymore, it'll always be my favorite city in the world. You know I just lost my dad, who worked on the sign on the roof of the Hollywood Roosevelt Hotel, where they had the first Oscars. He used to take care of everyone's swimming pools——Peter Lawford, Mario Lanza, Jayne Mansfield, Rod Steiger.

As much as I've seen, been through, what I know about my hometown is that the real magic is on the street. They're building up now, up and away from the streets that gave me everything——the people, the stories. A lot of old Hollywood is gone.

I was walking along Sunset Boulevard smoking a joint with a friend of mine, ol' Mississippi George, who is actually not from Mississippi at all, but a Jew from Jersey who plays mean-ass slide lap steel guitar. Anyway, a nervous clutch of teenage girls came up to us on the corner of Sunset and Highland and asked if we knew where Kat Von D's shop was,

⚡ HIGH VOLTAGE TATTOO. ⚡

II.

GEORGE KNEW, and pointed them in the right direction, but it warmed my old scaly heart, it was so old Hollywood, you know, but it wasn't like the buses of tourists up on Hollywood Boulevard, oohing and aahing over the concrete footprints in front of Grauman's Chinese Theatre; or the rich Europeans posing in front of their rented limos up on Beachwood Canyon and taking pictures of each other in front of the Hollywood sign; or the endless tour buses, hearses, and every other vehicle possible hauling around pale Midwesterners with some dude at the wheel barking local trivia through a bullhorn.

These were young girls, Latinas, and for a second the veil lifted and I was looking at a gaggle of teenage girls clutching their movie star magazines, hoping to get a glance of Lana Turner going into Schwab's, or of Liz Taylor and Richard Burton stopping into Musso & Frank for a martini.

I love Hollywood, I'll say it again, and it was such a moment, I'll never forget it. They reminded of me of me when I was fifteen, roller-skating along over the stars on Hollywood Boulevard. Even through the grime and the exhaust fumes and the puke and the cigarette butts and piss, the dull brass edges of the stars in the sidewalk still manage to shine, and I love nothing more than to walk down the boulevard and behind my shades smile at the tourists stopping and reading the names on the stars in the sidewalk. Someday you'll have one. (Insert smiley, teary-eyed icon.) As a matter of fact, I should send a copy of this to the chamber of commerce (noted).

WHO, IN MY HOMETOWN, I thought, is this girl bringing back the old-school throngs of kids——not just kids, but brown kids, white kids, not the old face of Hollywood and Los Angeles? But Los Angeles is not just the Hollywood in the old movies. It's always been a melting pot, the very name of the city is Spanish, so the media face of Hollywood has not always been fair and true to the city I know and love. For the first time, I saw the young faces that were true to the city and the country I knew, and they were girls. I'm not and have never been a militant feminist, and you must know by now everyone will try to claim you for their own cause. I just do what I do and happen to be a woman. It's too deep of a subject to get into here, so I won't. But things have changed, and are changing. The world has turned. The face of America is fresh, young, and nothing is impossible again. It hasn't been this way for many, many years——since before you were born. You're an insanely talented, driven, self-made, smart woman. You're freakin' German-Argentinean-Mexican beautiful and everything that makes America rock. You knew what you wanted to do and you did it, and never let anyone tell you couldn't. You knew yourself and what you could do.

When those girls came up to us on that corner, I knew someone was carrying on in the grand old Hollywood tradition, but had no idea until coincidence, which I really don't believe in to be honest, brought me to the shop for my Nikola Tesla tattoo.

IV.

I'M LAUGHING out loud about that. I didn't bring makeup, just screwed it all up, but I just wanted to talk to you forever. Of course, since then, I've seen *LA Ink* and I love it. I love the stories and the way people

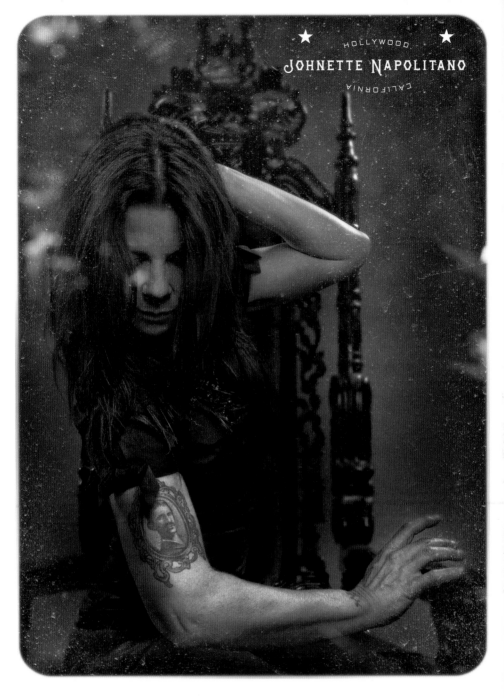

open up to you and the team. It's a gift when people feel that safe to tell you everything, talk to you like that. But: I met my daughter that day. I'm laughing out loud again, because I would tell you so many things that you, like my own daughter, would never listen to (insert winking, smiling icon). But, God willing, we have many years. We're all here to learn from each other.

Thank you for being as strong as you are, because without that strength you would not have been able to keep working, to keep bringing the joy and wholeness to those who are lucky enough to have been touched physically by your art. To those who haven't, and are appreciating your art via this book or your show or both, I want to say: This girl loves you very much, and I happen to know you mean the world to

her. Stay with her, she's giving her whole heart and soul to you. She loves you and life and the world.

The change is happening, and I remember the feeling on the corner that day: I can rest, Ricky Bobby. Hollywood is in good (tiny, sweet) hands.

FOREVER YOURS, ANGEL—

Johnette Napolitano

HOLLYWOOD, CALIFORNIA

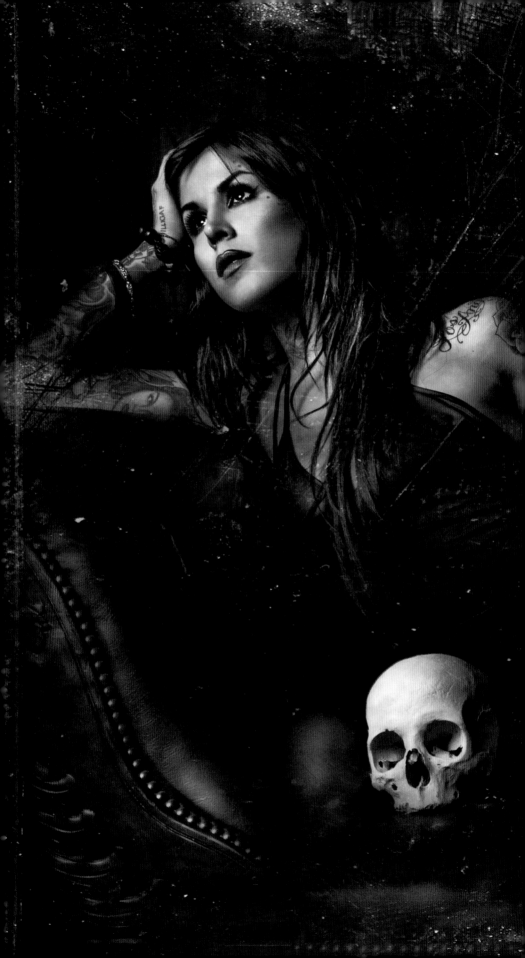

INTRODUCTION

Kat Von D

INTRODUCTION

FROM **MAY 2008** *INTO THE* **SUMMER OF 2009,**

I found myself trying to juggle many things: tattooing while both filming the show, *LA Ink*, and running my shop, High Voltage Tattoo; struggling to make time for my family and friends; and being in a relationship with someone who had an equally busy schedule. Carving out any amount of time for myself was virtually impossible for the most part, but every now and then I got to paint, play my piano, meditate, and catch up on sleep, if I was lucky!

I found myself tattooing almost every day and was constantly bringing my work home with me at the end of each night. Some days, I'd tattoo one person, but most of the time I was averaging three to five tattoos per day, each loaded with a backstory, whether uplifting, inspiring, endearing, educating, ridiculously hilarious, or entertaining.

 But I think it's safe to say a large portion of these clients' tattoos **DEALT WITH DEATH**, which naturally can be mentally draining, sometimes revitalizing——but often times quite depressing. And sometimes that would really bring me down. Or sometimes I would just feel downright low.

I don't really like to blame my moments of sadness or depression on what some might consider a clinical diagnosis, although my father told me about how the Von Drachenbergs have had to battle severe depression throughout our history.

Instead, I like to think my hypersensitivity to whatever is going on around me plays a big part in the emotional unbalance I find myself in. Sometimes these sad spells last long enough for doctors to diagnose me as depressed, but to me, that's just life——a series of roller-coaster rides that I hope will end with some kind of "light" at the end of the tunnel.

For a workaholic like myself, work was an escape, an easy way to ignore these feelings at first, but that was really only a temporary fix. There was nothing wrong with being productive, but using it as a way to ignore my problems had a similar effect that drinking did before I got sober. I was sidetracking myself so that I wouldn't have to cope with reality.

For many of the people I've been **LUCKY ENOUGH** to cross paths with through the wondrous world of tattooing, it's their first time meeting me, and their first time venting to me throughout the few hours of the tattoo. But for me, this kind of interaction is an everyday occurrence. I'm like a therapist, but without the training. Having tattooed since the age of fourteen puts me in a place where handling so many people's intense, true-life encounters with death and the grieving process that follows can be heavy at times, especially because I don't have the education and training of a therapist.

My uncle Harold is a seasoned **PSYCHIATRIST,**

dealing with a lot of patients who are seeking serious help when it comes to their issues, and I've seen first-hand how that plays a role in his personal life. I'm sure there must be a form of therapy for the therapists out there, and I can only pretend I could ever begin to imagine the load that's left on their shoulders, based on my experiences tattooing several therapists over the years and hearing only a little slice of their dealings during our sessions.

As much as I'm positive I should seek some form of therapy, I opted going for the journal route instead and reading as much as I possibly could about studies on the different facets of the human psyche. I especially took to those books that honed in on the grieving process——books that broke down and analyzed how people cope with loss. Getting that understanding was the best form of therapy for me, really.

The journaling really helped me not only sort out my thoughts on my own (which is how I prefer to work anyway), but also, like a weird cleansing ritual, relieve me from whatever energies would pass through my office door. Figuring out a way to not carry some of these feelings home with me into my own relationships was quite the challenge at times.

The writing proved to be effective in the sense that I started allowing myself to work to vent a lot of those heavy ideas out onto the pages of these journals. I could process what information I'd taken in at that moment and reach a conclusion.

Some clients' stories I could write in just one paragraph. Some would take up dozens of pages.

And some of them I wished I'd never come across at that particular moment in time, but as a result of all the writing, the most beautiful, life-changing thing bloomed in front of my very own face without my realizing it at first.

I was learning how to truly listen to people——not just nod my head and "hear" them. I was eager to learn how people live—— love, mourn, celebrate. Life lesson after life lesson unfolded before me. I could take my genuine interest in everyone and figure out so many of my very own issues. I discovered I could understand my own self so much better through others' experiences——and what an amazing gift that was.

And because of this, a new-found love for tattooing was born for me. I felt like I had fallen in love again with a lifelong soul mate. I felt I could embrace my clients for who they were

and whatever baggage they'd bring to my shop. The act of tattooing on my part became a bigger honor, the hugs became stronger, and the thank-yous became much more meaningful to me.

It's hard at times to see the silver lining in every situation——especially when it comes to death——and especially when you're in it. Looking at the "bigger picture" can often seem off-putting. But if there's one thing I've taken from people I've tattooed over these years it's that we're all going where we're supposed to be going. In other words, things do happen that leave us baffled and desperately seeking the answer to the question why?

And it sure as hell doesn't make anyone going through the nightmare of losing a loved one or experiencing something traumatic feel better about their trials and tribulations by hearing things like "everything happens for a reason" or "look on the bright side."

But in all honesty, I believe there always is a reason——and a brighter side. A domino effect does occur whether you want it to or not. Living means learning and teaching all at once. And the more people talk about it, the more we'll learn from each other——in the same way I'm learning from my clients.

My journal entries are as intimate as the stories clients share with me.

But one thing is certain: the words in this book are in no way meant to be read as gossip or criticism of anyone. I'm publishing my journal to share all I've been lucky enough to learn from folks from many walks of life.

By retelling the stories and sharing some of the crazy rants that have saved me from myself in these blood books of mine, I'm hoping that those things in life and love that were the hardest for me to overcome will become a little bit more understandable for those going through similar experiences.

—KAT VON D

MAY 2008

★

Katherine,

I HAVE BEEN WRITING DOWN MY
Hopes, Dreams & Disappointments
IN JOURNALS JUST LIKE This ONE
FOR MOST of MY LIFE. I HAVE
WORKED OUT EVERYTHING Thru
PEN & PAPER, whether it Be
Big or SMALL. I Hope you Love
YOUR FIRST JOURNAL AS much
AS I Love you....
Forever They SAY....
Forever I KNoW....
THru THick & THiN.

"ONto These pages Flow your
Thoughts only to Lighten your
WINGS enough to Fly High
into The SKY AND Then
Return to my Arms"
 I Love you
 IKKI

THIS JOURNAL BELONGS TO:

BLOOD BOOK

V

May

MMVIII

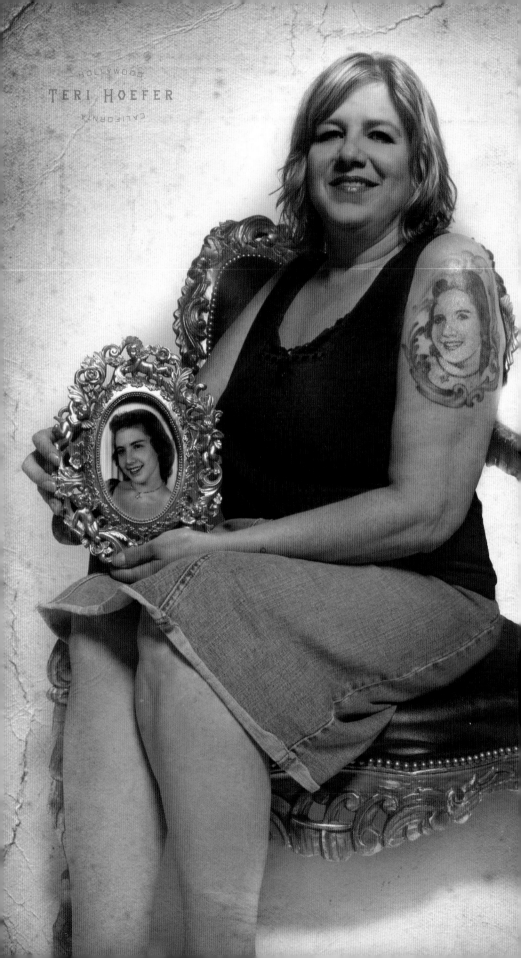

TERI HOEFER
HOLLYWOOD
CALIFORNIA

TERI HOEFER

May 12, 2008

Tattooing a memorial portrait of Teri's mother, Joyce, the day after Mother's Day was heart-rending and inspirational at the same time. With Teri, there was an element of celebrating her mother's life, not just commemorating her death. But watching her eyes light up as she reminisced about all of the sweet memories they shared wasn't enough to outshine some of the lingering worries I've been having lately about my own relationship with my mom.

So much back and forth in my brain when I think about the whole thing——the thought of what a distant relationship I had with her growing up used to make me sick to my stomach at times. And as much as I know the divorce with Dad was probably the scariest thing for her to go through, it was what forced us to finally talk about everything.

If it's true that life does flash before your eyes prior to dying, the unforgettable movement of her hand reaching across the table to hold mine will definitely be one of those flashes. Or maybe it's what she said seconds after. In her most sincere and apologetic Spanish she said, "I am so sorry, *mi hijita*, for taking this long. Your father and I separating made me realize how much I don't want to waste any more time. Can we start over? Because I love you." That was the day they announced the divorce to us.

Why is writing this down on a piece of paper harder than thinking about it?

Even though now our relationship is the closest it's ever been, the looming sense of guilt has been hard to shake, and I can't help questioning whether I'm being present enough with her now. If I say I don't take my loved ones for granted, why do I let myself get so consumed by work? I want to be able to talk about all the times I've had with Mom, like Teri does.

Like so many of my clients before her, Teri said, "you just never know. . . . " And we really don't. Joyce is just another example of that. After battling and overcoming so many health issues, she was tragically killed in a car accident at the age of seventy-three.

When the portrait of Joyce was done, Teri told me how the tattoo was an important part of her trip out here from Arizona. Her plan had been to get this tattoo, and then head over to the Four Seasons Hotel——Joyce's favorite place to sip Bombay and tonics poolside——to spread a few ashes from her urn, in honor of Joyce.

FIG. I

Jeffree STAR

May 14, 2008

Jeffree is one of the most beautiful creatures I've ever encountered—more than five years of friendship and I am still only now discovering the many layers to this fascinating, fabulous person. His style hovers between glamour and androgyny. He is fierce but still somehow vulnerable.

Jeffree has one of the most interesting collections of tattoos from me by far! We've done portraits of everyone from JonBenét Ramsey, Princess Diana, and Anjelica Huston as Morticia Addams on his legs to Sharon Tate and Marilyn Monroe topped with a human heart and spotlighted atop a pedestal with the words "Beauty Killers" fanning down below it on his left arm. Today, I'm going to do the first male portrait Jeffree's ever had (not counting the one of him as a seven-year-old), and add Matthew Shepard to his body.

Matthew Shepard. That was such a tragic story. Only twenty-one years old, and brutally murdered because he was gay. Beaten and tortured, then tied to a fence for eighteen hours. Matthew was already in a coma when they found him, only to die several days later.

Well, Goethe said it, "There's nothing more frightening than ignorance in action."

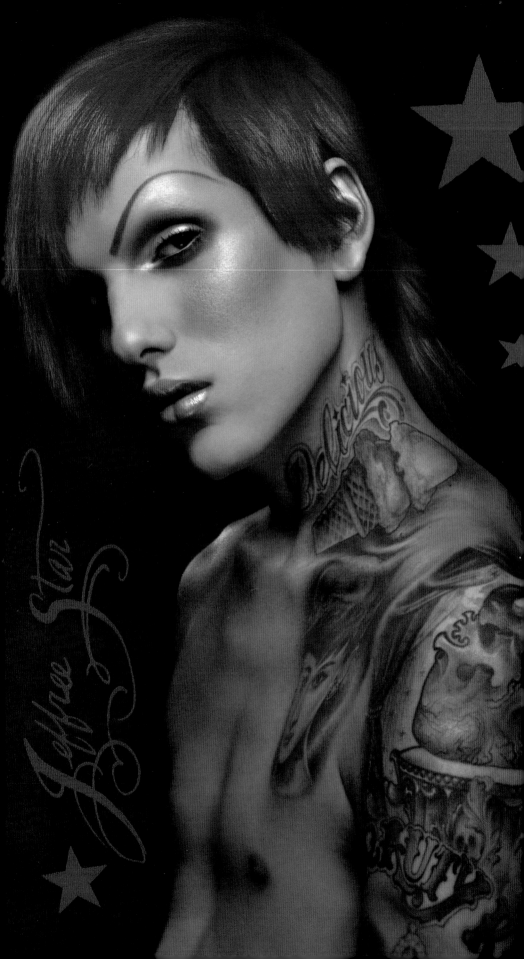

Jeffree chose to add the words **"ERASE HATE"** under Matthew's portrait—very appropriate. I think it's a beautiful homage to a martyr sacrificed just because of his sexuality.[1]

This is a pretty timely tattoo, actually. Today, the Supreme Court of California became the second state in America to say that same-sex couples could get marriage licenses. Of course, there are a lot of people who are going to disagree on that point. In the end, I guess everyone's entitled to their own opinion. But I just wish people would remember the importance of loving and respecting each other, regardless of where we come from or the color of our skin. Regardless of our sexual preference.

Perhaps I tend to be extra-sensitive on this particular subject because I know firsthand what it's like to feel "different." And when people argue a stance against same-sex marriage I am reminded of the comments I'd hear once I started getting heavily tattooed.

Tattoos aren't ladylike.

How do you ever expect to find a husband?

She must be a drunk.

Even worse were the people who'd offer remarks just loud enough for me to hear, just quiet enough to not have to claim them as they slipped away into the passive shadows they came from. It was probably just as hard for me to understand why people reacted that way to me as it was for them to understand that tattooing wasn't just a self-inflicted label for degenerates, but another form of self-expression for me.

"GROSS—I WOULD NEVER DO THAT TO MY BODY."

"MAYBE SHE'S A HOOKER."

"SHE'S PROBABLY ON DRUGS."

"I FEEL BAD FOR HER PARENTS."

Those assumptions came from a place of fear, a fear of the unfamiliar, ignorance born out of ignorance.

At times, those judgments would rile me up. On a bad day, I might have said something in retaliation, something sharp with anger. Sometimes, I'd have full-blown conversations in my head, where I'd tell these people just what it was I was thinking, putting them down for their judgments the way they put me down for my choices. Or sometimes, feeling softer, I wondered how they might react if I reached out and tried to explain why they were wrong. But as much as it angered me in my teenage years, it was just more fuel for achievement: now I was going to prove them all wrong.

But none of that stuff even really matters. I might as well have laughed it all off. Even then, deep inside, I knew that I had made more of an impact on them in the moments they took to judge me, versus my blurry memories of their forgettable faces.

I love living in Hollywood. This town never ceases to show me its tolerance, with its array of characters all living out their different lives. Hollywood's diversity makes it such a colorful, vibrant community. It's a place where it's easy to live and let live. I'm constantly surprised, entertained, and even shocked at times by what I see and hear. I've been blessed to meet and sometimes tattoo so many different kinds of people— mediagenic superstars and Charlie Chaplin impersonators, strippers and Superman's stunt double, good cops and bad cops, homeless teenagers and whiz kids, prostitutes and sex therapists, alcoholics and born-again Christians, psychics and pastors, soccer moms and soccer players, transgendered transvestites and drag queens, straights and gays. Amazing people, fascinating stories.

All of the "categories" above may sound normal and acceptable to some, and others, for whatever reasons, may find some to be weird. To me they are all fascinating and beautiful.

[1] JEFFREE LATER HAD THE OPPORTUNITY TO SHOW THE TATTOO TO MATTHEW SHEPARD'S PARENTS. THEY WERE VERY TOUCHED BY THIS GESTURE—HIS GESTURE.

KIRK HAMMETT
★ METALLICA ★

May 15, 2008

Nikki got me a camera today! A real camera! It weighs as much as a baby! After our routine coffee together in the morning, we strapped on our helmets and jumped on his motorcycle. My arms wrapped around him tight with excitement as we buzzed over to the mystery place he wanted to take me to——he said he had a surprise for me.

Without a clue as to where we were going, I might as well have been blindfolded. Every windy road we'd turn onto was unfamiliar to me—— I really had no idea——until we pulled up to Harry's Camera. But even then I didn't know why we were there. Nikki lead me to the Nikon counter and ordered up a slew of fancy photography lingo——"I'll take a Nikon D3 with a 72 mm, yadda, yadda, yadda." Might as well have been speaking in another language.

I felt so silly holding this foreign object in my hands once we got back to his house. The last camera I owned was a fully manual film camera that Dad passed down to me when I was sixteen. This digital beauty was a completely new monster, and I could not wait to start shooting with it! But first things first. I had to race down to High Voltage in order to make my appointment with Kirk today.

ROUGH SKETCH OF
KIRK'S TATTOO

Kirk brought in a brass sculpture figurine, a devil-like character holding a black cat's tail, as the cat gripped a planet earth with its claws.

Kirk was so polite and appreciative of my time——which is always refreshing nowadays, considering how pompous rock stars can oftentimes be. A few years back, he found out that Gunner, Nikki's oldest son, was a big Metallica fan, and had been thoughtful enough to send over an autographed guitar as a gift.

Metallica is in full swing on the American leg of their tour, and from the reviews, they're still tearing it up like no other. It's impressive to see bands maintain such a huge following after decades and still have what it takes to headline such a rigorous tour. Why the hell haven't I seen them play? I should take Kirk up on his offer to go see the upcoming show in Los Angeles.

Word on the street is that Kirk is one of the biggest horror film memorabilia collectors around, and that's true. But he showed a lot more interest in my antique Odd Fellows[2] collection, displayed throughout my office——and revealed himself to be a collector of secret society stuff himself. Again, I'm impressed.

OVERALL, TODAY WAS A GREAT FUCKING DAY.

2 A FRATERNAL GROUP DATING BACK TO THE 1700S WHOSE MISSION WAS TO CARE FOR THEIR MEMBERS AT A TIME WHEN THERE WAS NO STATE WELFARE SYSTEM.

NIKKI SIXX

May 16, 2008

I TATTOOED NIKKI'S ARMS ALL DAY TODAY, reworking a number of the tattoos he's had for more than twenty years. Regardless of how well the tattoos were done back then, time hadn't been so kind to a lot of the color. I'm sure the years of sun worshipping didn't help the lines maintain their original crispness either.

One of Nikki's first tattoos was a once-colorful, now-faded bat-and-moon design on his upper arm. Directly under it was a muddled cluster of letters, which once clearly read, "Mötley Crüe." Revisiting each of the pieces on his right arm was something Nikki never thought he'd have to do, but after reoutlining, reworking color, and adding much needed highlights, shading, and background we made 'em look brand-spankin'-new!

Started at 1:30 today and finished at 9:30! My man is a champ!

When we were done I HAD to text Pearl to thank her for introducing me to Nikki. Back about a year ago, before I had even met Nikki, I tattooed Scott Ian of Anthrax and he brought his long-time girlfriend, Pearl Aday, along.

During the session with Scott and Pearl, we talked about everything from our fave AC/DC songs, the typical tattoo-related chitchat, to touring, and finally, relationships. I admired how much Scott and Pearl loved each other——there was a certain interconnection they shared——maybe it was because they'd been together for so long.

I, on the other hand, was in the midst of my divorce. I had left Oliver on Memorial Day of that year——and the transition was tough to say the least. If I wasn't getting grief for whatever some tattooers considered "success" on *LA Ink*, a line had been drawn in the sand, and some of the tattooers that were once mutual friends of ours during our three-year marriage chose to display even more of a negative stance toward me.

I had been taking advantage of my newfound "freedom" in the single life and chose to channel my energy focusing on building up High Voltage Tattoo and *LA Ink* at the same time. The idea of diving into a new relationship was the furthest thing from my mind. So when Pearl casually suggested "hooking me up with Nikki Sixx" (he had worked on some music with Meat Loaf [her dad], and she had sung backup vocals on the Maximum Rock Tour with Mötley a few years back), I naturally assumed she was talking about a tattoo appointment. So I agreed. Without even realizing I had accidentally signed up for a blind date, I went on about my day.

That evening, when Pearl texted me asking if the following Thursday at 6 P.M. at Chateau Marmont would work for me, it dawned on me what I had so casually agreed to. Awkward.

You know, the fact that I had never in my life been on a blind date wasn't really what turned me off to the idea. It was more the thought of being in a relationship with a musician that didn't sound appealing. It was easy to imagine the clichés that followed a lot of the "rock star" types——party all night in whatever town with whatever girl, then off to the next show.

Not to mention Pearl's message that followed: "You and Nikki would be a perfect match! He just got out of a marriage, too!"

GREAT—another person with LOTS of baggage. Maybe we could go to a therapy session after the date! Match made in hell . . . But being too scared to offend anyone, I couldn't find a "nice" way of saying no.

Soon after our introduction was made virtually official, I got the first of many humorous text messages from Nikki. Some were about his interest in getting a tattoo from me. We also had a funny back-and-forth banter going—an argument about whether Baja Fresh was "real" Mexican food or not. (Which it is NOT. And I still think I'm right.)

The inevitable day of the dreaded date rolled around. I had just finished doing an interview for Latin MTV at Universal Studios, and I felt forced to bail out last minute. I remember this moment as if it happened yesterday. I must have rewritten my text to Pearl a million times, worried that my excuse for canceling sounded weak. I let her know that press had "unfortunately taken a lot longer than I expected, and wouldn't be able to make the Chateau on time."

Instead, Matt Skiba and I grabbed dinner and drinks at the Rainbow down the street——and I vented to him about how stressful the situation leading up to tonight was and how thankful I was that it didn't work out.

Nikki accepted my apologies, and we went on to become "phone" friends, sending each other messages, but never meeting. I was dealing with the aftershocks of the end of my marriage, and I was ending another relationship that had been ruining me——my relationship with alcohol. It was a time of intense personal growth for me. For months and months, Nikki was a bright moment in many difficult, confusing days, a flash of

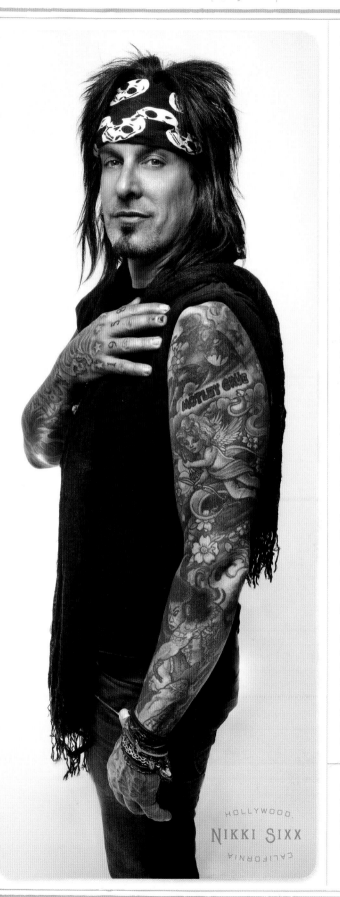

HOLLYWOOD
NIKKI SIXX
CALIFORNIA

light on my cell that told me that a friend was thinking of me.

Time passed and I found myself in my first relationship since the divorce with a fellow named Orbi, automatically putting Nikki in the "friend zone." And I assumed Nikki was probably in a relationship anyway because our textual conversations never steered toward romance.

I remember several months into my relationship with Orbi, we were going through a rough patch. It was raining and, feeling alone without any place to go, I sat in my car in the parking lot of High Voltage staring off into nothing as I listened to the rain on my windshield. The dismal silence of my depressed state was only interrupted by the buzzing of a text on my phone. Nikki.

"How are you?"

"All good," I lied.

"Really? Something tells me you're down. . . ."

How could he have known from my two-word reply?

"Ha! You must be psychic. But really, I'm fine."

"Oh, I see . . . You're doin' that strong Latina woman thing you do."

I laughed at how right he was, and in a nutshell explained the current status of my drama.

"I hope it works out with you guys," Nikki told me.

All of a sudden life wasn't so bad——at least for those few minutes we texted before we said our goodnights and I forced myself to begin the drive home. Sure, Orbi and I worked it out that night——but only to eventually fall back into the arguing that finally broke us up.

A FEW MORE MONTHS went by before I met Nikki in person——my match——in hell, heaven, or whatever you wanna call it.

William Green

May 17, 2008

The telepathic nature of our friendship must have instigated the next chain of events——he invited me out for dinner. Maybe it was destiny, God, or the universe pointing us in the direction of taking our friendship to the next level. I think it was all of the above. After all, I do believe we are all going where we are supposed to be goin'. In retrospect, the timing couldn't have been more on our side, really. The months between Pearl's initial introduction and our ultimate meeting set the stage for us to know each other as friends before we realized that it was so much more.

By the time Nikki and I went to dinner that night, I must have been about five or six months sober. Not knowing too much of Nikki's story made his past trials and tribulations all that more fascinating at the restaurant, especially his sobriety. Our conversations flowed so freely, and I felt at home in his presence. Being me, with all my imperfections, felt good. It was like I was talking to the male version of myself.

At one point, I thought about what it would feel like to be a fly on the wall looming over our secluded candlelit booth, the two of us gabbing away the evening like hens in a henhouse about life——about divorce, work, music, everything. I never thought I'd meet someone who embraced their inner nerd as much as I did, someone who was genuinely a romantic like me.

Our rants about business, real estate, and overall workaholism escalated to other subjects and uncontrollable laughter, then turned to religion, art, literature, and travel. He seized every bit of my attention. He was fascinating.

WHEN WE ORIGINALLY BOOKED HIS APPOINTMENT, I HAD NO IDEA WHAT A HEARTBREAKING STORY WOULD COME ALONG WITH WILLIAM'S TATTOO.

The blurry photo depicting a young girl propped up on a carousel horse had been taken at a distance, losing much of the important detail and adding to the graininess of the image. A well-focused photograph eliminates the chances of warping the subtle shapes that make each picture look like the actual person. This reference, on the other hand, was far from perfect, and I knew I'd have to approach it in a different way than I normally would. Instead of using a single needle or a three-liner in order to achieve precise and fine line work, a bit of a bigger needle grouping would allow me to mimic the shapes without overcorrecting the obscured details.

While doing the tattoo, I came to learn that William and his sister had been separated back in 1998——he never really went into the details of what sounded like a bad situation, and I couldn't bring myself to ask. All I know is they never reunited. Aside from the vague recollection of a little girl, this ten-year-old hazy photograph was the only memento William has of his baby sister, who by now has probably grown into a teenager.

I can only imagine how incomplete my arms would feel without my sister and brother's tattoos, let alone how it would be if they weren't around. Karoline's portrait was the inspiration behind my very first forearm tattoo, and not too long after, I got a caricature of Michael on top of my wrist. What a comforting feeling it is to be able to carry them with me wherever I go.

Now there is no danger of his losing the photograph, the only one William has of his lost sis——but will he ever find her again? And what if they cross paths one day? Would he even recognize her now? Does she even remember having an older brother? William can't worry about those things——his focus is on finding her. His failed attempts at finding her on MySpace and Facebook won't stop his search.

THAT'S WHY HE CHOSE TO GET THIS TATTOO ON HIS CHEST, ABOVE HIS HEART. IT IS A REMINDER TO NEVER LOSE HOPE.

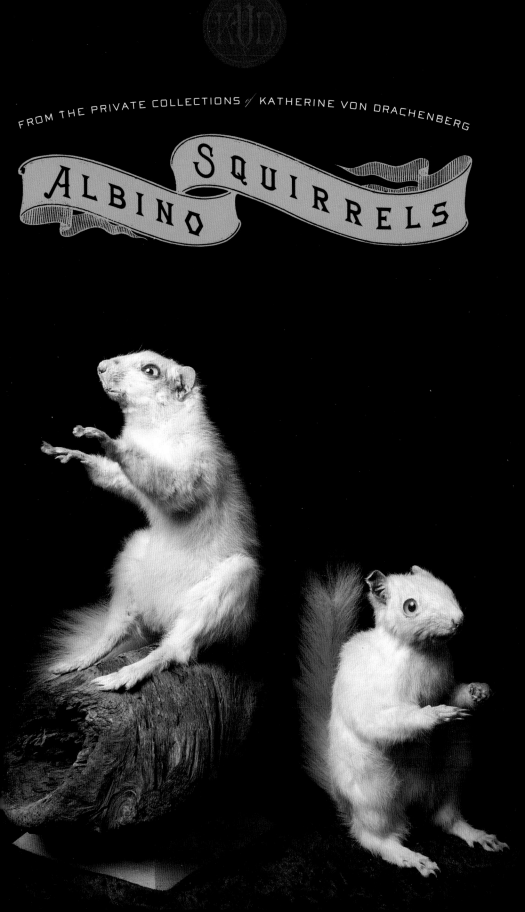

ALBINO SQUIRRELS

JEFF WARD

May 18, 2008

For my birthday last March, Jeff——the newest tattooer at the shop——gave me an art book of oil paintings by the figurative Norwegian artist, Odd Nerdrum. At the time, I had no idea who Odd was, nor how spectacular his paintings were, but after opening that book for the first time, and turning page after page of mind-blowing images, Odd instantly became my favorite contemporary painter.

When Jeff approached me with the idea of tattooing his entire front torso with the *Buried Alive* painting found in the book, I was thrilled! What an amazing opportunity to take on such a project on that large of a scale! Knowing this piece would take well over several sessions, I looked forward to getting to know Jeff better, as I hadn't spent much time with him yet.

Knocking out all the line work went by quickly, and to our mutual surprise, we were able to get a lot of the shading completed during this first session. But we are nowhere near being done with this massive piece. These beginning stages are always so exciting to see, and give us a much better idea of how many more sessions remain. I say maybe two or three more, and we're golden.

M. Shadows

(Avenged Sevenfold)

May 20, 2008

When M. and a few of the other guys from Avenged showed up, positive vibes filled the room. Between the laughing and inside jokes, they exuded a brotherly love so obvious that it was hard not to think they were all related!

The hilarity centered around the reference photo M. brought in to get for his first tattoo with me——a comical head shot of his dear friend Jason (who they all referred to as J.B. Diz). Taken during their last tour, the photo wasn't the typical image people usually bring in when getting portraits tattooed. It wasn't shot professionally, and the zany expression on J.B.'s face was pretty kooky. I can't imagine he'd ever anticipated that shot would wind up as a tattoo on his friend—— but today, that's exactly where it ended up.

Even though the image itself can best be described as silly, my approach to the portrait was nothing short of serious. From the start, my goal wasn't only to make the tattoo identical to the photo, but to create a nice layout of the portrait by adding a wispy background that would compliment J.B.'s long hair, adding movement to the tattoo.

Speaking of which——the hair. A bet had been made between the two of them, to see who could go the longest amount of time without cutting their hair. M.'s laughter was infectious as he described to me how much of the crazy, wild side came out of J.B. the longer his hair got, making that tour one of the most entertaining ever: "It was as if the hair turned him into a whole other person——the ultimate roadie!" Not only has J.B. been a friend to M., who does lead vocals for the band, for the past thirteen years, but he has gotten to work and travel the world alongside Avenged as one of their roadies, putting some serious hang time in each day.

M. went on and on about how much J.B.'s friendship meant to him, telling me how I'll never meet a more loyal person than him, and how J.B. was even the best man in M.'s wedding. J.B. cherishes the friends he has so much that he started getting portraits of the people close to his

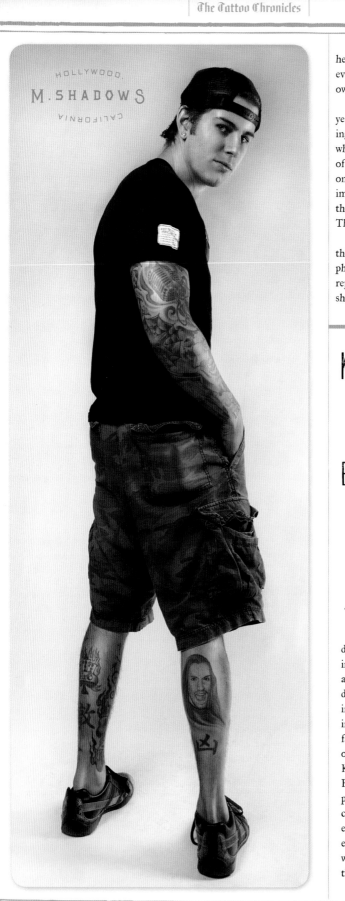

heart tattooed all over his arms—everyone from M. and his wife to his own grandmother.

And then it hit me! I remember years ago, a fellow tattooer was telling me about how he met this guy who had an entire sleeve of portraits of all of his friends—and how not only were the tattoos themselves impressive, but the idea of getting this "friendship" sleeve was, too. That was J.B.!

I then realized that although this tattoo was derived from a silly photo, the meaning behind it was a representation of what true friendships can inspire.

KELLIE SAAVEDERA
A N D
BRANDON SAAVEDERA

May 22, 2008

Last year there were

465

deaths from motorcycle accidents in this state alone. Tomorrow is the anniversary of Jason Saavedera's death. Only in his twenties, he died in a motorcycle accident—almost instantly—leaving his immediate family and a young son behind. It's only been one year, and his mother, Kellie, and his younger brother, Brandon, have come in to get his portrait tattooed. It's really hard to connect with a number—but it's easy to connect with the grief I feel emanating from the Saavederas, who can claim one of those 465 as their own.

MAY 25, 2008

IT'S CRAZY TO THINK TOMORROW WILL MARK ONE YEAR OF
MY SEPARATION FROM OLIVER. LAST YEAR ON MEMORIAL
DAY, I WALKED AWAY FROM HIM—I FELT LIKE A HORSE
WEARING BLINDERS, HEADING STRAIGHT TOWARD THE
DOOR AND REGARDLESS OF HOW MUCH IT HURT MY
HEART TO NOT TURN AROUND THIS TIME, THE PAIN I FELT
FOR OLIVER THAT DAY WAS BALANCED BY THE LOAD
LIFTED FROM MY SOUL. IT WAS THE BEGINNING OF THE
INEVITABLE AND LONG-TIME-COMING END FOR US AS A
COUPLE.

NOW I GET TO LIE NEXT TO NIKKI. ALL THE HEARTACHE
AND SUFFERING MAKES SENSE NOW. THERE'S NO WAY
THAT NIKKI AND I COULD RELATE TO EACH OTHER
AS MUCH IF I DIDN'T GO THROUGH THE NIGHTMARE OF
THAT DIVORCE. I MEAN, HIM HAVING GONE THROUGH TWO
DIVORCES OF HIS OWN MAKES APPRECIATING EACH
OTHER THAT MUCH EASIER. BEING WITH NIKKI IS A
CONFIRMATION THAT EVERYTHING DOES HAPPEN FOR A
REASON.

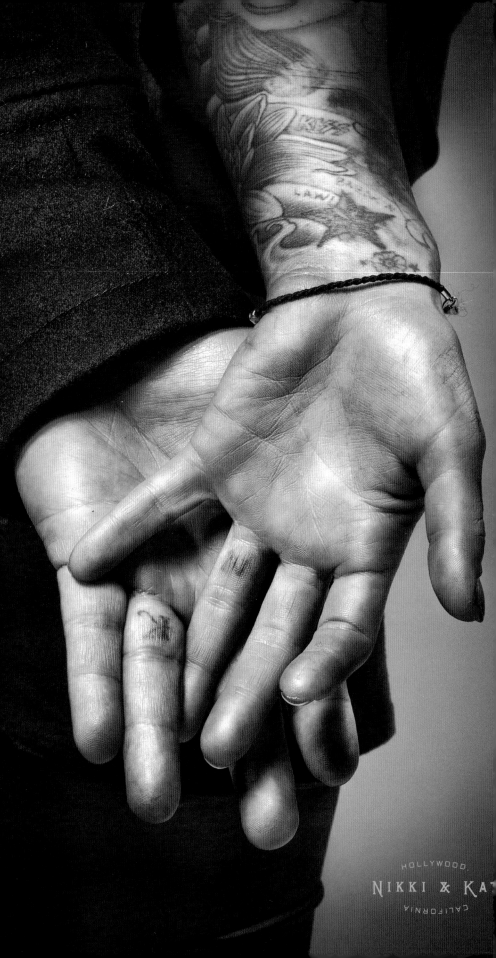

NIKKI SIXX

May 26, 2008

We tackled more tattooing than Nikki and I had originally planned today. Not only did we do a portrait of his grandfather Tom, but also added a portrait of his youngest daughter.

After bandaging him up, we asked Jeff Ward if he would tattoo the inside of our ring fingers. I got an *N* and he got a *K*. I wanted to get the *N* on the underside of my ring finger——the main reason being that this marks the artery that can be followed straight to the heart. Its symbolism for me is not unlike that of the wedding ring, a never-ending circle. It's like the infinity symbol: no beginning, no end——what eternal love should be.

I don't believe the superstition——getting a lover's name puts a curse on the relationship. I've done it before——names, initials, even a portrait——and I don't regret it. But unlike those tattoos, this time is different on so many levels.

THIS TATTOO IS LIKE THAT ETERNITY SYMBOL TO ME. I GLADLY ACCEPT THE PROMISE IT OFFERS, NO MATTER HOW MUCH TIME PASSES AND HOW MANY WRINKLES APPEAR. I CAN ALWAYS LOOK DOWN ONTO MY RING FINGER AND BE REMINDED OF THIS VERY MOMENT, AND LIKE A SECRET NOTE WRITTEN JUST FOR NIKKI AND ME, THIS TATTOO CARRIES JUST AS MUCH MEANING AS ANY OLD RING.

May 28, 2008

Yesterday, I spent the day with Matt Skiba and the rest of

ALKALINE TRIO

working on the video for the song, "Help Me." Matt owns such a special part of my heart, making it that much more of an honor to be a part of the music video. It was a solid day of shooting against a green screen, knowing a lot of the video's aesthetic detail would be added later through the magical world of CG designing. The premise was so neat——set to take place during the turn of the century, we were all decked out in magnificent costumes. I played the damsel in distress——helplessly tied to the front of a train, desperate to be saved by none other than the Alkaline Trio boys, who with the help of jet packs and other

STEAMPUNK-LIKE

devices, successfully save the day!

I wish I could say yesterday's bright and cheery vibe outshined the negative one that overcame the shop this evening, but I wouldn't be telling the truth. The creepiest thing just happened. I'm struggling to just even understand all the things this incident brought up for me.

I was tattooing out front like I usually do, totally focused on the

TATTOO,

when I heard Adrienne calling me to my office; there was a strange urgency in her voice that I had never heard before.

I pulled my gloves off and moved my client and his half-finished rooster tattoo from my station out front into my office while Adrienne tried to remain calm as she explained that she had just discovered a man huddled in the corner of our biohazard room.

He was convinced that he and I were connected on some type of cosmic level. When she sternly—but carefully—asked him to leave the premises, he refused, insisting that he get the chance to speak with me. After Dennis marched him up front to the waiting area and tried to convince him to peacefully exit the shop, Adrienne dialed

No more than two minutes had passed by before we heard police cars buzzing out front. I don't

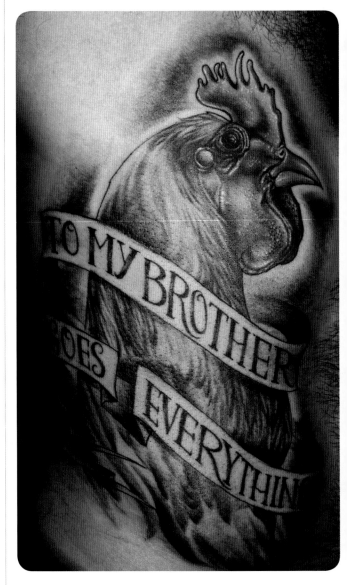

know why I felt the urge to look, but I did, and I caught a glimpse of the stalker staring back at me as they handcuffed and escorted him out of the building. I feel rattled every time I think of it.

Once he was in the backseat of the police car, my friend Rhian, who'd witnessed the entire thing, turned to me and jokingly said, "Well, I guess this can only mean you've arrived!" I didn't find her comment funny in any way. And if this is what "arriving" is, I'm not so sure I want anything to do with it.

Adrienne set my station back up, but in my office. I don't think I'll be working out front for a long time now. High Voltage is my home—but I don't feel safe here right now.

FROM THE PRIVATE COLLECTIONS *of* KATHERINE VON DRACHENBERG

ALBINO PHEASANT

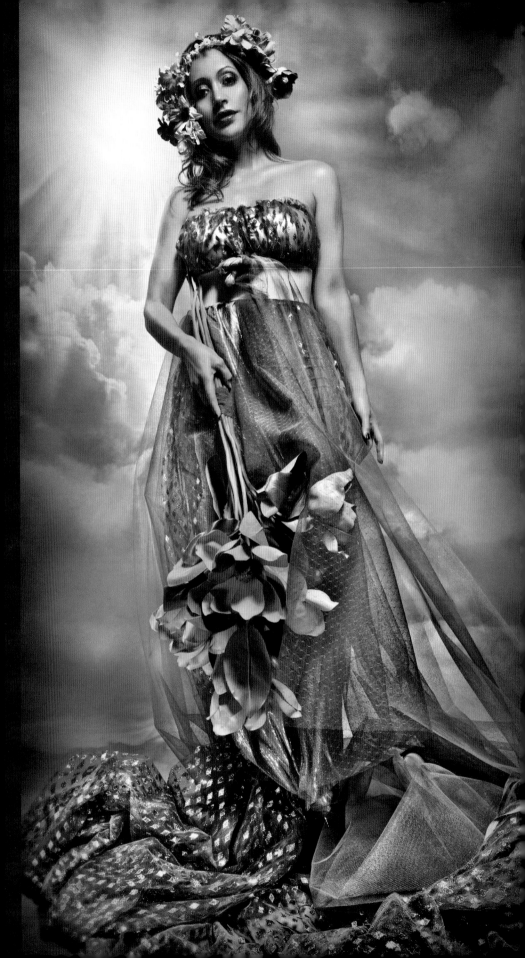

BLOOD BOOK

VI

June

MMVIII

June 3, 2008

Waiting at the airport terminal for my flight to New York to board. I'm going out there for only a few short days to film a charity runway show where this clothing designer has created a dress for me to wear on the runway——the dress will get raffled off later.

Lately I haven't felt very attractive, definitely not enough to parade myself alongside the likes of professional models on a popular television show like *Project Runway*, where I'm going to have to walk the runway to model a dress that's going to get auctioned off later. Great . . . I've been so damn busy——six months of complaining, and I still need a proper mani-pedi——my skin looks like shit——and I could definitely use some exercise. I know that I always look however I feel——so New York should be interesting——not to mention my overall feeling of missing Nikki already, and the plane hasn't even taken off yet.

One time, when Nikki and I were waiting for our plane to board, I was doodling in one of the little sketchbooks that I carry in my purse——an old habit of mine——and noticed Nikki took interest in what I was drawing. There's always been something about eyes that I have loved since I was a kid. I'd draw them all the time——male or female eyes, in every angle imaginable, sometimes crying, sometimes gazing upward, sometimes even closed.

The little boy in Nikki started pouting, and he said, "I wish I could draw like that . . ."

"You can," I told him. "Anyone can! You just have to practice."

I quickly sketched out a simple little diagram while he complained of his lack of drawing skills. I've applied this diagram since I can remember whenever I'd draw these eyeballs. It gives you a center point to start from. I handed over the sketchpad and pencil to him.

"Here. You try."

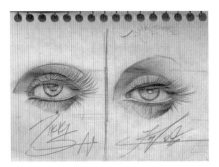

Step-by-step, he followed my lead and drew a pretty damn good eye! After the drawing session we shared that day, it wasn't uncommon for me to find little pieces of scratch paper or Post-its throughout his house or in his

car with eyeballs he'd drawn, each one getting better than the one before. I began noticing pen marks depicting this familiar eye on his jeans——I even found one he did with a marker on a lighter by the candles in his bedroom! The man was on fire with these drawings! And deserved a big fat "I told you so!"

It's crazy how in such a short amount of time we've been together we've become so close. It's amazingly wonderful and painfully torturous how it works. The euphoria I feel when I'm with him can only be matched by the incomplete feeling that takes over when we are apart.

He inspires me to write all of the time——and songs I've heard a million times over now hold new meaning.

NEW YORK

never came off as a romantic city to me, until my twenty-sixth birthday, when Nikki surprised me by flying into town and spent the weekend at the

BOWERY HOTEL

with me. We got our first matching tattoos on my birthday: we took the Bowery Boy design from one of the hotel doilies and got it tattooed down the street, at New York Adorned. I fell in love with the city that night.

June 4, 2008

Landed in LA about an hour ago from the hit-and-run trip to New York and have since been in traffic——delirious and outta my mind due to no sleep. I'm laying across the backseat of the car that picked me up to try to sneak in a power nap before my hectic day begins, when I got the craziest thought: Nikki will be 50 in December. I know I'm not supposed to think about these kinds of things, but it really scared me the other night when we were laying in bed recapping all the fun times we have had so far. He turned to me and said, "And to think we have at least fifty more years of this to enjoy!"

We both smiled in the silence, doing the math in our heads. I mean, most people don't live to see one hundred——ten years from now he'll be fifty-nine——and by the time I'm fifty-nine, he'll be eighty-three. As much as I didn't want to, I started thinking about life without him and the thought literally brought tears to my eyes.

As selfish as it sounds, I pray that day never comes. Fuck——

I NEED SOME SLEEP.

NIKKI SIXX

June 6, 2008

When it comes to being a great dad, Nikki takes the trophy. He really loves those kids——and their relationship is so communicative. As a teenager, there were so many times I would have loved to have confided in my parents about things that troubled me, but there was this invisible barrier between us, so I often didn't allow those honest conversations to happen. Looking back, what was I scared of? I don't know why I felt like I was going to let Dad down if I told him that I felt different from the other kids at school. Or why I felt like the only way I could have gone to see a band play at the neighborhood venue was if I snuck out in the middle of the night while Mom was fast asleep. I could have just explained to her how harmless an all-ages show really was——and if I had, my parents might have very well let me go. Instead, I often put myself in dangerous situations. Pretty typical, I guess, but I wonder why is it that I still feel this way sometimes, even as an adult. I haven't mentioned Nikki to Dad yet. I'm pretty scared of telling him about our age difference. It's one of those things——any daughter probably understands. As close as we are, I know how judgmental he can be at times before really looking at the situation.

Dad gets frustrated with me, especially when it comes to relationships. He thinks I don't take enough time off in between, giving myself time to "heal," he says. I understand where he's coming from, especially after how upsetting my marriage to Oliver had been for him. I only knew Oliver for two months when I eloped with him at such a young age——and without introducing him to the family. I think that left Dad with this idea that my decision making is sometimes reckless. Sure, I've made mistakes in life——and who hasn't? For the most part, I like to think I've done pretty damn good for myself.

As much as I can see where Dad's coming from, it doesn't make it any easier.

Anyway, Mom and Dad and I are in a great place now. But sometimes, when I hear Nikki's kids share their feelings with him about the teenage drama at school with their friends, ask him for

with their crushes, or his opinion about their hairstyle, it's easy for me to wish I had a similar relationship with my folks growing up.

With Nikki's upcoming tour just around the corner, I can hear the reluctance to leave the kids behind in his voice. Getting their

PORTRAITS
TATTOOED

is gonna be a positive reminder of the family life that waits for him at the end of the tour. As much as I'd like to think I could complete the portraits of all four of his kids, two is a good start for now!

MARJORIE & JOE WALSH
~~~ *THE EAGLES* ~~~

### June 7, 2008

It's always an honor when people choose you to do their first tattoo—and even more so when that someone is Joe Walsh and his wife, Marjorie. I've been a longtime fan of the Eagles, but even more so of James Gang, so tattooing a romantic matrimonial tattoo like this on them makes it that much more special to me.

In the beginning of their relationship, they discovered something in common: both wanted to get tattooed one day. What an amorous thing to do together! Joe's Buddhism inspired the yang (masculine) portion of the yin-yang symbol, while Marjorie got the yin (feminine). The balance of male and female—separate but complete as a whole—was the perfect way to match their tattoos while making each one their own.

Joe and Marjorie complemented each other so well. I watched them finishing each other's sentences, and gazing into each other's eyes as they took turns getting their tattoos. Witnessing this kind of energy between two people who truly love one another made me think of Nikki and myself. There's a mental picture I get sometimes when we're together—the two of us will be doing whatever morning routine we do, reading to each other, playing the piano, painting, or photographing on the front porch of the house—growing old together like gypsy pirates. When I told Nikki that the other night, I felt like anyone else would think I'm strange or too lovey-dovey. But Nikki got it—and it was easy to see he envisioned the same.

# BRANDON McLAUGHLIN

## June 13, 2008

The first time I tattooed Denise Richards, she brought two people along: her best friend and her father. Her strong connection to family was something I really vibed on. I'm a sucker for father-daughter relationships, and to see the kind support her dad gave her made me smile. She had come in for a cover-up of a relatively small tattoo of her ex-husband's name. We made it happen with a colorful fairy——making good use of all the detail in the wings to successfully conceal "Charlie."

In the short amount of time it took to complete the tattoo and bandage Denise up, she mentioned that her brother, Brandon, was interested in getting portraits of his children. I figured the apple doesn't fall far from the tree, and if her brother were as down to earth as she was, setting him up with an appointment would be a good thing.

I was right. Brandon, who had a good number of tattoos already, was a treat to work with today. The two portraits of his sons on his chest made him smile, and he kindly thanked me before going to show the rest of his family the tattoo.

Tattooing always seems to introduce me to people I might not otherwise get a chance to meet——making this job that much more of a blessing.

Nikki gets to meet Dad tonight for the first time! We're having an early Father's Day dinner so I can spend some time with my Pops before I leave for London for the *Metal Hammer* awards. Thank God, Dad's been such a big support through all of this. I can't help but wonder if he means it when he says he understands. I keep promising myself that when I'm done shooting this season of the show, I'm gonna take Dad somewhere neat——or maybe invite myself on one of his fishing trips. But there's always gonna be something——if it's not this season, or additional episodes, press, the shop, a tattoo appointment, Nikki, or whatever——that falls in the way. There's always something else.

The stories from my clients teach me about the importance of making the most of the time we have together in this life——they are daily reminders to not take my loved ones' company for granted. And I think it's pretty apparent that I need to start paying attention to this when it comes to Dad.

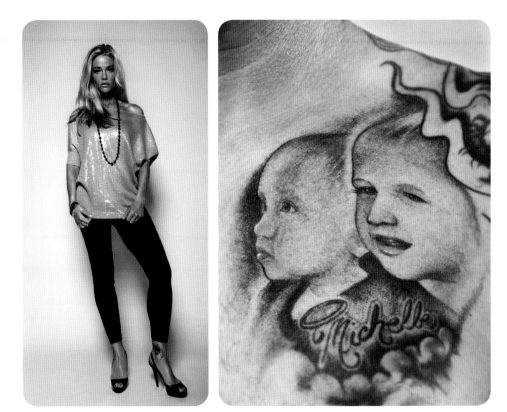

DENISE RICHARDS        BRANDON'S TATTOO

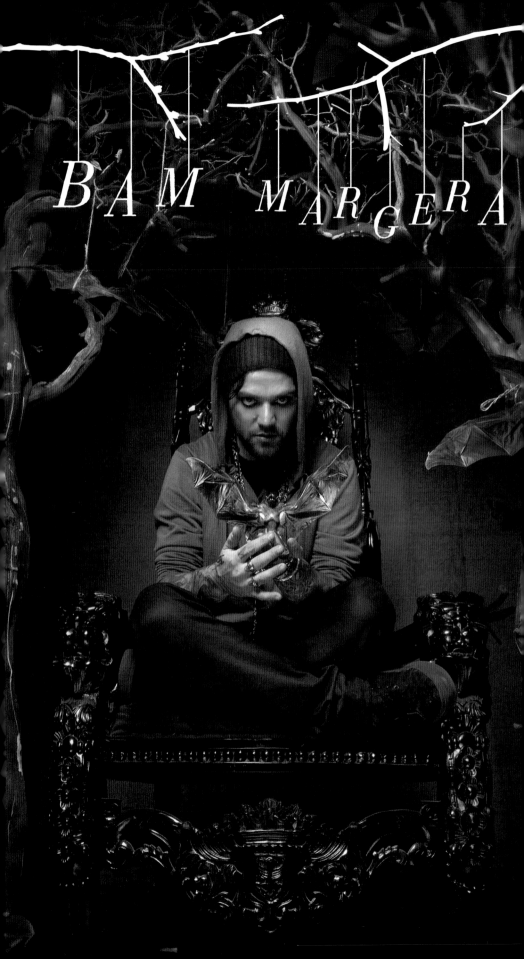

## June 14, 2008

Last night I was semi-nervous, but mainly excited for Nikki to meet Dad. I really think Nikki was a bit nervous, too. He knew how important this was to me——and it really couldn't have gone any better. We made reservations at a nice Argentinean restaurant in Pasadena I knew Dad would like. Karoline and Michael met up with Nikki and me, and Dad and Sharon. [3]

I was surprised at how much Dad and Nikki connected——it was almost weird. How the hell did he know about Nikki's book? Obviously Dad's been surfing the Web or something. Whatever it was, it doesn't matter. All I know is that never has Dad been so receptive to any of my past relationships. The two of them were chattin' up a storm the entire dinner, and Nikki was making him laugh so hard! More than I do—— what the hell?

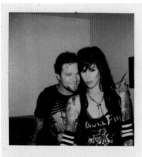

BAM VON KAT

I was so excited to tell Bam how well it went when he came in today for the black-and-gray portrait of Andy McCoy——lead guitarist of Hanoi Rocks——that he's been enthusing about for the past year. Man! I miss talking with Bam——so much time has passed since we last hung out.

Over these last few years, my list of friends has dwindled down to three——maybe four. Bam is definitely one of them, but him living out in Pennsylvania doesn't exactly make us neighbors——and the times we get to be in the same place at the same time seem few and far between. The last time we got to enjoy a solid window of uninterrupted time to talk was months ago when I went out to Westchester to be a part of the movie he was filming, *Where the F*ck Is Santa?* I think as much as he likes the attention he gets from all the *Jackass* stunts and the TV shows, he's just as vulnerable as I feel at times. Amid all the commotion around us with the cameras and the overwhelming amount of people in his house, there was this sudden moment of desperation——he turned to me and said, "Let's get the hell outta here. Like, right now." Caught off guard by his request to abandon ship in the middle of all of the action, I also understood his anxiety, because I've felt that way, too——especially when I'm on set. We went and sat in his car for a few minutes until his heart rate came down a bit.

Feeling unable to connect with one single person in your surroundings can make everyone feel like a complete stranger, and that is usually what triggers my anxiety. I understood why Bam felt anxious and think connecting with me helped him feel better.

Later that night, when the dust settled from the end of the hectic day of filming, I was finally able to sit down with Bam and explain why I haven't really been around the last few times he came to LA. I told him that it wasn't that I didn't wanna see him, but I just didn't think I was strong enough to say no to the endless nights of drinking that usually come with "partying" with him.

And in no way were my intentions to hurt him or to put down his lifestyle——that it was just something I had to get off my chest.

Bam's response was funny because he said the same thing to me. It's been a struggle for him to find friends who don't expect him to always be the life of the party and won't think something is wrong if he's not pounding shots like usual. And although he wasn't planning on quitting drinking, he's wanted to lie low for a while now, explaining why he hasn't been around me either. We both laughed at the fact that this whole time we had been avoiding each other in fear that the other would wanna drink.

Today, in LA, I look at him and think about how Bam is selfless. True. Smart. Beautiful. Loving to others. Hard on himself.

I love tattooing him, and the portrait of Andy made him so happy. He can't wait to show it to him in July when he heads out to Finland for Ruisrock. He really wants me to come, but I'll be visiting Nikki on tour in Florida to celebrate his seventh year sober.

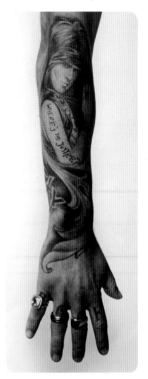

3 SHARON IS MY FATHER'S WIFE.

# LONDON

*(METAL HAMMER GOLDEN GODS AWARDS)*

### June 17, 2008

I really wanna go home. I miss Nikki, and the jet lag isn't helping. It's 7:21 in the morning in Los Angeles right now, and he'll probably wake up soon if he hasn't already. I have a feeling that when he's on tour, it'll probably feel a lot like this——a constant feeling of missing each other. I wonder if he feels the same. I just never wanna get used to this feeling.

So fucking tired——but the sun is out and is playing tricks on my brain. I need to go home already.

### June 18, 2008

Sitting in London traffic en route to the airport to fly back home. Nikki asked me the other day why people associate the human heart when they talk about feeling love. He says when he feels it, it's in his stomach. Deep in his gut. I'm smiling. It's incredible to feel so in sync with someone——we may not be the same age, but we share so many of the same thoughts and make the same connections. We're a lot alike.

---

Our childhoods mirror each other——two kids with "dreams," as cheesy as it sounds, with an innate drive to do what we were born to do and not let anything get in the way. We both got on a Greyhound that eventually spit us out in Hollywood, where we felt most at home. What some might consider the "hard road" was the only way we saw possible. At one point, Nikki lived with prostitutes in a room not bigger than a closet, working several day jobs in order to be a musician by night. At around the same age, I did the same, living with a hooker for several months in order to work my first gig at a professional tattoo shop. I had no driver's license, let alone access to any transportation other than the public bus and the occasional cab—— and managed to hold down two other jobs, one in a mall in Riverside, one peddling popcorn at the local theater in a town twenty-five minutes away. All of this so that I could support myself and tattoo the rest of my waking moments.

---

Still, there was an element of family present in my life that was missing from Nikki's childhood. The concept of a "normal" family unit was something foreign to Nikki until he became a father. Listening to him talk about his estranged father is at times heartbreaking to say the least, but his ability to recognize the mistakes his own parents made and not repeat those patterns is mind-blowing. For me, one of Nikki's most attractive qualities is his passion for being the best father possible.

### June 22, 2008

## IT'S 3:40 A.M.

and I just got home from a hectic, never-ending day. It started off at 8:00 when I woke up to Nikki's face. I knew that his car would come collect him at 10:00 to go to the airport for his warm-up show, in Montreal. With Crüe Fest about to start, things have been rough to say the least—— thanks to our schedules. I was just in London for about four days, and upon my return, I found out that Bam was still in town. I really haven't had much time to spend with him since I tattooed him last and thought it was important to carve out some hang time during his visit, before I headed out to

## NIKKI'S.

That drive is becoming such a PAIN IN THE ASS.

---

The last few days have been a whirlwind of appointments to make, errands to run, places to be. My time with Nikki has dwindled down to three-hour increments here and there, and those few hours are mainly spent sleeping. Understandably, he's been trying to spend as much time as possible with the kids before his trip——and it's so hard not to be

## SELFISH

with his time. But there's got to be a balance. I mean, I can't be the only person on the planet dating a single parent——how do they MAKE IT WORK?

FROM THE PRIVATE COLLECTIONS *of* KATHERINE VON DRACHENBERG

# N U N S

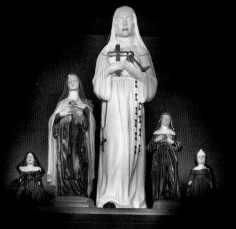

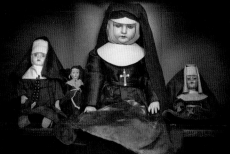

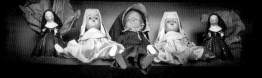

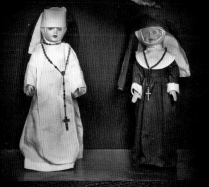

June 23, 2008

# TOMORROW

the new Mötley album comes out! So excited for Nikki! It feels so good to be proud of my other half and witness all of his hard work pay off. Makes me wanna take on the world!

He's in New York right now doing Letterman and a bunch of other press, and I don't think I've ever in my life wanted to be in New York this bad, although I did manage to have fun at the Steel Panther show tonight. Never thought I'd have this much fun without drinking.

I'm feeling pretty good now, but I know that Karoline thinks I've been isolating myself. So does the rest of the crew—I can see it in their faces—almost as if they're walking on eggshells around me. Where there was once a relaxed comfort in the way they moved about me, I can now sense a hesitancy in my fellow tattooers, when they quietly knock on my office door as if they're interrupting a meeting.

Lately it's becoming a whole lot easier to get stuck in my hermit ways, and a whole lot harder to be around large amounts of people. The overwhelming sense of anxiety has been getting harder and harder to mask, even with something as simple as going out front to use the copy machine.

I think I'm thinking too much—that may be the problem. My brain has become my own worst enemy. I'm overanalyzing everything time and time again. Maybe it's the feeling of the public's expectations being so high that's making it harder for me to tattoo out there. Getting booed in my own shop by "fans" for not dropping the drawing I was working on to take a picture the other day—or being yelped at like I was a dog while trying to concentrate

on a tattoo, with someone complaining that I had "turned Hollywood" because I didn't take the time out of a packed day to greet them—all these things have been making me feel pretty small.

I've noticed my lack of eye contact with the outside world for the most part, catching myself staring at the floor a lot of the time in order to avoid making that connection. And maybe it's my fear of letting people down, which I battle with on a constant basis.

Sure, I can't expect anyone to fully understand some of the paranoid thoughts that come and go through my head. And I sure can't expect anyone to know how much I miss feeling like one of the guys, or how much I truly love what it is I do: tattoo. If only I could do that out there without feeling this way.

# I STARED AT THE PICTURE OF EMILY

on my fireplace this morning before heading to work. One of my biggest fans—the first Make-A-Wish girl[4] I was supposed to meet, but I missed by one hour. She had autographed a picture of herself for me before she passed away, and told her mom that she knew I'd end up wanting her autograph if I met her. And even though Emily wasn't able to give me the photo in person, I treasure that picture and placed it in my home, where I knew there'd be no way of leaving the house without seeing her sweet face.

## *Emily is my daily reminder*

to enjoy each moment and each day. She is my fearless hero. Some days, I walk past the picture too wrapped up in my melancholia to remember why she's even up there. But most of the time, there's no ignoring her. Like today.

Inspired by her, I decided to tattoo out front again for the first time since the stalker incident a little while back—I broke out of my shell and joined my crew. I had several appointments today, and it felt so good to work next to them.

The commotion up front in the lobby, where tattoo collectors from all over the world are discussing their ideas for their next tattoo, bumping elbows with the visiting tourists, and snapping photos of the shop to show off to their loved ones back home, sets the tone for the rest of the energy in the shop. Dennis and Adam were cracking jokes and hovering over the community light box, preparing the line drawings to be stenciled for their next appointments.

**TATTOOING** outside the isolating realm of my office makes me feel like I'm a part of my own shop again. And as much as I enjoy working in the comfort of my private office, nothing feels as much like home as tattooing out here. Being able to tattoo side by side with my team of tattooers and shop managers makes me feel guilty calling this work.

---

4 MAKE-A-WISH HAD SET UP A TIME FOR ME TO MEET EMILY. SHE WAS THIRTEEN YEARS OLD, AND HAD THROAT CANCER—SUPER-RARE FOR A TEEN-ACER. SHE WAS HOSPITALIZED IN SAN DIEGO, AND A FEW DAYS PRIOR TO OUR MEETING, I GOT A PHONE CALL FROM HER MOM, TELLING ME THE DOCTORS DIDN'T THINK SHE WOULD LIVE THROUGH THAT DAY. I WAS IN THE MIDDLE OF FILMING A TATTOO (WHICH I NEVER WAS ABLE TO FINISH), BUT I STOPPED AND RACED TO THE HOSPITAL—A TWO-HOUR DRIVE FROM HOLLYWOOD. SHE DIED ONE HOUR BEFORE I ARRIVED.

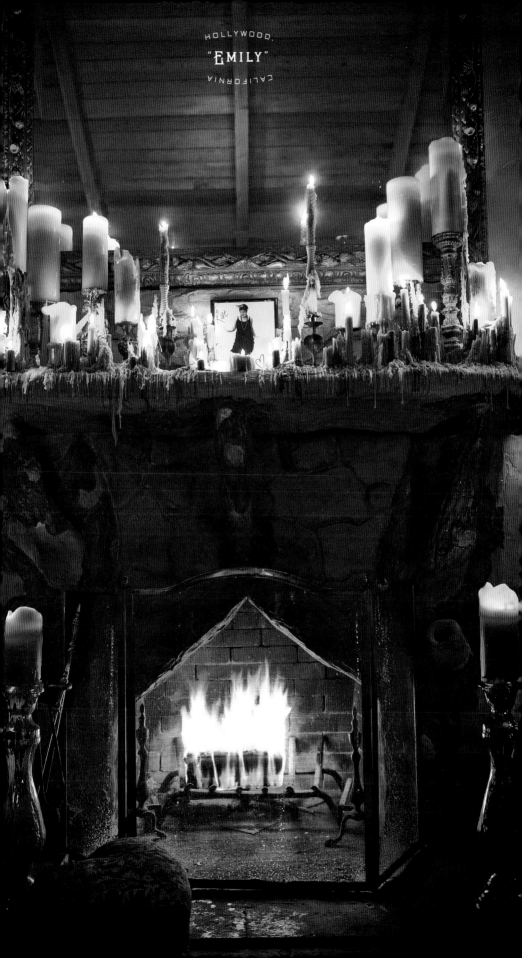

# ELLIOT GRÆBER

S till, by the time I got to my last appointment, to tattoo Elliot, I didn't mind taking him back to my office to keep this tattoo on the down-low from Adrienne and Greg. Elliot wants to keep it a total surprise from Agatha. I can't think of a bigger form of flattery than when your husband gets your image permanently tattooed onto his body——and that's what he came to do. His wife, Agatha Blois, is a world-renowned leather apparel designer, and her work is nothing short of amazing. I had always admired her leather pants, vests, and jackets that I'd see on some of my favorite musicians, and when Agatha and I finally met, we became fast friends. I fell in love with her New York accent and biker personality as much as I did with the clothing she made for me.

## AGATHA
IS SUCH A MAGNETIC BEING. Adrienne got the first Agatha portrait I did a few months back. And come to think about it, a woman at my gym has Agatha's name tattooed on her arm, too. So oddly enough, Elliot's tattoo isn't going to be the first time I've tattooed Agatha's face on someone——although obviously this tattoo he's getting of her on his ribs is going to be a lot more personal.

When she returns from her trip to the East Coast, she's gonna flip!

## I CAN'T WAIT!

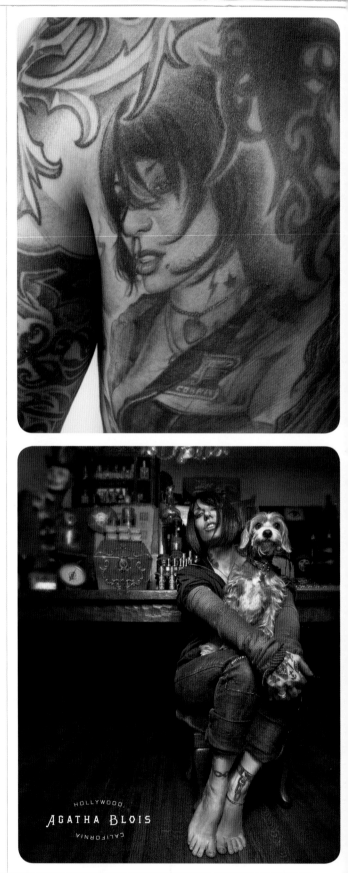

HOLLYWOOD,
AGATHA BLOIS
CALIFORNIA

# Mike Portnoy

## [DREAM THEATER]

### June 25, 2008

> ALTHOUGH I AM A FATHER TO TWO CHILDREN (human ones), my dogs, Bongo and Maggie, are very much like children to me as well. The term "man's best friend" is for real. I love them both and miss them immensely when I'm on the road. Sometimes being away from them is harder than being away from my wife and kids, because I can't talk to them on the phone!
>
> Bongo is in her teens (in human years) and starting to get old, and I've been thinking about how devastated I would be without her, so I wanted to immortalize her and Maggie forever and always have them with me. ——Mike Portnoy

Nikki and I just hung up from a shitty phone call. He's tired and in a bad mood, I guess. I'm sure the pretour craziness he's been dealing with isn't helping his anxiety, but I can't stand ending a phone call on those terms. I can't wait to start this tattoo——it'll take my mind off things, like it always does.

# TATTOOING

has always been like a form of meditation—— regardless of whatever thoughts and feelings are sparring in my head, there's a quiet wonder that happens when the tattooing process begins. I can submerge myself into every detail of the tattoo, making it easy for me to let go of my problems for a while——but unlike drugs or alcohol, it's a healthy way to adjust reality. It opens up a stream of thinking that gives me room to take a step back and think before acting on my emotions. I am the most present when I'm tattooing. I am able to focus on microscopic details as the world around me spins and tumbles, but like the eye of a storm, my heart is calm and my mind is nowhere but in that very moment.

Due to the chaotic schedules of a tattooer and a musician on tour, we've had to reschedule Mike three times——so today is the day! Finally! Between Dream Theater and the rest of Mike's roster of side projects touring, he managed to squeeze in time to pay tribute to his two dogs, Bongo and Maggie. Without making the tattoo look like a totem pole of dog heads on Mike's calf, I was so thrilled to make good usage of the vast area and really get into creating a sense of depth. Before even starting the tattoo, I knew by the angle the photos had been taken (from above) this challenge was going to be my favorite part to tattoo.

I think it helps when a client like Mike is open to an artist's interpretation, giving me the creative freedom to go off on backgrounds. As simple as the shading surrounding Bongo and Maggie seems, it made a world of difference when it came to really bringing out the sparkle in the dogs' chains, and the highlights in the eyes and fur.

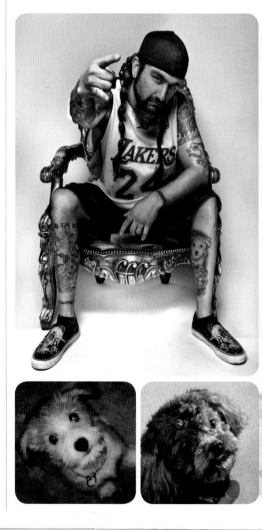

# Joni McLelland

## June 27, 2008

# MUSIC.

Such a fascinating phenomenon: Certain songs trigger childhood memories, recollections of old loves, past experiences, and feelings. Some songs, when heard, can evoke a certain taste in your mouth.

# BEETHOVEN

was right when he said music should strike fire from the heart of man and bring tears from the eyes of woman. Because it does. Paying homage with a tattoo to musicians who inspire us seems like such a natural thing to do. It was hard not to smile the entire time I tattooed the portrait of Steven Tyler on Joni today. Nikki always speaks highly of Aerosmith when we talk about our influences growing up—and when I saw how Joni's eyes lit up when she talked about Steven, it made me want to tell this story Nikki loves. Sharing the story with Joni made me feel that much more connected to her. Here it is, in Nikki's words:

## "STOP, FROG!"

Life is complete is what they will say when you die.

"Died and gone to heaven" is another.

But may I ask what it's called when the journey you're on seems heavenly? You're full of life, kid-like, and no coffin in sight?

The year was 1988, the place was Maui. The characters in said setting numbered only two.

A kid from Idaho and an older brother from Boston. The youngest was me, the oldest was Steven Tyler. Me from Mötley Crüe, and him from Aerosmith.

I was in Hawaii on a well-needed and much-anticipated vacation when I heard my name called from behind a bush and up pops my childhood hero and sober companion in rock 'n' roll. Two very different men, both somewhat childlike.

Steven, always one to motivate, said, "Let's get some bikes and go explore." I thought it was foolish, but didn't think I could say no so I didn't.

The hotel came up with two rusty old mountain bikes and off we went. I remember finding a pretty cool walking stick, which I stuck into the basket that was mounted on the front of the already somewhat embarrassing bicycle.

As we were peddling along, the competition got fierce. At some point, we were in a full-on race, riding up the hill toward a blissful Hawaiian skyline when I shouted,

## "STOP, FROG!"

In barely a blink of the eye, we dumped our bikes to the ground and were standing over what looked like a dead bullfrog, belly-up and eyes peering. I grabbed my walking stick as Steven said, "See if he's alive."

I poked it once or twice, and at that moment we were both twelve and nine again respectively. We weren't rock stars but kids. We were in heaven.

Then I heard, "Hey, it's Steven Tyler and Nikki Sixx."

Life had boiled down to that magical moment only to be woken by the reality of a passerby.

Life comes full circle many times in life if we're lucky. That was one of the luckiest days of my life.

—N.S.

"

I have always been a huge fan of

## AEROSMITH

since I was a kid. Steven's life and his music have inspired me every day, and that's why I chose to get a tattoo of him. I admire the strength he has in overcoming his demons and coming out on top as one of the greatest rockers in history in one of the greatest rock and roll bands of all time. They continue to make great music to this day after thirty-six years and put on one hell of a show. I knew I wanted a portrait of him, but I wanted it to have Steven's iconic image. So I chose a great photo of him screamin' into his mic, like everyone pictures him.

—Joni McLelland

"

JUNE 29, 2008

WE'RE OFF TO THE AIRPORT. NIKKI THOUGHT IT BEST
TO FLY TO FLORIDA A FEW DAYS BEFORE THE FIRST
SHOW TO MAKE SURE EVERYTHING'S IN ORDER WITH THE
ROAD CREW AND THE SET. THE NEXT FEW DAYS ARE
PRACTICALLY THE ONLY TIME I'LL MANAGE TO GET OFF IN
ORDER TO SEE HIM DURING FILMING.

———————

ALTHOUGH I AM EXCITED TO HAVE SOME TIME ALONE
WITH NIKKI, I DON'T HAVE THE BEST FEELING ABOUT THIS
TRIP. I KNOW I SHOULDN'T MANIFEST ANYTHING NEGATIVE
BEFORE EVEN GETTING TO THE AIRPORT, BUT WATCHING
HIM SAY GOODBYE TO THE KIDS WAS HARD—HIS VOICE
HIT A PITCH I HAD NEVER HEARD BEFORE. HE'S TRYING
TO STAY POSITIVE THROUGHOUT ALL OF THIS. JUST RIGHT
NOW IN THE CAR HE LOOKED AT ME AND TOLD ME HE
WAS REALLY HAPPY, BUT FOR SOME REASON I'M NOT SURE
I BELIEVED HIM. MAYBE IT WAS THE FORCED SMILE
THAT FOLLOWED THAT SENTENCE.

BLOOD BOOK

VII

July

MMVIII

July 2, 2008

# SEVEN YEARS FOR NIKKI, ONE YEAR FOR MYSELF.

## SOBRIETY—WHO WOULD HAVE EVER THOUGHT?

**I KNEW HOW IMPORTANT** it was to Nikki for me to fly with him to Florida. Not only was tonight the kickoff to the first of many to go on the Crüe Fest tour, but also today was Nikki's seventh year sober.

Knowing tonight would be a monumental time for us, I came prepared with a travel-sized amount of my tattoo equipment, just in case we found time to celebrate with a tattoo. Nikki's back piece had been unfinished for years—and it became the inspiration for his bright idea of chipping away at a section on his right side, just below the giant sun design. The outline of the angel seemed abandoned compared to the rest of his tattoos, and was really missing touch-ups in the line work as well as full shading through the wings, fabric, and hair in order to look complete. We were able to find the time to work on the piece after our romantic room service dinner, and by the time we were done with this tattoo, the angel matched perfectly with the rest of the tattoos on his back.

Some people call this a birthday, and I can see why. A year ago, I would have never thought sobriety would have been something to celebrate, and how could I? The amount of tequila I was pounding on a daily and nightly basis made it impossible. As much of a fun party-animal reputation as I thought I had gained during my drinking days, I'm pretty sure that title wasn't accurate. I was probably somewhat of a nightmare to be around at times. I wasn't a good friend, girlfriend, boss, coworker, sister, or daughter—how could I have been? Living in a constant drunken blur in order to not cope with all the issues looming over me felt like the perfect escape for me. And when you're as wasted as I was, who else could I have been thinking about—other than myself?

# CLEANING UP MY ACT WAS EASY

in some ways and a real struggle in so many others. I remember feeling so alone and so angry at everything and everyone. I secretly resented those who could maintain the weekend warrior lifestyle or people who had mastered the art of pacing themselves—something I never got a grip on. I felt like I couldn't relate to anyone. And I didn't want to, either.

The first six months of getting sober consisted of nothing but accumulative isolation. My phone stopped ringing the minute word got out that I had put the bottle down—and that was pretty painful. I wasn't hurt by the fact that my "friends" weren't including me in on the action, but it was reality sinking in that I had no real friends that stung the most. I had social pals, relationships based on nothing more than partying. I guess you could say I made myself into a party favor.

But that was probably the thing that ultimately made it that much easier to let go of that lifestyle. Water does seek its own level, and eventually when I broke out of the hermit shell I had been living in, bit by bit, other sober people who shared the same feelings began coming out of the woodwork. And maybe it was because I was learning more and more about this idea of living a life without alcohol that I could recognize similar traits in my clients, and relate to them all the more.

At that point, building solid friendships from the ground up became a recurring thing. I found conversations gravitating toward words with substance, less filler, more meaning, and wisdom.

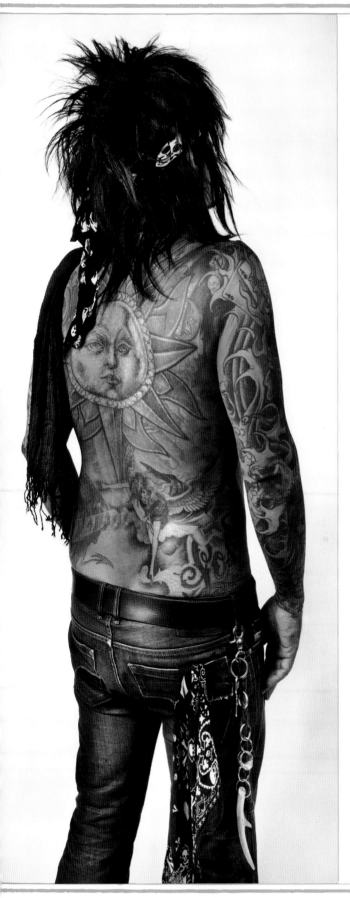

I was setting myself up to be in a place where I could be the best sister to Karoline and Michael, the best girlfriend to Nikki, the best friend anyone could have, and the best peer to work next to. These relationships took living life to a whole other level. This new life, much like a rebirth, felt like beginning for me.

# SOBER BIRTHDAYS

are important to me now. They're not about giving you a thumbs-up for being a good human. You don't get extra credit for doing your homework, but to me, it's more of a celebration acknowledging that we are capable of overcoming problems.

THIS BIRTHDAY is just as important as Nikki's

coming up in December.

## July 5, 2008

Layover. Dallas/Fort Worth. One hour to kill before my connecting flight back to Los Angeles. Just left North Carolina, where Nikki is playing tonight before making his way to DC.

Although the first few days were so hectic for Nikki, we were able to spend the past two days in pitch-perfect love—sleeping cozy on the tour bus, watching him play two shows a night, tattooing him in the hotel room, drawing together, meeting his friends and road crew—being a part of his world. Nikki was so busy with press, a bunch of meet and greets, and everything else a good amount of the time, leaving me backstage or on the bus with my pencil and paper and plenty of time to get in my drawing kicks. I can't believe I was able to complete two entire graphite portraits of him the first night. When was the last time I had a second to sit and draw? And just for fun?!

Watching him play was the most resonant part of my adventures on the road. The stage show was impressive, the smoke, the pyro, the set—but what really made me happy was seeing Nikki become the performer, the entertainer, the artist he was born to be. For me, there's nothing like seeing him immersed in his element.

I miss him already. I wish I could have stayed with him on the entire tour. Why does filming the show have to start at the same time? I'm not looking forward to the endless nights of trying to fall asleep without him. To think—two months of this until he returns.

Just being in the Dallas airport is squeezing memories out of me. My head takes me down these roads, and it's hard to pull back. But how could I forget when I used to have to fly back and forth from Dallas to Los Angeles when I was married to Oliver? The three-hour flight felt longer and longer as the state of our marriage grew worse and worse. Today is the first time I've been back in this airport since Oli and I dissolved.

It isn't just the airport, though. I've been thinking about Oliver, just wondering how he's doing. I know he's good—he's always good.

It baffles me though. I knew from day one our marriage was doomed—even then, I still went through with it. The whole time I was getting to know this stranger who happened to be my husband. Weird. I swear to God if we never would have gotten married, Oli and I might have been best friends instead. He was so damn smart, funny, and honest.

I think I miss his friendship—it's really too bad we'll probably never speak again. But maybe I just miss friendship in general, considering how lonely I've been feeling.

---

## July 7, 2008

# 4:42 A.M.

There's no ignoring the physical distance between Nikki and I today—and it's only been a day—God, I miss him—can't sleep. How am I gonna get through the next two months? More importantly, how the hell did I become "that" girl? I feel so damn clingy—needy almost....UGH.

We start filming in the morning.

---

# LATER...

# WES BORLAND

## (LIMP BIZKIT)

## "TRY TO LIVE IN THE MOMENT, BABE."

That's what Nikki said. And I agree. Too often, my brain seems to work against itself, making me the queen of self-sabotage. Too often I ignore the advice given to me by people who have experienced the kind of workload that I'm juggling now. They caution that if I forget to enjoy myself, I'll end up regretting it. And I get it—or at least I think I do.

---

What happened to me? Why do I feel about as fun as a funeral? I know I used to be considered fun. I know I used to feel like I was having fun. But it isn't fun anymore, because it feels like there is absolutely nothing real about this docuseries they call *LA Ink*. These forced, overproduced scenes I've been doing lately make me feel like a puppet, and being jerked around on strings makes it difficult to enjoy the experience. Nowadays, the only part that is real, the only thing I can relax and enjoy, is the tattooing. Unfortunately, I only get to spend a few hours a day on the tattoos; the rest of my time is monopolized

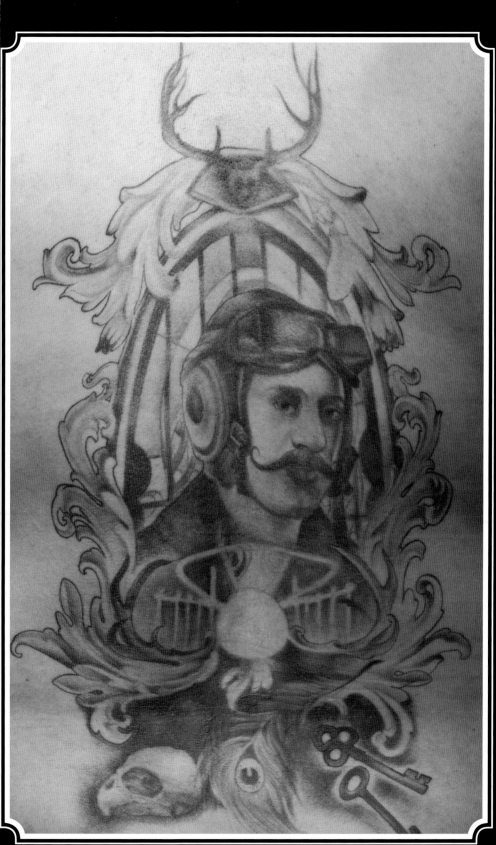

by filming the faux minidramas the producers call story beats.

Maybe that's why it's been too easy to forget to live in this moment and enjoy it. To top all of this off, missing Nikki, who's on the road with the band on the East Coast, isn't making today go by any faster.

Nonetheless, today's the first day of filming, not the first day of school, and this isn't my first **RODEO,** so being the solution instead of the problem is the name of the game.

My goal today is to dive into this next tattoo, fully immerse myself in whatever challenges it brings, and really push myself. I want to outdo myself this season. If I have no control over what the final edits of the drama part of the show will reveal, I know I do have control over the tattoos I create. And maybe, just maybe, the tattoos will outshine the

# BULLSHIT.

I've spent the last week compiling all of Wes Borland's ideas and references for his tattoo into a line drawing suitable enough to cover up the bold name——his ex-wife's——on his lower back.

Of course, Wes couldn't have married a girl with a three-lettered name, like Sue or Ann. He had to go big with Heather. On the bright side, his concept for combining the myriad elements will make

for a successful——but most likely painful!——cover-up tattoo.

CENTER STAGE ON THE tattoo went to a man sporting a Salvador Dalí-esque waxed **MUSTACHE,**

who looks as if he might have been a pilot of some sort during the turn of the century. We added an ornate oval frame around the portrait. At the base of this cameo-like tattoo, Wes gave me free rein——to incorporate anything relating to natural **ODDITIES,** which I love. A few peacock feathers, a small rendition of a bird skull as well as a deer antler or two, and voilà! Goodbye ~~Heather!~~

Due to the high amount of detail and shading that this tattoo needed, we were only able to get through a majority of the line work and get a little taste of the shading to come——and doing that took a good three hours. As

amped as the two of us were on the possibility of knocking out this  **12-INCH BY 12-INCH** tattoo on his back in one day, we both were satisfied in the progress so far. We're keeping our fingers crossed that we'll only need one more session before he heads out to reunite with Limp Bizkit and the rigorous tour that awaits him.

"

I knew I wanted to start a back piece and that I wanted it to center around a portrait. I'm obsessed with mustaches and vintage, sharp-looking guys. My grandfather was also a pilot, so the portrait became this fictional, Red Baron sort of character.

I hunted for old photos in antique stores for months. I began merging the faces of these dandy gentleman types in Photoshop and then photographed additional elements to complete the mock-up. From there, the tattoo was a collaboration with Kat: together, we assembled the collage of other items that would become the frame. Some of the internal design work was taken from different iron fences by Hector Guimard, the architect and artist who designed several of the Metro entrances in Paris.
——Wes Borland

"

July 8, 2008

# 4:00 A.M.

Can't sleep to save my life——and it's killin' me.

## It's just me and Ludwig⁵ again . . .

5 LUDWIG VON DRACHENBERG, MY BELOVED HAIRLESS SPHINX CAT.

# JARED RIVERA

### July 11, 2008

It was awesome to vibe out with Jared. He's a community organizer with such great positive energy. He's thirty, and this was his first tattoo, which he wanted to get in order to celebrate his mother's life and influence, to honor her memory. He asked for a Day of the Dead skull, and added two flags behind the skull: one British, the other for the United Farmers.

Jared's mom was born and raised in England. Three years ago, when she died at the young age of forty-four from lung cancer, Jared was left missing his mom. The British flag reminds him of her. The UFW flag represents Jared's career as a community organizer and his passion for social justice. Jared told me about how he ran an organization in LA that fights for more affordable housing, immigration reform, and several other issues——pulling together regular people so that they can have a voice in the decisions that affect them. Jared's involvement with UFW was directly influenced by his father's history as a migrant farm worker.

That tattoo took a few hours because it was full color, and color always takes longer than black and gray. Jared was elated with the tattoo when we were done, and he told me an amazing story about a time that his mom was at a Desmond Dekker concert back in the day. When Desmond was done with his set, he got off stage and rushed Jared's mom with a crazy-huge kiss! He begged her to run off with him——but she didn't.

The rosary was probably my favorite element in that tattoo. Like the romantic I am, all I could think about when doing the rosary was the beginning of my relationship with Nikki, and the rosary he gave me the day that we made our relationship official.

Nikki and I had casually gone out to dinner down the street at Citizen Smith, back when we were still in the "friend zone." Afterward, we made our way back to my office without a second wasted in silence. He was so eager to play me a song; I was happy just having him near me. He was so funny, making me laugh these deep guttural laughs no one could ever fake. He completed my sentences; I finished his. As adamant as I was to remain single after my recent breakup, I was pretty damn sure I was heading into a dangerous place. And I liked it.

He played me the song he had been working on that week for the new Mötley album, as I made myself busy with whatever knick-knacks lay around the office, both of us dancing around the obvious **CHEMISTRY.** The song was good and only set the vibe for what was about to take place.

But then our eyes connected for a little too long. He bit his lower lip, and I tried desperately to disconnect from that damn eye contact. He leaned closer and closer.

Before his lips reached mine, my instincts not to get attached to him suddenly kicked in. I jumped away like a scared cat, I tried to karate chop his throat out of the

# KISS.

What the hell was I doing? That's what he asked.

"If I kiss you, that means I'm gonna like you——really, really like you. And I can't like anyone right now."

That was the rule I abided by in order to stay single, but my attempt failed when he moved toward me, this time with his hands grasping my face and pulling me closer——our first kiss!

Less than a week later, on February 22, he stood at my front door with a beautiful rosary, a cherished piece from his collection. He put it around my neck and told me he wasn't interested in seeing anyone else. He hoped I felt the same. I did.

Words can't describe how giddy I'm feeling this very moment, knowing that tonight at midnight I will be on a plane flying to Philadelphia to see my love.

XOXO

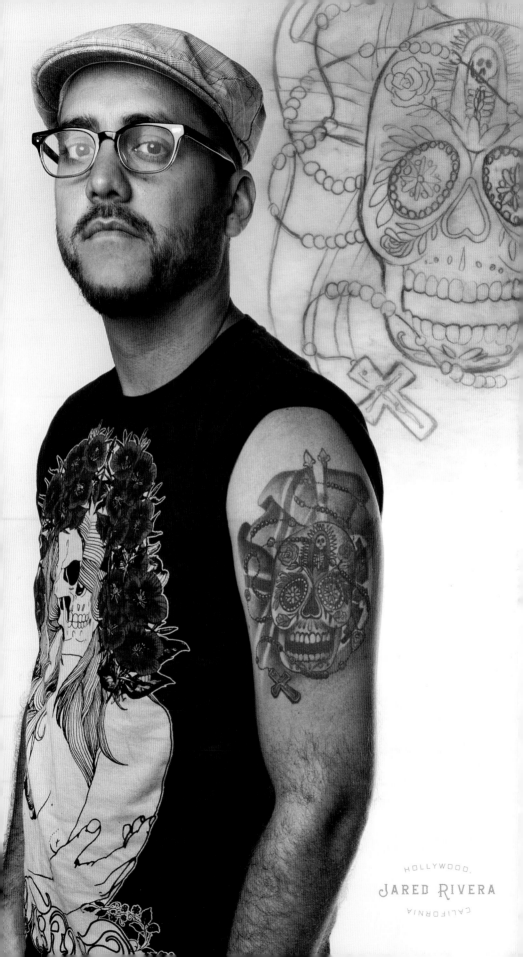

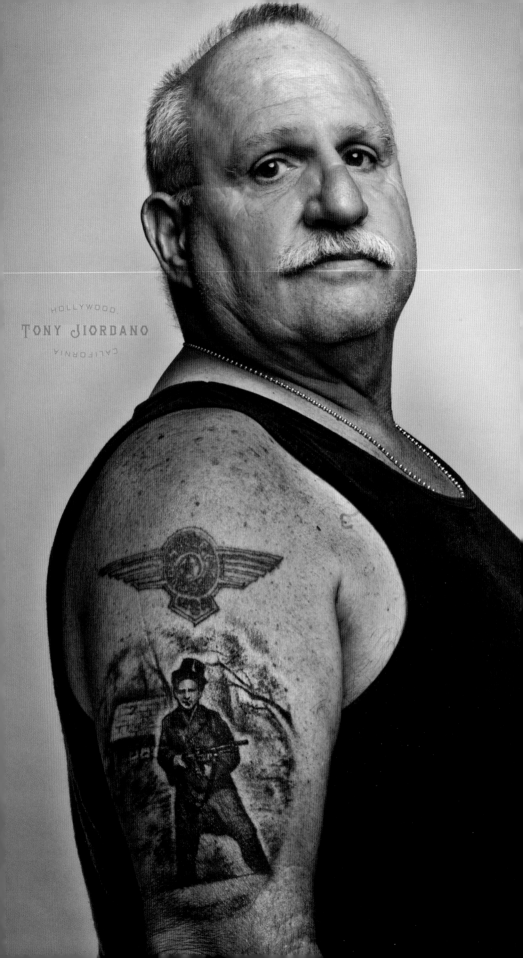

# TONY JIORDANO

## July 14, 2008

Tony had been scheduled by production for an on-camera tattoo. Whenever these clients were scheduled by casting, I would have no idea what to expect. The producers would tell us little to nothing about them in order to capture the most organic reactions that occur when meeting someone for the first time. The only thing I knew about was the artwork, which we approved weeks earlier. I remember approving Tony's photo——and was curious to hear the backstory, considering the unique personality conveyed by the expression of the man in the black-and-white vintage **PHOTOGRAPH**.

As Tony explained in his letter, the photo was taken during his late father's time in the military, circa World War II. I thought that was odd because he was wearing an oversize trench coat and top hat, not your typical military attire. When Tony explained further during our tattoo time, it all made sense.

His dad and his squad had been patrolling the countryside in France when they ran across a squad of German soldiers. They were outnumbered pretty badly, so they did the best thing under the circumstances——they hid. Tony's dad jumped over a wall, only to land in a pile of manure. When they emerged from their hiding places, his dad smelled like hell, but continued onward, stumbling upon a deserted farm house with a trunk full of old clothes: a pair of pants, an overcoat, a hat. They told his dad to put them on so he wouldn't stink so badly. When he was wearing the clothes, they took his picture, and he carried it with him until the day he died.

Clients like Tony are the best. His positive attitude was infectious to say the least, and our time spent listening and talking about each other's life experiences made my heart full.

When Tony was growing up, he had a love-hate relationship with his father. More hate then love, I'd say. The way Tony described it, his father was an old-fashioned Sicilian and raised Tony the way his father had raised him. He explained, "That meant if my dad thought that you needed a good beating, he was more than happy to give you one. I was a very

# HARDHEADED,

rebellious kid and thought that the only way that I could get even with him was to do the complete opposite of whatever he wanted."

And that's what Tony did. I was shocked to hear he started to run away from home at the age of five! And he continued on like that until he was old enough to leave home for good. Before he knew it, being incarcerated became something that was all too familiar. Tony didn't care, as long as he knew it would hurt his father.

I asked him if he ever found closure to all of this. I mean, carrying around so much anger and resentment from such an early age is a heavy cross to bear throughout one's life.

About four years before his father died, Tony was at his house in Las Vegas and with the help of liquid courage he was able to finally tell him all of the things that he had forced down through the years. He told me, "I was drinking quite a bit. I started telling my dad just what I thought about him and how wrong he was in the way that he raised me and how it felt when he beat me."

Tony's dad just sat there, listening as Tony went on. When he finally stopped and looked at

his father, he saw that tears were streaming down his face. He had never seen him cry before—— and it was really shocking to him because he was forbidden from crying as a kid. As painful as it may have felt, the conversation that day with him opened up a dialogue between them. Tony's dad began to tell him about his childhood and his experiences in World War II, that he was a decorated hero, which Tony didn't know.

But that day pushed them closer and closer as time went on.

When Tony's father fell ill and was in the hospital, Tony rushed to be by his side. He made it just in time. Later, the doctor told Tony that his dad had waited until he got there before dying. When Tony found the picture of his father that he remembered seeing as a child, he decided to get it tattooed so he could have his father with him always. Tony told me something that really moved me: "I loved my dad very much and just wish that we could have had that talk earlier in life."

I think he's blessed to have had it at all.

It always hits home for me when I hear some of my clients explain feelings of regret. Almost all of the memorial tattoos that come my way are backed with a story that reminds the client, and me, that life is all too short. Before you know it, that long list of things you contemplate doing but never get around to, turn into "shoulda-woulda-couldas" in a second. It's a shame that it so often takes something as irreversible as death to remind us to make time for the people who are

# IMPORTANT

in our lives, to stop procrastinating, to say how we really feel. Lucky for Tony, he was able to get through to his father before it was too late.

## July 17, 2008

# ON A PLANE, YET AGAIN—

this time on my way to New York. I have such a rigorous schedule laid out for me that even Karoline began to get anxious as she went over it with me.

---

I land at 8 A.M. and go straight to a meet and greet at Sephora for the launch of the makeup line. I'm hoping people actually show up.

## WHY DO I ALWAYS GET SCARED NO ONE'S GONNA SHOW?

## July 18, 2008

Every day is starting to blur into one, and if it weren't for these journal entries, I probably wouldn't know what day it was. Landed in New York——and both my cell phone and laptop ran out of juice on the flight. I can't tell if I'm tired or not——I think I'm so used to feeling exhausted that my body just doesn't know any other way anymore. Been listening to a whole lotta Little Richard lately——for some reason, it seems to amp up my energy.

---

Karoline booked me a room at the Bowery, the hotel where Nikki and I stay. I don't know why I'm staying there, though. I don't really want to be there without him.

---

Oh, enough of the whining——it's gonna be a fine trip. Last minute last night, I booked flights for Karoline and Naheed[6] to come out with me—— man oh man, I'll be happy to see their faces outside of the shop!

## LATELY, I'VE FELT SO LONELY.

So has Karoline. It's strange how similar Karoline and I are. We're both so damn obsessive about work. I think she really is the only family member I have that understands all that I've been going through with all the stress——filming the show, Nikki being gone, deadlines for Sephora, and everything else——and the nonexistent time left for myself. Sometimes I wonder if she feels sorry for me. Nahh . . .

 I think her heart goes out to me at times, but she doesn't feel sorry for me. I could see how proud she was of me at the meet and greet, though. In the middle of all of it, she said, "Kathy, can you believe you created all of this?" I can tell when she feels like all of her hard work has accomplished something. Without her, none of this would work. And her efforts never go unnoticed.

---

6 NAHEED SIMJEE IS A FRIEND OF MINE WHO I'VE KNOWN SINCE I WAS SEVENTEEN. I MET HER AT THE VERY FIRST TATTOO CONVENTION I EVER ATTENDED, IN HOLLYWOOD. I TATTOOED HER TWO YEARS LATER, AND WE'VE BEEN DEAR FRIENDS SINCE.

# RHIAN GITTINS

## July 19, 2008

Every year on Rhian's birthday, I tattoo her as my gift to her—— and it's something she always looks forward to. This year, we're tying in all the tattoos on her upper arm with honeycomb background and bees. When she came in with the basic idea of getting bees to fill in some of the empty spaces between the tattoos on her arm, I don't think she had any idea what I would come up with. My goal for this tattoo was to blow Rhian's mind. As simple as a bee design is, I knew it was the background that would allow me to really push the envelope, and for this I had to consult my reference books to find real life depictions of honeycombs.

---

I like a challenge, but man! Once I was finally done with an intricately graphed-out line drawing of the honeycomb, it was clear to me that this tattoo would take me much longer than anticipated. And it did. But my ambitious approach to Rhian's tattoo gave us hours to chat, and that didn't bother me a bit.

All this time I've known her, I had no idea that her grandfather was a beekeeper back in Saskatoon! And hearing about it, as well as a lot of her childhood memories during her visits with her grandfather, made this tattoo that much more memorable for the both of us.

Even though today was a great and productive day, I wish Nikki had made some time for me so I could have shared it with him. I kept thinking he would have come visit me at some point, considering it was his day off, but I guess he got wrapped up with stuff. The idea of a relationship based on a few text messages here and there isn't sitting well with me.

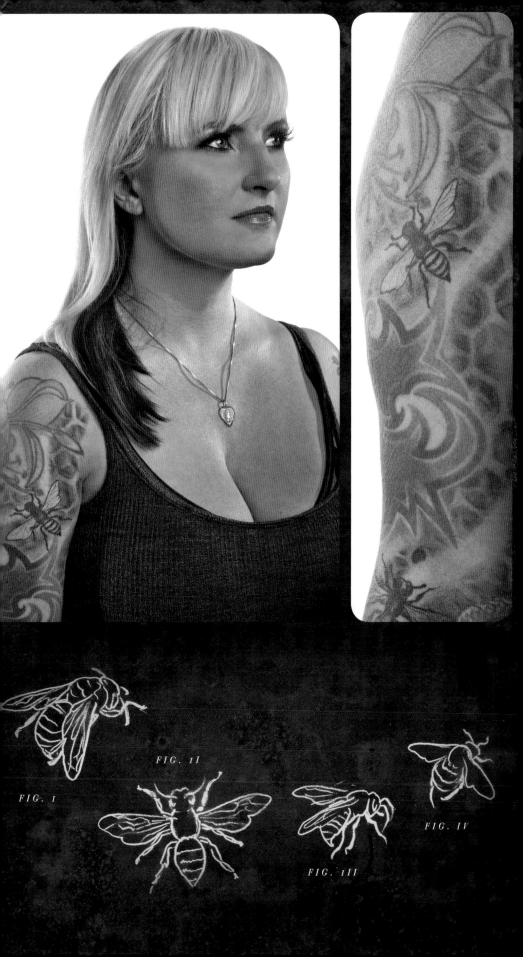

FIG. I

FIG. II

FIG. III

FIG. IV

# Nikki Sixx

### July 25, 2008

Listening to Nikki take a trip down memory lane while I tattooed a portrait of Mick Mars on his right thigh, hearing him reminisce about all the good, the bad, and some of the very ugly he's experienced with Mick made me feel closer to him, and even closer to Mick in a strange way.

Since the portrait was going to be a surprise for Mick, we decided to film the entire process for the show, from the birth of the idea to the final reveal. One thing I really like about filming the show is the moments when we are able to capture and document the whole process, so that later we can catch an outsider's point of view on events such as this one. These instances are rare, but when they happen, they are truly a blessing.

Somehow, somewhere in the middle of the night, somewhere in time, Katherine and I were talking about inspirational people (we do this a lot), and Mick's name came up. I was going on and on about how he inspires not only me, but everybody who meets him, either through his music or because of his strength of character.

"I had mentioned getting a tattoo of him, and she thought it was a great idea. She is the only one I would trust enough to tattoo a portrait of such importance.

"The photo was taken by Paul Brown for the *Saints of Los Angeles* album artwork. I thought Mick looked really cool with his top hat slammed down over his eyes, and Katherine and I thought it was perfect for a tattoo. The image pretty much sums up the cool that is Mick Mars.

"I love all the guys in the band like brothers; Mick has been like a big brother to me and the rest of the band. I met him years before the other guys, when I worked at a liquor store in Burbank. We argued over muses and rock and roll, and he stormed out. I saw him play that night in a local bar. I was blown away by his playing, but we wouldn't meet again for years, until Mötley Crüe was formed.

"Mick has been through so much and fought so hard to recover from his disease[7] that I felt a tattoo would be a great way to honor him in all that he has achieved. This tattoo honors his playing and his strength as a wonderful person. Mick has not changed. He is completely and sometimes bluntly honest in his approach and belief in music. There is no bullshitting around with him.

——Nikki Sixx

7 ANKYLOSING SPONDYLITIS, A CHRONIC DISEASE THAT CAUSES INFLAMMATION OF THE JOINTS BETWEEN THE SPINAL BONES AND THE JOINTS BETWEEN THE SPINE AND THE PELVIS

# Heather Peggs

## July 29, 2008

Today, I tattooed the Capital Records building on Heather. Shortly after moving to LA, she got a gig working at a rock radio station where she quickly found that her strength was in discovering fresh bands. She said she'd drive past the Capitol Records building and pray to one day work there. It was calling her.

So, five years later, we're in my shop celebrating Heather's triumph. Listening to her talk about how passionate she is about her calling and how it inspired this tattoo made me wonder how she'll feel about the tattoo if she leaves to work somewhere else. I guess it's like any other tattoo, a landmark in time that celebrates the good things.

The architecture of the building is awesome, and she shared so many interesting and mysterious facts about the building itself. There are so many secrets inside Capitol Records. There's a secret recording studio built by Glen Ballard on level twelve, with an entrance hidden in the wall. And some not-so-secrets— a good thirty feet below the boiler rooms, under the parking lot, are the Echo Chambers, eight recording studios built by Les Paul in 1955, before the Capitol Records building was even started. These studios are now a national landmark and have been used to record many famous records from bands like the Rolling Stones, the Beatles, the Beach Boys . . . She also said that Nancy Sinatra told her the building had an underground tunnel built especially for Frank. It supposedly goes from underneath Capitol straight across to Club Avalon, but Heather's never found it.

But much like any other male-dominated industry, being a woman in the A&R business isn't always "fun." After being hired by Capitol Records, Heather had many experiences being mistaken for an intern, just because she was a woman. Much like the time I went to my first European tattoo convention, when I was eighteen——I felt so small every time other tattooers assumed I was just "some tattooer's girlfriend."

I loved the idea of Heather getting this tattoo— it represents something much bigger than just an architectural structure. It's a reminder that you can achieve a dream if you have a positive mental attitude, drive, and put in the hard work.

## July 31, 2008

After meeting Dave last year, every time I'd run into him, there was always talk about getting together to do a tattoo in memory of his mother.

Well, today was the day! And Dave came in beyond prepared for the portrait, with an array of beautifully shot photographs of his mother taken during her modeling and acting years. Although Dave already has other tattoos that commemorate her life, like her name, he didn't have any visual images of her.

There were so many amazing shots, it was difficult to choose one, but keeping in mind the placement of the tattoo on Dave's ribs helped us hone in on the right visual image to honor his mother. The photo showed her standing on a rocky coastline, gazing at the beach, a serene expression on her face.

Not long after I completed the line drawing, we were both barefoot and ready to start the tattoo. Before today, Dave had told me his mother had been murdered, but I didn't know that the story was so shocking until he talked about it throughout our session.

When we were done with the tattoo, I felt closer to Dave in a lot of ways. Tattooing has an astounding way of making people connect, whether it's with a first-time client or a longtime friend, and for that, I am always thankful. Being able to make these connections, which teach me some of my most important life lessons, while simultaneously offering my help to someone, is the most fulfilling part of my job.

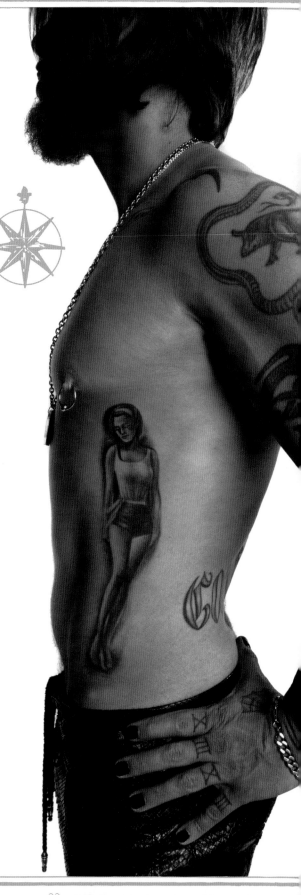

# Jane's DAVE NAVARRO Addiction

"TWENTY-FIVE years ago my mother was murdered by her then boyfriend. She had been with him for about five years. When she broke up with him, he evidently couldn't handle it. I mean, it was essentially like the jilted, jealous ex-boyfriend. He broke into the house one night and killed my mom and my aunt. The whole thing was just so dark. So scary. And so fucked-up. It was a miracle that I wasn't home, because I think if I were, he would have gotten me, too.

It's weird because when something like that happens, it's such a shock and it's so powerful. It almost takes time for the grieving process to actually kick in. And in order to deal with the feelings and the anger and the resentment, I tried a lot of different avenues. I got heavily addicted to heroin and cocaine, and clearly that didn't work. So I turned to music as the one thing in my life that I had. That spoke volumes, and not only gave me an outlet but also gave me a career.

Shopping, food, sex, drugs, all those outlets act as a Band-Aid, but until you actually get down and dirty, you're never going to get to a place where you feel that sigh of relief and you're ready to move on. It's going to take walking through some discomfort to get to the other side, but you're a stronger individual as a result of it.
——Dave Navarro"

BLOOD BOOK

VIII

August

MMVIII

# BRETT PARVIN

## August 1, 2008

Nikki thinks the perfect time to surprise Mick with the reveal of his tattoo is during the big LA show for Crüe Fest. I can't believe he was able to go this long without spilling the beans to Mick about the tattoo——and it was perfect timing for me to take a road trip from the shop.

I wish it were already tomorrow! The excitement is killing me! Thank God today's appointment made time fly.

Brett flew in from Colorado. I was finally able to do the Caravaggio rendition of Medusa that I've always wanted to do. Although there are many renditions of the famous decapitation of Medusa, Caravaggio's interpretation has always been my favorite.

I'VE ALWAYS LOVED

# CARAVAGGIO,

and his reputation for being an emotional wreck, a drunk, and even a murderer only made my fascination for him and his art grow even more. I knew there was a reason for his paintings being so dark——and I am not talking about his use of light. Like most painting of that era, religion seems to take full reign on subject matter, but Caravaggio's versions almost always depicted gloomier times. They are so much eerier, and definitely present a more sinister view on these biblical stories.

## BLOOD, GUTS,

and tears signifying fear, frustration, rage, and abandonment. Saints and Christ bear tortured, frightened expressions instead of the lighter, more placid expressions most people choose for tattoos. And his work was about deep self-expression: in his many paintings of decapitations, the likeness of the person getting his head cut off or served on a platter very often is Caravaggio himself. Knowing Brett was looking to get his tattoo as close as possible to the original Caravaggio image, but in black and gray, I was fired up on this tattoo concept.

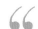

*MY FATHER IS AN ARTIST* and has instilled in me a respect for realistic art. I have always been interested in the macabre and wanted a tattoo that was both realistic and grim. I had considered a Medusa tattoo before; since I am a huge *Clash of the Titans* fan, I thought about an image from the movie, but I wanted a more realistic Medusa. As soon as I saw Caravaggio's 1597 version, I knew it would make a perfect tattoo. The painting is realistic and edgy——very intense. Medusa's expression after her beheading is perfect; not many tattoo artists could capture it.

Everyone remarks on how well tattooed it is.

——Brett Parvin

# NIKKI'S REVEAL

## August 2, 2008

"I WISH MORE PEOPLE
COULD BE LIKE MICK MARS."
—NIKKI SIXX

Imagine getting a portrait of your friend tattooed on your upper thigh, and having the chance to show him afterward. You know the reaction is gonna be huge! Everyone who heard about Nikki's gesture of friendship said the same thing: "Mick is gonna flip!"

With a Gone Fishin' sign hanging on the front door of the shop, the entire High Voltage crew played hooky and ventured to the Mötley Crüe concert together.

Our sound guys had been concerned that we would run into problems because Mick didn't have a mic on, but Nikki convinced Mick that a big-time television crew wanted an exclusive interview with him that covered the behind-the-scenes life of Mötley Crüe's guitarist. He was hesitant, but Mick agreed to be miked by John, my sound guy. And patiently he waited for an interview that wasn't gonna happen.

Backstage, the whispers and giggles among the road crew and the bands grew by the minute, and I was getting scared someone was going to accidentally tell Mick what was about to happen.

## TEN MINUTES

till the boys were due on stage, there was no time to waste, and the suspense was killing all of us!

Once Nikki and Tommy were miked up and the cameras were rolling, the producers gave us a thumbs-up to head to Mick's dressing room. It was like a surprise birthday party, with Nikki bursting through the door with all of us behind him.

## "WHAT THE HELL IS GOIN' ON?" ASKED MICK.

"Mick. How old was I when I met you?" asked Nikki.

"Gunner's age. Seventeen."

"Well, I saw you play that night, right?"

"Yup."

"You've been my favorite guitar player ever since then so . . ."

Nikki unzipped his pants.

"Whoa! Whoa! I don't wanna see that shit!" Mick yelled, shielding his eyes.

There's an uproar of laughter in the dressing room.

"No, no, no. It's all good, Mick. You ready to see this? I got your portrait tattooed on my leg."

Mick dabbed his thumb onto his tongue and tried to rub the tattoo to see if this was a prank. Then when the permanence of the portrait hit Mick, he forgot the cameras all around and didn't hesitate one bit. He got up and hugged Nikki.

I looked around the room at everyone's faces. You should have seen Tommy's eyes——they were filled with tears. You could see everyone admired Mick and Nikki's true friendship. Later Nikki told me, "I didn't know how he was going to react. I thought he wouldn't be as blown away as he was. He contains his excitement really well, so I thought he might just inform me that I was a bit of a bonehead for doing such a foolish thing. But when I showed him, he was on the verge of tears. He hugged me so tight, and I knew for sure at that moment he knew how much I truly loved and respected him."

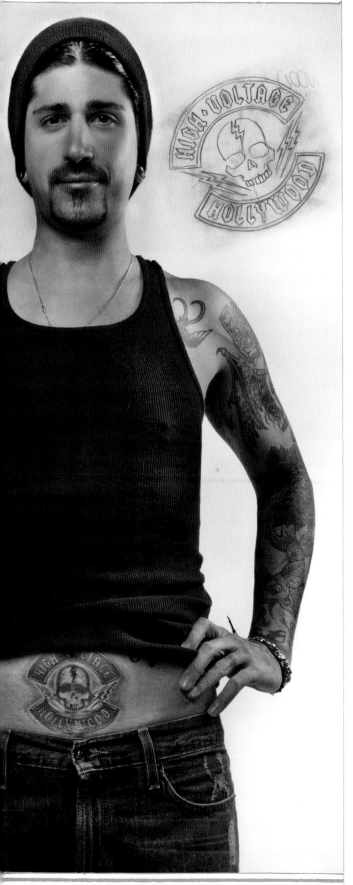

# DAVID

## DONIKIAN

August 8, 2008

**D**avid is probably one of my fave clients. I've been tattooing him for the past few years and I think it's been equally as exciting for him to watch the shop grow into this awesome business as it's been for me. Today, he wanted me to tattoo the High Voltage logo on his abdomen. Wow!

WHEN I FIRST DECIDED ON

# HIGH VOLTAGE

for the name of the shop, I went straight to Agatha's house for a fitting, to get a leather jacket made in honor of it. The

inspired lettering of the name complete with the lightning bolt skull that Agatha came up with for the jacket was never planned to be the shop logo, but after the rest of the crew saw the design on the jacket, we unanimously voted the logo ours. We never once imagined that someone would want to permanently adorn their body with it!

## August 10, 2008

Nikki went to Storm's[8] room to say his goodbyes before we head out on more of this never-ending tour. I'll be in Portland today. I'm feeling pretty good, aside from the sleep deprivation.

# CRÜE FEST

## August 14, 2008

Riding for hours to Canada from Portland via tour bus isn't our idea of a dream vacation——but we'll take what we can get at this point. I had no problem leaving the shop for a short while just to see Nikki.

Due to the custody schedule, Nikki and his ex take turns each year with the kids during the holidays. This year, she's got all four kids for Christmas, leaving Nikki with time off from his typical Mr. Mom schedule.

We had thrown around the idea of taking a real vacation. Considering I've never actually been on one in my entire life——this sounded exciting!

"What do you think about Fiji?" he asked me.

What about Spain, Morocco, Rome, Germany——they all sounded amazing! But at this point, we could go to Kentucky for all I cared, or even just stay in Southern California. I was just excited about the idea of spending romantic time with Nikki, unplugged from anything work- related, even if it was just for a few days.

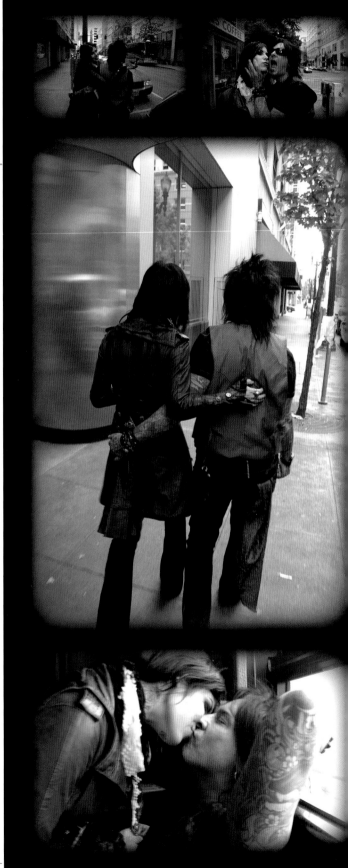

**8** NIKKI'S OLDEST DAUGHTER.

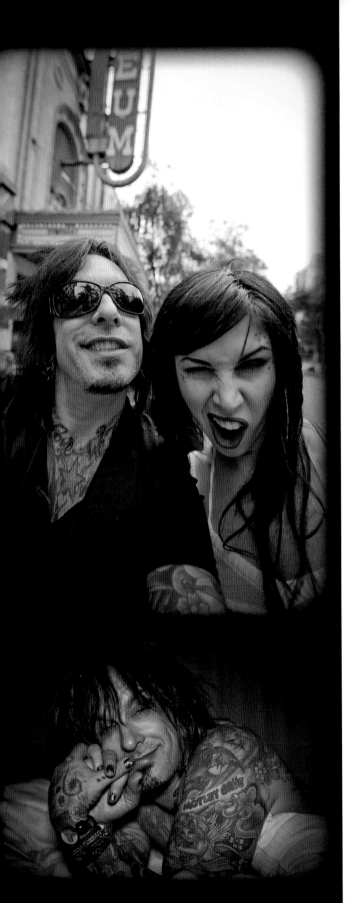

From Oregon, we made our way to Vancouver, Edmonton, and then Calgary. On one of our flights together, while I worked on yet another drawing of him, Nikki told me that he's never had a great birthday celebration. Last year, he spent his birthday on a plane coming back from Japan—away from his family. He said it was the worst way he could imagine spending another birthday.

So I knew right then and there my goal was to throw him the most memorable birthday celebration known to man. His birthday is in December, so I figured I'd have plenty of time. Our time together was crazy and beautiful, full of music and love. This always makes it harder to part—but duty calls, and work awaits. Taking a flight back home now.

VANCOUVER

KAT VON D

CANADA

## August 15, 2008

Landed back in LA after having some of the best moments with Nikki on the road. Took some rad photos of him with this new tilt-shift lens he gave me!

Nikki's fallen in love with photography once again after a bit of a dry spell, I guess you could call it, when a few years back rough times were far from inspiring to him. So seeing him excited about photography fills my heart just as much as watching him glow on stage, lit by his music. But even more so, because it's just him and his camera. No bandmates, no tour managers, no tour bus, no expectations. Just doing something for the sole purpose of creating. And when he finally takes a photograph that he is happy with, there's no ignoring it. It's beautiful.

The only bad part of the trip was leaving, but the knowledge that I would soon be on my way made it hard for me to stay positive. I need to make sure for the remainder of the tour that I try my best not to be so negative. I spend way too much time worrying about tomorrow instead of living in the now. It has never been a better time for me to have scheduled my first Transcendental Meditation session——from what Matt says, it's gonna be the best thing that I could do, especially with all the hectic stress I'm dealing with at the moment.

# MATT SKIBA

has always been one of those people in my life that I love just being around——he always seems to have a certain calmness and peace about him, even when faced with adversity. Writing a record, touring, dealing with a divorce, these are all cards that have been dealt to Matt, yet for some reason he always seems to be handling these problems like Buddha!

He's not one of these annoyingly "happy" guys who makes you feel bad for having feelings of anger or depression, but I always find him in a centered place. I don't feel bad about feeling this way around him, but it definitely inspires me to not wallow in my depression when he's around. One day, I finally had to ask him how he handles it all.

### "YOU HAVE TO MEET NANCY," HE SAID.

Nancy's name has popped up several times in conversations, and Matt's not the only person who's pointed me in her direction. Without really knowing very much about Nancy or Transcendental Meditation, I called her.

I didn't really know what to think about the whole thing, all I knew is that by the time I hung up with her, I had an appointment set for the following Sunday. I was instructed to bring three pieces of fruit (noncitrus) and seven flowers with stems. And she strongly urged me to not drink coffee prior to our session at her home in Beverly Hills.

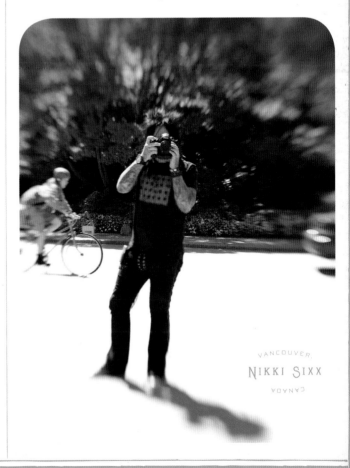

VANCOUVER,

NIKKI SIXX

CANADA

# Jim Rota
(FIREBALL MINISTRY)

### August 16, 2008

I really was hoping this day would never come, to be honest. For as long as I've known him, Jim had talked to me about getting his mom's signature tattooed. I remember meeting her for the first time on one of her trips to LA to visit Jim—right here in this very office—we were all talking about how cool Jim's idea was. She was alive then, and the sentimental value behind the tattoo was simple—just another way of telling her he loved her.

FIG. 1

Now it's different. Today was the first time hangin' with Jim since his mom lost her battle with

# LUNG CANCER

less than a month ago. Before that, I hardly saw Jim around because he was busy flying back and forth from here to New Jersey, desperately trying to spend as much time with his mom as he could, knowing the chances were that soon there would not be anymore time.

It was interesting to hear about how each member of Jim's family dealt with it all during those last days. I think Jim was trying to be

the most pragmatic about the situation, but in a moment of huge frustration about the disease, he blurted out, "I felt you could have fought this harder, Mom." Needless to say, she wasn't pleased with what Jim said and wouldn't talk to him for the next two days after that.

I never thought an exchange of energy between tattooer and client could be this intense, especially considering how little time the signature actually took me. But when Jim started telling me about what his mother told him after the two days of silence, it was hard not to fight back tears of my own.

He actually said, "After those two days, she finally came around and admitted to me that it was just too hard without Dad. She wanted me to know that it didn't mean she didn't love us less than she loved my father—it was just that cancer was too much for her to take alone."

JIM + HIS MOM

I think we've all dealt with loss in our own ways, and as difficult as it feels, especially when it's as fresh as it is for Jim, he'll be able to come to peace with it all in time. Jim's friend Rob said something about the healing process that really resonated with him, and I think it's true. He said, "You'll never really get over this, you'll just learn how to live with it." And Jim is still learning.

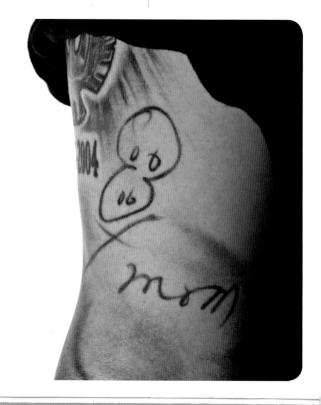

KAROLINE

Von Drachenberg

### August 17, 2008

When the producers told me the scheduled portrait of the day had been canceled last minute due to the woman getting sick, I wasted no time suggesting to Karoline that I work on her sleeve on camera instead. *The Last Unicorn* theme had been outlined for so long, and although we took several stabs at finishing it throughout these past months, my schedule hasn't allowed for much downtime to tattoo my friends or family. Karoline was surprisingly giddy at the idea, even though it meant face time on the TV show, something she isn't so wild about.

Either way, I was excited to chip away at this incomplete project

# KAROLINE

and I started so long ago!

I bet people assume because Karoline is my sister, she'd have the privilege of getting tattooed whenever she'd like. And I bet my sis would love it if that was true, but sadly, it's not. Karoline is probably the last person on the list of family and friends to get tattooed. She's in charge of my schedule and sees how much "free" time I don't have. She books my tattoo appointments and takes care of everything else, too. She's the one who'd schedule naptime if I ever did get the chance to take a nap. So to her, scheduling herself in feels like asking a whole lot.

I need to change that, because this year has been so hard on our personal relationship. The fights have become way more frequent than I'd like. Even though we see each other every day at work, I fear we've drifted apart as sisters.

Tattooing Karoline gives us these hours of uninterrupted up-close-and-personal time. We are, for those moments, forced to talk about anything and everything except work.

She tried to keep her phone at ear's distance, and for the first part of the tattoo, I let it slide every time I felt it vibrate with another work-related e-mail. Bless her workaholic heart, but man! Why can't she step away from work for just one hour?

After the millionth time that **PHONE BUZZED,** I kindly but sternly asked her to put her phone away in my station drawer, where no one would be able to hear it, let alone answer it. Whoever was calling, texting, or e-mailing could fucking wait!

She hesitantly turned the electric leash off and stowed it away in the drawer——and everything began to feel calm. She lay on her belly on a massage table, even though we were tattooing the back of her upper arm. When the cameras weren't rolling, it felt like we were transported back in time to when we were little kids who laughed at the same silly shit even though nobody around us would be laughing as hard as we were. We used to blame our laughing fits on our creative personalities, concluding that we were blessed with far more visual imaginations than other people——and that's why no one else was laughing at our jokes.

It seems like the older Karoline and I get, the more psychic or **TELEPATHIC** we become. She gets me. Like, really gets me. We could be walking down the street in silence, then see someone or something across the way. All we have to do is look at each other, and we know what

each other is thinking——without uttering a word. It happens all of the time. Maybe it's the fact that Karoline knows me better than anyone else on this planet.

Anyhow, it felt so good to tattoo her today. I finished this section of her soon-to-be-complete sleeve in just an hour and a half. We had outlined a castle in the distance behind the tree witch, shifting the mystical, fantasy-inspired original idea and stylizing the castle to resemble our ancestors'

# Castle,

## SCHLOSS VON DRACHENBERG.

I used a reference photo of the castle that a fan had mailed me with a sweet letter of affection handwritten on the back. She acquired the image on a trip to Cologne, where the castle is—— and what better reference to use for this tattoo than that?

I must have spent a good amount of our time on the table on the highlights alone—— adding sparkly stars in the night sky and a glistening gate at the entrance of the castle. And if you look really closely at Karoline's arm, at the bottom of the road that winds down to her elbow, there are two travelers making their way to the top of that Dragon Mountain. One is holding a staff, and the other holds a lantern, leading the way to the castle.

I told Karoline that the two travelers were her and me.

SCHLOSS DRACHENBERG CASTLE

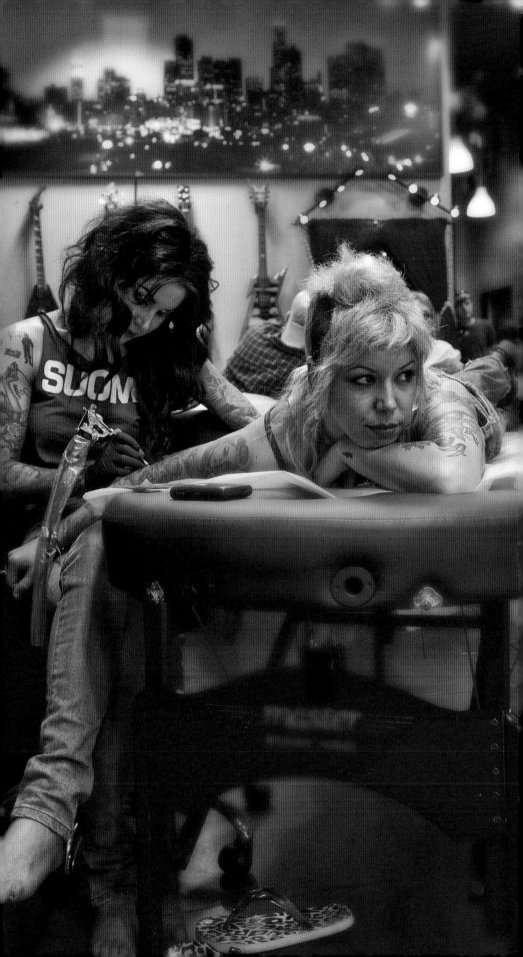

# LATER...

Went over to Nancy's for the first time——I'm blown away at how something as simple as Transcendental Meditation triggered such a noticeable shift in my energy. It's like I've discovered a button inside me that I press, and for those moments——the noise and war in my head are gone——even if it was only for fifteen minutes. IT WAS AMAZING.

Contradictory to what I thought meditation was, this was simple. It was practical. There were no levitating Buddha-like poses, no psychedelic colors and sparkles swirling in my brain when I closed my eyes. Being still and breathing on Nancy's couch in her bedroom as I repeated my mantra in my mind was just that. It was me taking the time to be in tune with my body, mind, and soul. Fifteen minutes of peace and silence, when no thoughts about my past or future could interrupt that very present moment.

With as much friction as Nikki and I deal with on a daily basis, I've got to share this with him.

## GAGE MUNSTER

### August 19, 2008

I've had to do a lot of interviews lately that Sephora sets up for the makeup line, and I always get asked about who some of the style icons are that have influenced me in creating it, or the way I do my own makeup. I always say it may sound ridiculous, but Elvira is definitely one of them.

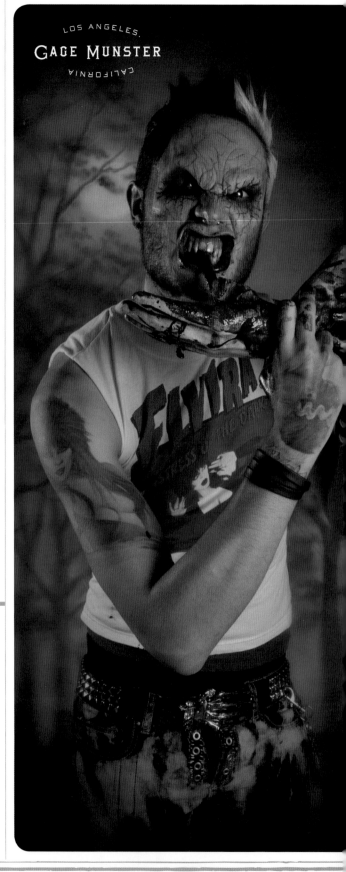

LOS ANGELES, **GAGE MUNSTER** CALIFORNIA

Tattooing my first-ever portrait of Elvira on Gage today was something I had been looking forward to since I approved the artwork for the show a few months back. I mean, I not only like the aesthetic aspect of doing this portrait, but am very fond of Elvira myself, and all that she represents. As I learned, Gage shares the same admiration. We talked about how we always felt that you should go through life proud of who you are, confident in what you have to offer the world, and never doubt yourself. Easier said than done, well, at least for me, but Elvira herself, is a symbol of strength, courage, and individuality. In spite of what others might have said about her, in her own fun way, she rose above it.

The photograph we used for the tattoo was picture-perfect— a bust shot of Elvira in all her dark glory, trademark rocker hairdo and all. Gage gave me all the artistic leeway any artist could ask for, offering up a prime spot on his upper arm for his tattoo.

I really loved chatting away the two hours of this tattoo, getting to know him—we related to each other in so many ways. Gage told me that when he was growing up, he felt like an outcast from the norm for being "different," and this alienation helped him identify with the unique characters from horror films and television. I can see why. I mean, most of the time the monsters in those films aren't even the real monsters of the story. It's always a play on society and how "normal" people were actually more monstrous than those characters could ever be. For Gage, that was his reality. He told me that going through

difficult times dealing with the "real-life monsters" of his own childhood made finding comfort in these films natural for him.

I told him that if anyone knew about how it felt to grow up and not fit in, I did. It wasn't even so much about how I dressed (even though I did stick out in my own way, I guess), but more so that the things that inspired or interested me weren't what drew the attention of the majority of my peers at school. Maybe it was because I grew up too fast, or maybe how unimpressed I was by the social circles in my age group, or maybe I was just broken in my own way and chose to gravitate toward the arts and music. Who knows— but I think a lot of good came out of that, to be honest. I wouldn't have called myself a "loner" so much, because as much as I didn't relate to a lot of the kids, I didn't have a problem getting along and functioning among them. But I would find myself drawing inward a bit, especially after elementary school. I was immersed in the art that I was constantly creating—and that sort of intensity plays a huge role in the way I approach my art now.

Just like art helped me get through some of my difficult adolescent stages in a lot of ways, Gage's

# HORROR-FILM

influences inspired him from an early age to become a special-effects makeup artist. He left home at seventeen, landed in what he calls, Horrorwood, California. By twenty, he was working in horror films, making the same NIGHTMARISH creatures, blood, guts, and gore that he grew up with.

I felt so privileged to be a part of Gage's tattoo, because this wasn't just a cool photo of Elvira. The tattoo was his way of commemorating the inspirations that fuel us to pursue whatever we want to do in this life—and I admire that.

I made this severed arm special just for Kat! I knew that if anyone could look at a severed arm and appreciate it besides me, it was her!
——Gage Munster

AUGUST 22, 2008

8:50 A.M. WAITING TO GET THROUGH CUSTOMS IN TORONTO TO
HEAD BACK HOME. LOOKS LIKE I MIGHT MISS MY FLIGHT.
NOT GOOD CONSIDERING I'VE GOT A FULL DAY'S WORTH OF
FILMING SCHEDULED ONCE I LAND.

YESTERDAY FROM 8 A.M. TILL 4 A.M., IT WAS ABSOLUTELY
NONSTOP WITH INTERVIEWS TO COORDINATE WITH THE
UPCOMING RELEASE OF THE HOLIDAY COLLECTION FOR MY
MAKEUP LINE. CANADIANS ARE SO RAD! AFTER PRESS I
DOVE STRAIGHT INTO A FIVE-HOUR MEET AND GREET—AND
MAN! THEY SEEMED SO INTO IT!

ONE FAN THANKED ME FOR INSPIRING HER TO BECOME
AND STAY SOBER. ANOTHER TOLD ME I HELPED HER
THROUGH A HEAVY DEPRESSION, AND A MOM HUGGED
ME AND TOLD ME HOW THANKFUL SHE WAS THAT I TOOK
THE TIME TO MEET HER DAUGHTER, HALEY, WHO FROM
WHAT SHE DESCRIBED, "HAD IT ROUGH GROWING UP." SO
MUCH POSITIVE ENERGY—IT WAS IMPOSSIBLE TO NOT BE
THANKFUL FOR EVERYTHING.

NIKKI AND I KEPT MISSING EACH OTHER ALL DAY,
PLAYING PHONE TAG. I WANTED SO BADLY TO TELL HIM
ABOUT ALL THIS GOOD STUFF. IT FEELS LIKE A YEAR HAS
PASSED SINCE I LAST SAW HIM, EVEN THOUGH IT'S ONLY
BEEN A WEEK.

# MICHAEL HUSSAR

## August 23, 2008

I'd been a fan of Hussar's paintings long before we ever became friends. I never thought the day would come when I would actually be asked to tattoo him!

I remember how excited I was to introduce Nikki to Hussar's work when we were first dating. When we saw Michael's rendition of Hans Memling, there was no denying how bad Nikki wanted to have it. I secretly called Michael to inquire about it, but the painting had already been spoken for by a collector in Europe.

Michael's reference for the

### SACRED HEART SKULL

he wanted on his forearm was directly taken from one of his own personal sketches. This is the part of the tattoo that intimidated me the most, because not only was I tattooing one of my favorite modern-day painters, but he had asked me to replicate an original

## DRAWING

of his. The thought of him taking home my version of his artwork and closely inspecting it afterward sort of made me sick to my stomach.

I thought it best to not alter the drawing in any way, as it was already as perfect as could be and, anyway, fiddling with it would have felt like blasphemy. I was about to make the stencil when Michael asked if I had a sketchbook he could doodle in for the meanwhile · pretty cool. I handed him a sketchbook and went to make the stencil.

LOS ANGELES
MICHAEL HUSSAR
CALIFORNIA

Then it was time to actually do the tattoo. Intimidation. I could tattoo motherfuckin' Elvis all day long and not blink an eye. But put Hussar in the chair and watch me! A one-hour tattoo took three. When all was said and done, I felt like I had given birth——mentally exhausted and relieved that it was over, but proud of the final outcome.

### AFTER MICHAEL LEFT,

I picked up the sketchbook he had set aside, and found a special gift tucked away in the pages. It was the original sketch of Hans Memling.

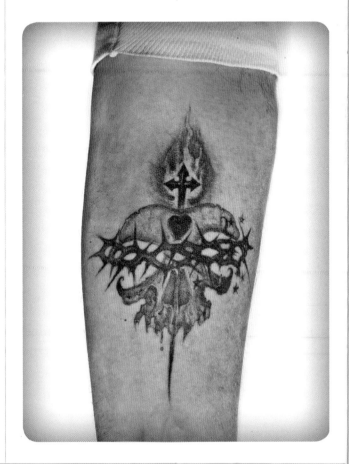

August 24, 2008

# NIKKI'S

obviously excited about our vacation idea by all the e-mails he's been sending me—each one filled with images and links to sites of potential destinations, depicting beautiful and exotic vacation spots all over the world.

I have always wanted to go to

## Prague,

and I was really surprised that Nikki hadn't been either, but had always wanted to go, too. From what all my friends tell me, words do it absolutely no justice. The architecture. The art. The history! It had Kat and Nikki written all over it! This is gonna be so much fun!

Going over both of our schedules was a different story now. We were both booked up solid, but the heavens smiled down on the last week of December. The both of us had ten days with no appointments, interviews, meetings, or events. This is gonna be my only chance to get away before the new year catapults me into nonstop work.

## PERFECT!

# YOLANDA PEREZ

August 27, 2008

Yolanda is an American singer who specializes in banda music. Her career started when she was just eleven, and after winning a contest that enabled her to record an album, word got out about her talent. Yolanda took this genre of music a step beyond the traditional Mexican style, and infused it with hip-hop and R & B elements, leading her to include Spanglish phrasing in her lyrics——making her tattoo, a list of Spanish and English words, especially appropriate: faith, happiness, wisdom, *fuerza* (strength), *exito* (success), *amor* (love), and *sinceridad* (sincerity).

## WE DID THE LIST IN CALLIGRAPHY,

and as simple as this tattoo was, I think it's some of my best lettering yet, and it suits Yolanda's strong-yet-feminine qualities.

# TOMORROW

I meet up with Nikki in

## CHICAGO

and then it's an East Coast tour on the bus——Saratoga Springs,

## SCRANTON,

## AND PITTSBURGH

here I come. As much as it's important for me to see Nikki, I have to admit I am exhausted—but it's not just that. My workload has also gone past the point of overwhelming, too.

The idea of Prague has definitely helped me get through the last three days—at least I know I'm going to be working toward a well-deserved break over next few months. And as much as I love

# TATTOOING,

it isn't the sole provider of inspiration. Removing myself from the everyday routine at the shop is

## SOMETHING I NEED.

HOLLYWOOD
YOLANDA PEREZ
CALIFORNIA

BLOOD BOOK

IX

September

MMVIII

## September 11, 2008

When Jodi walked in for her appointment with a hefty stack of reference photos for her idea, I knew I was in for a lot of work. Page after page of about a dozen specific insects that she wanted stretched across her entire upper back filled the whole front desk as we had our consultation. It was easy to envision the winged insects flying across her back, but I ran into a problem trying to imagine the placement of the more beetle-like ones. Then I had the idea of incorporating a branch in the background to create a horizon of some sort. Artistically, this would make more sense in order to include each of

## THE BUGS,

and Jodi was receptive to the idea——so off to the drawing board for me.

Taking a tracing of each bug wasn't the difficult part of the line drawing, but sizing each one accurately with all the others was, so for that, I needed Jodi's help. We sat at the light table comparing each individual drawing, with Jodi pointing out the ones that had to be enlarged or reduced. Most of the insects were ones that Jodi collected and pinned by herself, so who better to help me out!

Jodi was a bit surprised to find out we shared a fascination with

## PINNED INSECTS,

as I told her about the beautiful collection of mounted and framed bugs I had just bought for Nikki's photo studio, Funny Farm. I have been rigorously trying to redecorate the entire space before he returns from the South American leg of the tour, sometimes working into the late hours of the night when my schedule was already draining me of any "spare" time, but it's important to me. I want Nikki to feel like Funny Farm is just as much his home as his house is, but on an artistic level.

My goal is to turn the space he once used to record music and have meetings into an ambience-infused creative space for him to do all of his photography. I figured each room should be thematically styled, so I came up with the idea of making the main lounge area feel dark, seductive, and late Victorian. I imagined book shelves filled with antique artifacts, velvet and sheer fabric draped across the wall-to-wall damask wallpaper, ornate baroque-inspired frames, and of course, taxidermy.

Collecting taxidermy has been one of my passions, and it's one that Nikki has started showing interest in, too. The mounted insects fit so perfectly in that lounge area. I can't wait until he sees it!

Back to the tattoo. After the tedious preparation of Jodi's line drawings, I decided it would be much easier if we stenciled each individual element of her tattoo separately instead of trying to tackle one huge stencil. This would be more time-consuming, but the way I saw it was we needed to do whatever it took to get this

# Perfect!

FIG I. ALBINO TOAD          FIG II. MYSTERY BIRD

# GURDEEP SINGH

September 9, 2008

I was so fired up to add the final touches to Gurdeep's back piece that we started two sessions ago. The leafless tree stretched across his entire back, done in black and gray, made for a very dramatic effect.

## GO BIG OR GO HOME!

# JERRY BURGESS

September 13, 2008

Jerry wanted a tattoo of the famous photograph *The Kiss at Times Square*, taken in 1945 by Alfred Eisenstaedt, just after

# WORLD WAR II.

This is the perfect example of a historic and timeless image I've always wanted to capture in a tattoo! As the story goes, the sailor had

# KISSED

his way down the street, and after this passionate embrace was

# BROKEN,

he received a slap for his efforts.

HOLLYWOOD
TINA CASSER
CALIFORNIA

# TINA CASSER

September 16, 2008

TINA'S fascination with

# BATS

inspired her tattoo. Although she wanted this fruit bat pollinating a flower in full color, I approached the image much like I would a portrait, making sure to capture exact DETAIL AND TEXTURE.

It was hard for the two of us to stray far from the subject of bats during the tattoo, and Tina's vast knowledge of bats was impressive! She told me all sorts of facts— like an anticoagulant from vampire bat saliva may soon be used to treat human heart patients and that bat pollinators are critical to agave plant production (without them, no more Tequila!). And she also told me that bats are NOT BLIND, contrary to popular myth. I had no idea I'd learn so much from my session today with Tina!

# BUZZ THOMAS

September 18, 2008

A lot of the portraits I do tend to be memorials, but getting a portrait of someone and being able to show it to them is just as fulfilling if not more. When Buzz's father got diagnosed with cancer, he realized there was no better time to get a portrait of his parents than now.[9]

After Buzz left, Adrienne came into my office to break down my station. We talked about Revecka and Khoi's[10] upcoming wedding at the end of the month. They were going to get married at the courthouse——just the two of them——without any elaborate wedding plans. Everybody in the shop has been trying to come up with a fun way to surprise them. After a little powwow with the rest of the guys, we thought that even though the couple wasn't planning on making a huge event of the wedding, it would be hilarious to crash it dressed as pirates——making the day a little wild and something that they'd obviously never forget!

9 BUZZ LATER TOLD ME THAT HIS DAD ABSOLUTELY LOVED IT. WHEN BUZZ SHOWED IT TO HIM, HE SAID, "SEE SON, I'LL ALWAYS HAVE YOUR BACK." THAT MEANT A LOT TO BOTH OF THEM. 10 KHOI NGUYEN, A TATTOOER AT HIGH VOLTAGE, AND HIS FIANCÉE, REVECKA JALLAD.

# NAHEED SIMJEE

September 19, 2008

I've known Naheed for years now, and tattooing her forearm for the very first time really felt like a big deal. I knew what a big step this was for Naheed, considering, like me, her parents have never really been all too fond of her tattoo collection. This is one that would not be easy to cover up! Regardless, we moved straight into the tattoo once she turned in her reference. She had asked her friend Jon Schnepp, who's a director for the cartoon *Metalocalypse*, to design a special character for her—a cartoon-themed heavy metal harlot on an armored horse, totally reminiscent of the show *He-Man*.

John had accessorized her with a battle-ax, a sword with blood, and cat-skull shoulder pads, like a hell-spawned Barbie!

# Justin Venezia

September 20, 2008

FIG. 1

JUSTIN and HIS WIFE, Sara, are newlyweds who flew in from Arizona. They decided to make a trip out of their tattoo appointment and check out Los Angeles. Justin got a sexy little baseball themed pinup girl sporting a number 24 on her baseball uniform, just like Justin had when he played—this was the new Mrs. Venezia's wedding gift to her husband. Now that's an

# AWESOME

WAY TO START A MARRIAGE, if you ask me.

SEPTEMBER 21, 2008

BY THE TIME I MADE IT OUT TO FUNNY FARM AFTER WORK
LAST NIGHT, THE SUN WAS WELL PAST SETTING, AND
NIKKI WAS JUST AS SPENT AS THE DAY WAS. LATELY
IT SEEMS LIKE WE'RE ALWAYS RUNNING ON FUMES.
EVEN WORSE, IT FEELS LIKE THE FEW TIMES I HAVE
MANAGED TO GET TO FUNNY FARM BEFORE DARK, I MIGHT
AS WELL HAVE SPENT MY TIME AT HOME—SOMETIMES
IT'S LIKE I'M NOT EVEN THERE. LATELY, NIKKI SEEMS TO
BE MORE INTERESTED IN PHOTOGRAPHY THAN ME. HOW
MANY TIMES HAVE I HEARD GIRLS COMPLAIN ABOUT THEIR
MAN WATCHING TOO MUCH FOOTBALL OR WANTING TO HANG
WITH THE GUYS OR PLAY GOLF ALL DAY? THIS IS NIKKI'S
VERSION OF IT—JUST A DIFFERENT PASSION REALLY.
I GUESS I'M HAVING A HARD TIME ACCEPTING THE FACT
THAT THE ATTENTION NIKKI GIVES PHOTOGRAPHY ITSELF
ISN'T THE PROBLEM—THE LACK OF TIME IS. ISN'T THIS
WHAT I ASKED FOR THOUGH? I WANTED A GUY WHO HAD
PASSIONS, A WORKLOAD, AND A LIFE OF HIS OWN. I
DIDN'T THINK ABOUT THE FACT THAT AS IDEAL AS ALL
THOSE THINGS SOUNDED, THE REALITY OF ONLY HAVING
TWENTY-FOUR HOURS IN A DAY DOESN'T LEAVE EITHER OF
US WITH MUCH DOWNTIME TOGETHER.

# Angel Portillo

## September 22, 2008

When Angel and his wife arrived for their noon appointment with me, I was in the middle of setting up my station and asked them to make themselves at home on the couch, while I finished. We chatted a bit, getting to know each other through small talk. I quickly learned they drove down from Northern California and had been married for quite sometime now. I mentioned something about my marriage at one point, and Angel's wife, surprised by the fact that I had been married, asked me how old I was at the time.

"Oh, twenty-two. Kind of young, huh?"

They looked at each other in a knowing way and chuckled. I found their reaction sort of odd, and curious, asked them why they found that so funny. Angel quickly replied, trying to explain that in no way were they laughing at me.

He said, "It's just funny, because of course, you would say T W E N T Y - T W O. This number is a recurring coincidence for us."

Looking back at why I approved this tattoo, I remembered the original photo Angel had provided wasn't necessarily the best to work from. It was pretty blurry and taken from afar. The picture depicted a young man in wrestling gear with the number 22 on the front of the uniform; he was crouched in the grapple pose and smiling. I don't know why I approved the image, considering I usually would have passed on something like that. Maybe because I was on the girl's wrestling team in junior high? But I'm glad I did, because Angel brought light into my world.

Not only was Angel's son number 22 on his wrestling team, but he also passed away two years ago on the twenty-second of the month at the age of twenty-two. Even today, when finding a parking spot in front of the shop, all spaces had been taken except one: meter

# NUMBER
# 22.

The way he talked about his son, reminiscing all the great things they've done together as a family was refreshing. There were no solemn feelings or sad undertones during the entire time we chatted. And it was clear they had been a really tight family——they really loved their son and were very proud of his son's wrestling talents. Angel even brought in a photo of a shrine he had built in their garage——wall-to-wall trophies, ribbons, and plaques. When he really misses his son, going into their garage and seeing all those achievements comforts him.

Angel and his wife have come to the conclusion that twenty-two has become a form of communication between them and their son. They believe it's like he's watching over them all the time, saying "Hey Dad, I'm still here with you."

There are no clocks in my office, but we wrapped up the tattoo at 2 P.M. Angel and I chatted a bit while I bandaged him, then he went out front to use the ATM to settle up with Adrienne. Before the couple left, they came back to my office to say goodbye and thank me. Angel had a receipt in his hand——and showed it to me. He thought his card wasn't working, because it got stuck in the ATM. He was worried he wasn't going to be able to pay for the tattoo, and started to get upset, but his wife calmed him down, reminding him to check his clock. He looked at his watch:

# 2:22 P.M.!

At that moment, the ATM spit out his card.

I had forgotten today's date, and when Angel pointed out that it's the twenty-second, the comment earlier about my age when I got married made complete sense!

Angel said, "The number 22 follows us everywhere we go. At first we thought that it was just us trying to find the number in everything, but it comes up way too often to be mere coincidence."

# LATER...

Tattooing my friends on their birthdays is my way of saying I love you. Today I **TATTOOED SKULLS AND BONES** on Rob's stomach. The dude's almost done with his entire body. Then what will I give him on his birthday?

# MIKE VALLELY

September 25, 2008

I'm a huge Burt Reynolds fan. I especially like his late-1970s Saturday-afternoon feel-good flicks. When I was a kid, *Hooper* was one of my favorite movies; this tattoo is the image right off of the movie poster.

I used to think of tattoos as this overly serious thing, but they don't always have to have such a deep and profound meaning. Shit, just getting a cool tattoo because you think it's cool is way more profound to me. I wish I'd figured that out sooner.

——Mike Vallely

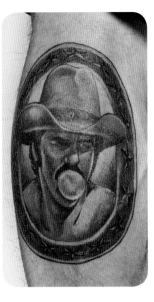

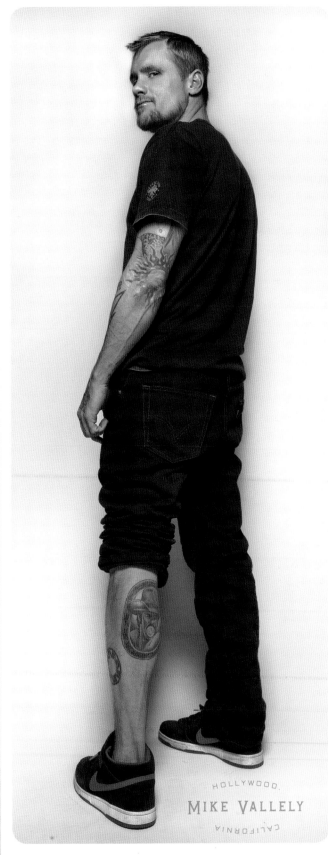

HOLLYWOOD, CALIFORNIA

MIKE VALLELY

# THE PIRATE
# WEDDING

### September 26, 2008

Nikki and I were all set to go to Revecka and Khoi's wedding tonight——pirate gear and all——when yet again, we had an argument. This time he's leaving for Mexico in a couple of days, and I'm bummed out that we haven't had much solid time for each other on this visit from touring. I can't join him in Guadalajara due to my filming schedule, and that doesn't make things any easier. Sometimes I just wish instead of arguing with me about how wrong I am for being upset about our schedules not allowing us to be together, he would just hold me.

I decided I'm not the best company to be around right now. Some alone time sounded the most appealing at that point, so I ended up driving home.

## THE LAST THING I WANT TO DO NOW IS ATTEND A WEDDING.

As much as I really wanted to be a part of this, I didn't want to show up solo, and have everyone ask, "Where's Nikki?" Even though I know Revecka and Khoi aren't going to hold my absence tonight against me, I'm sure they're going to question my support. I mean, everyone else from the shop will be there. I wonder if they'll think I don't care.

I do care——I think I'm angrier with myself really. I let this shit get in the way of me going tonight.

HOLLYWOOD
KHOI & REVECKA
CALIFORNIA

# LEMMY KILMISTER

## (Motörhead)

September 29, 2008

Journalists are always asking what celebrities I have dreamed of tattooing. The truth is that it is less about who I am tattooing and more about what I am tattooing. Celebrity doesn't get me off artistically, but great subject matter—such as a Caravaggio or a Michael Hussar painting—that really gets me excited.

Since the interviewers didn't always seem to care, I gave up on explaining mself and just started saying, "Linda Perry," or "Lemmy, from Motörhead . . ."

Well, today I tattooed Lemmy. He's been wanting to redo some of his tattoos that were done on his forearm decades ago. We redid "BORN TO LOSE & LIVE TO WIN," which was completely blurry. By the time we were finished, you could read it from across the room.

Before he left, he signed my guestbook and thanked me for making him legible.

My favorite thing about Lemmy is that what you see is what you get. There's a reason why certain artists and musicians get paid the respect they do. It isn't easy staying true to yourself—evolving and improving without changing in order to sell records. Lemmy has managed to be a successful staple in rock 'n' roll music without the help of radio play.

Anyway, tattooing Lemmy was completely a blast—and off on his tour he goes with fresh tattoos.

# Johnette Napolitano

## (CONCRETE BLONDE)

### September 30, 2008

There is no way of ignoring it when important people enter your life. When Johnette came along, it was at a time when I needed her the most.

My introduction to Johnette's voice came when I started listening to Concrete Blonde, just after I quit drinking. During a time of great transition, I found her music comforting.

I wish I could properly express the way I feel about Johnette. To me, she is a force of nature, a poem—as tragic as a romance between star-crossed lovers, but prophetic as the angels that spoke through saints.

I don't think I've ever been this excited about tattooing anyone in my entire career. The minute Johnette walked into the shop, I felt a strong connection to her. Diving deep into conversations about Catholicism and art, forgetting that the cameras for the show were up and rolling, we became friends, exploring the tangents that arose naturally in our conversation, to the point where the producers had to interrupt and remind us that we were still filming.

Less talk, more rock, I guess.

We began the tattoo process. Johnette's fascination with the inventor Nikola Tesla inspired her idea for this portrait set inside an ornate frame on her arm. A woman after my own heart!

Once we were seated and well into the tattoo, we went back to where our conversation began, never once even mentioning Concrete Blonde or her solo records. Instead we got lost in talking about flamenco dancing in Spain, Joshua Tree, and life and death. All good things must come to an end, and as much as I didn't want our session to be over, it was. I gave her one of the glass Jesus sculptures that hung from the chandelier as a gift——and she in turn signed my guest book and told me that I, myself, was a gift, which made me feel so honored.

I think that as people who create, we recognize the need to admire and appreciate the things that others do. It in turn inspires us. Johnette inspires me to create because I admire her, and even though I understand that all musicians and artists are just people, it's what they contribute to the world that makes them larger than life.

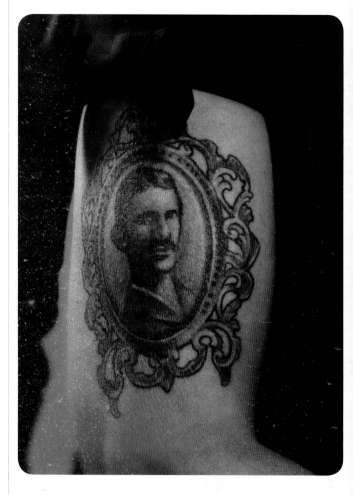

LIGHTNING + RAINBOWS + STARS BURN THEIR WAY DOWN FROM THE SKY

AND YOU HELD THEM ALL IN THE PALM OF YOUR HAND

DREAMS AND MACHINES AND THE BEST OF US WAS ALL IN YOU

AHEAD OF YOUR TIME

AHEAD OF THE MINDS OF YOUR AGE

SO MISUNDERSTOOD, AHEAD OF THE GAME

YOUR AIM WAS LIKE A LASER

AND YOU MADE ME FEEL REAL AND I KNOW YOU . . .

———

LOOK WHAT THEY'VE DONE

LOOK WHAT THEY'VE DONE TO MY NIKOLA

TO MY NIKOLA

LOOK WHAT THEY'VE DONE

# —JOHNETTE NAPOLITANO,

## "LOOK WHAT THEY'VE DONE"

# *LATER...*

# HIGH VOLTAGE

## ANNIVERSARY PARTY
### at House of Blues

I fought back tears tonight as I listened to the many toasts given by the High Voltage crew—each one reminiscent of the early days and celebrating how far we've all come in these past

It's the shop's second anniversary, and it feels like we've never been stronger.

It's crazy how much these guys mean to me. I never thought I'd have a family like this.

# Remember When

... WHEN YOU NATE AND I STAYED UP
ALL NIGHT PUTTING UP THE FAKE HEAD WITH THE
WHITE WIG IN PRODUCTION OFFICE, ALL PASSING-
OUT IN THE SHOP FROM PATRON,

ADRIAN'S CLIENT
TOOK OFF PANTS

WHY?

We were caught
MAKING OUT ON
your couch in
YOUR office BY
Baxter?
NIKKI ♡

I remember Kat and the Guiness
World Record and the radiance
that exuded from her worn
body. She was more beautiful
than I've ever seen her.

Remember the day Kat
brought Ludwig home +
he was so sweet + cuddled
me, Amy, Rhian + Kat on
her giant settee.

Kats hand blew up like
a catchers mit. after the
100 tattoos

I HAD THAT NAP ON THE
SIDEWALK IN FRONT
OF SUNSET PLAZA FROM
2:00 AM UNTIL APPROX.
3:00 AM — JUST A COUPLE
OF MONTHS AGO?

BECAUSE I BARELY DO..

We were having a meeting
in Kats office and
Corey called me
Gay instead of
Greg !!

I hung up THAT Guitar,
THEN you WANTED IT LOWER.
SO THEN I Lowered it.

the Pirate robot.
that Mojo attacked
with a sword.

BLOOD BOOK

X

October

MMVIII

# ALEX THOMPSON

## October 1, 2008

A lex came in to get two portraits on his arm in black and gray. The photograph Alex brought in was one from a few decades back and it features him and his brother wearing KISS makeup. Alex is black and his brother is white. Alex was adopted when he was two months old and raised in this biracial family. As if being adopted wasn't hard enough.

# PLANNING
## NIKKI'S PARTY

### October 2, 2008

A s much as the friction between Nikki and I has been making me feel low, I refuse to let that get in the way of making his birthday epic——I know in the end we're going to work everything out just fine.

Party planning for Nikki's fiftieth was in full effect while I worked on Rhian's tattoo. Someone had once

told her she was a bunny in a panther suit and she thought that was a great idea for a tattoo. She liked that some people see her as this panther——a heavily tattooed woman in business-prey mode, while on the inside she's a

## BIG SOFTIE—A BUNNY.

Rhian's amazing with party planning, and she had a never-ending list of fabulous ideas. Together, we are determined to make this celebration something Nikki will never forget.

One of the most important elements, for me, aside from the venue, the music, and gathering all of Nikki's closest friends and family, was putting together a beautiful book that would show him just how much he was loved. As one of my presents for him, I gathered hundreds of contacts from his phone and mailed out packages to everyone, each filled with pages of special paper and detailed instructions with a self-addressed, stamped return envelope. My idea was that each person could write, draw, cut and paste, do whatever they wanted in regards to sending Nikki their birthday wishes, then mail them back to me for the book.

Kevin Llewellyn——one of my dear friends and favorite painters——just recommended that I take these pages to one of the last traditional book binders in Los Angeles to start putting together this bible of a book!

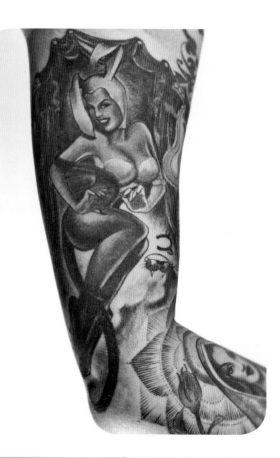

# LATER...

> The tattoo is inspired by a Green Day song, 'Horseshoes and Hand Grenades.' I really love the song, and I got the tattoo before we recorded it. I'm glad the song made the album!
>
> ——Tre Cool

# ALBINO COBRA

# NATASHA
# KAI

## October 9, 2008

A two-time Olympic gold medalist, NATASHA came in with a few of her soccer teammates. Originally we were scheduled to do a black and gray half sleeve of Hawaiian flowers, but that was before the U.S. Women's National Team won a gold medal——again! So now, she wants to get something to celebrate this triumph. Out of the many tattoos Natasha has collected over the years, this piece is the only soccer-related one.

She wanted a rendition of God's hands holding the Chinese character for the word *Believe*. Natasha told me Believe is an affirmation that's used in the

## OLYMPICS.

"If we believe in each other, then great things will come! And we

## WON!"

Aside from doing this fun tattoo, I had such a blast with Natasha. It's refreshing to be able to talk to another female working in a male-

## DOMINATED

environment. I'm so used to hangin' with guys all day, it's easy to forget that I'm a girl sometimes.

My conversations with Natasha and her teammates flowed so easily. Listening to them tell me about the diligent training, which takes over a majority of their waking moments, was the perfect example of dedication——both

## PHYSICAL

and mental——at its finest.

I couldn't imagine having a relationship while training and playing these high stakes games—— it sounded virtually impossible. It's hard to picture having an actual relationship like that unless you were with someone who was

doing the exact same thing, who would understand how much one has to dedicate themselves and their time to something. One of Natasha's teammates actually has a kid——and that made me think about how tough it is for Nikki to go out on the road and leave his kids behind when they aren't able to come along.

All this talk on the subject really made me rethink my behavior with Nikki lately. I think I need to be more understanding of his hectic schedule——trying to balance touring with being a father. I know it takes a lot out of him, trying to make time for all of it, including me.

Overall, it takes a certain kind of person to fully give their

## BODIES,
## TIME,
## ENERGY,
## HEART,

and soul to do what it is that they love.

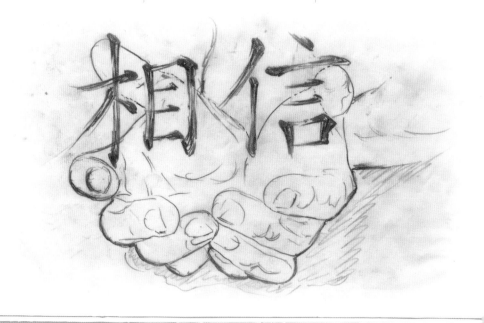

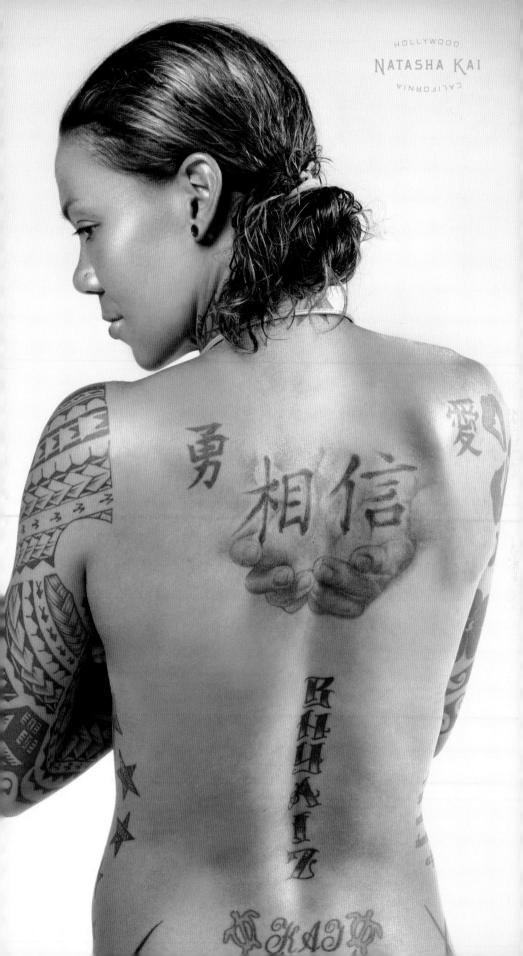

# GAGANDEEP & GURDEEP SINGH

## October 10, 2008

### YAY! MY FAVORITE CLIENTS OF THE YEAR!

Gagandeep and Gurdeep——the two brothers that make my day much brighter when I find out their appointments are up. Once I had finished up Gurdeep's back piece earlier this year, his brother Gagandeep made an appointment for this beautiful full-color image of a Sikh in prayer pose. He had showed me a profile shot of his father and was interested in replacing the image of the Sikh's face with that of his father. The intricate details of a temple off in the distant horizon would fill the composition of the tattoo nicely.

# I LOVED THE IMAGE

when he originally showed it to me and was more than excited to take on this project. Gagandeep on the other hand had been hesitant to ask for the appointment, in fear that I would be turned off by the idea of doing color. Because the show often airs the black and gray portraits we film, people have the misconception that I'm not too keen on color tattoos. After a bit of a struggle to convince Gagandeep of how excited I truly was to do his tattoo, we were both amped!

As I tattooed Gagandeep, I felt like I was getting to know him, just like when I tattooed his brother. He taught me about Sikh history and how it played a big role not only in his tattoo but his life.

Sikhs are known to be warriors, always prepared to protect their own. One requirement is to always carry a *kirpan* (strapped sword). The Golden Temple we had incorporated into the tattoo was also known as the Harmandir Sahib, and is the most significant place of worship for Sikhs. Interestingly, due to Sikhs being oppressed by others in the land, they decided to build the temple and open it to all religions of the world, to anyone who wants to pray, meditate, or listen to the prayers of others. The Sikhs' ability to still preach tolerance by sharing their temple with people of different faiths is inspiration to Gagandeep to respect everyone. But more specifically, the inspiration for this tattoo was definitely his father. Basically trying to live his life by his father's ideals and ethics, he wanted to get a tattoo that his father could possibly admire and respect.

Both of Gagandeep's parents are devout Sikhs, and this image plays a part in bridging the gap between the ideals of the Sikh faith and Gagandeep's lack thereof.

The placement of this tattoo was very thought-out and significant because it is a picture of his father. Since the Sikh father is known as the protector of the family, it was important for Gagandeep to put the image in a place where others could revere him. As beautiful as Gagandeep told me he thought the artwork was, though, he isn't one to show off the tattoo. He told me he planned on almost always wearing long sleeves because the tattoos are an intimate part of his life. I thought that was AMAZING.

After we finished Gagandeep's tattoo, he pulled a napkin out of his pocket on which he'd written something he planned to enter into my guest book. He thanked me not only for the tattoo, but for our friendship, too.

# MICHAEL STARR
★ *Steel Panther* ★

October 11, 2008

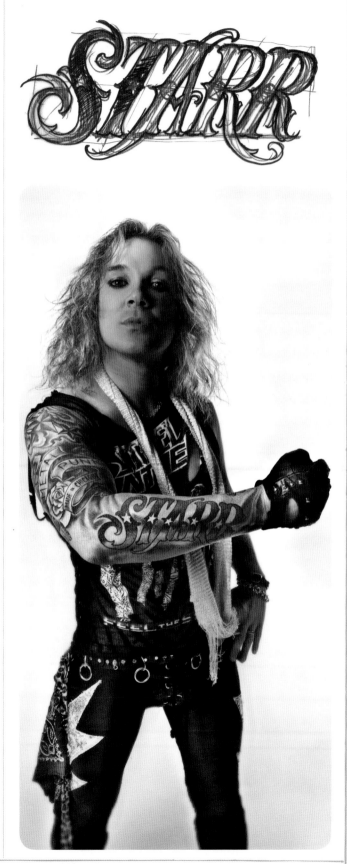

Completing a sleeve somehow makes me feel like I can breathe better. It's always nice to see a finished product after sessions of working on a tattoo, and today we were able to do that with Michael Starr——finishing the color in the lettering of Michael's

## LAST NAME

across his forearm and tying all the major elements of his sleeve together.

With my tattooing for the day done now, I can go get ready for the welcome-back pool party we're throwing for my brother Michael today at the Roosevelt. The idea of having the three of us siblings united for the first time in years is a wish come true. I'm so thrilled he decided to move back to LA—— having him manage all of the merchandising at the shop is going to help me out more than he knows!

The relationship I have with Michael is so different than the one I have with Karoline. I feel like I missed out on such a big part of growing up with Michael. He's the youngest, and I left home at such an early age. Aside from the few-and-far-between visits or family gatherings, I can't say I've spent real quality time with him.

Having him move back here and work alongside Karoline and me makes me feel like the shop will be unstoppable. Michael was the missing link! I can't wait to stop wasting time and really get to know my brother now.

OCTOBER 12, 2008

WOKE UP ALONE AGAIN. TOO TIRED FROM THE NIGHT BEFORE TO
DRIVE ALL THE WAY OUT TO NIKKI'S, AND HE WAS "TOO TIRED"
TO DRIVE TO ME—SAME OLD STORY. I'VE BEEN THINKING—MAY-
BE IT'S ME—MAYBE I'VE LOST IT. MAYBE I'M NOT AS "HOT" AS
I WAS WHEN HE FIRST MET ME? MAYBE THE HOURS I SPEND
CRYING OVER HIM I SHOULD SPEND JOGGING?
I TOLD MY SIS ABOUT HOW IT'S BEEN FEELING LIKE A ONE-
WAY STREET WITH NIKKI AND HOW IT WAS STARTING TO HURT.
SHE TOLD ME MY IDEA OF WHAT "LOVE" IS SUPPOSED TO BE
IS UNREALISTIC. "IT CAN'T ALWAYS BE ROMANTIC, KATHY."
IF THAT'S THE CASE, THEN WHY THE HELL DO I STILL FEEL
THE SAME? WHY AM I STILL ON FIRE? WHY AM I STILL WILLING
TO GO ABOVE AND BEYOND FOR TWO MINUTES OF BEING NEXT
TO HIM? I DON'T BELIEVE TRUE LOVE IS SUPPOSED TO HAVE A
"HONEYMOON" PHASE. I DETEST THAT TERM. WITH ALL MY GUTS.
THE HONEYMOON PHASE, THE PINK CLOUD—EVERYTHING'S SO
GODDAMN WONDERFUL IN THE BEGINNING—EVERYONE IS
ALWAYS A SELF-PROCLAIMED "ROMANTIC" IN THE BEGINNING.
THE POETRY AND THE BIRDS—AND THEN IT CHANGES. THE
MYSTERY IS GONE, AND LEMMY IS RIGHT: THAT FEELING YOU
FELT IN THE FIRST KISS WILL NEVER LAST. AND THAT'S THE
PROBLEM WITH ROMANCE. AND I GUESS THAT'S THE
PROBLEM WITH ME.
LAST WEEK WHEN I SAW LEMMY, HE WROTE, "ROMANTIC WITHOUT
BORDERS" IN ONE OF MY JOURNALS . . . AND I WROTE,
"HOPELESS ROMANTIC." FUCKING HOPELESS.

# MIKE MARIENTHAL

## October 13, 2008

**M**ike has probably some of my best black and gray tattoos to date. Today, I got to continue his Virgin Mary tattoo onto his chest, where I'm extending the frame of cherubs to a glorious-looking God gazing down on Mary from the sky.

Mike had been longing for that certain "something" that was missing in his life, but had actually witnessed for years in the examples set daily by his wife, Mary. He felt that this work of art made such a beautiful statement about what would await them when they were through here.

Mike's inspiration was derived from the Michelangelo painting *The Assumption of the Virgin Mary* as well as his recent conversion to Catholicism. It truly is a glorious piece. For quite some time, Mike had been drawn to this style of art due to the anatomy, realism, and spirituality portrayed in them.

I related to how Mike felt when he saw art like this. Not only are they beautiful images, but also they evoke

## POWERFUL

### AND INSPIRATIONAL EMOTIONS.

---

## LATER...

# RITA HANEY

**E**ver since I started tattooing her, Rita's tattooshave been in one way or another related to Dimebag Darrell, the love of her life, who was tragically murdered on December 8, 2004, while performing with

# DAMAGEPLAN,

the band that both brothers, Dimebag Darrell and Vinnie Paul Abbott, formed following the demise of their previous group Pantera, in Columbus, Ohio. [11]

Today, Rita wanted to get green lightning bolts that began at her temples and branched onto her face and neck. We must have spent at least an hour——maybe two——trying to talk Rita out of her idea.

My biggest concern was that, to the average Joe, the

## LIGHTNING BOLTS

would resemble a tree branch, especially since she had her heart set on them being Dime's signature lime green. I asked some of the tattooers that had been working today for second, third, and fourth opinions. Getting tattooed on your face is not a joke, and the last thing I want is to tattoo Rita with something that'll evoke the constant question, "What is that?"

Finally, with everyone in the shop agreeing that the style she wanted looked less like electricity and more like twigs, she decided to go with more traditional tattoo-style bolts.

There will be no mistaking her tattoo now.

---

11 DIMEBAG DARRELL WAS SHOT ONSTAGE FIVE TIMES, INCLUDING ONCE IN THE HEAD, BY AN OUTRAGED PANTERA FAN AND FORMER U.S. MARINE NAMED NATHAN GALE. DARRELL WAS KILLED INSTANTLY. THE BAND'S DRUM TECH AND TOUR MANAGER WERE INJURED AS WELL. GALE FIRED A TOTAL OF FIFTEEN SHOTS, TAKING THE TIME TO RELOAD ONCE. HE REMAINED SILENT THROUGHOUT THE SHOOTING UNTIL AN OFFICER EVENTUALLY SNUCK IN FROM THE BACK AND SHOT GALE IN THE FACE WITH HIS SHOTGUN. THE KILLER WAS FOUND TO HAVE THIRTY-FIVE ROUNDS OF AMMO REMAINING. ALTHOUGH NO MOTIVE WAS FOUND, SOME WITNESSES SAID THAT GALE BLAMED THE BROTHERS FOR PANTERA'S BREAKUP AND BELIEVED THAT THEY HAD STOLEN HIS LYRICS. GALE SUFFERED FROM PARANOID SCHIZOPHRENIA.

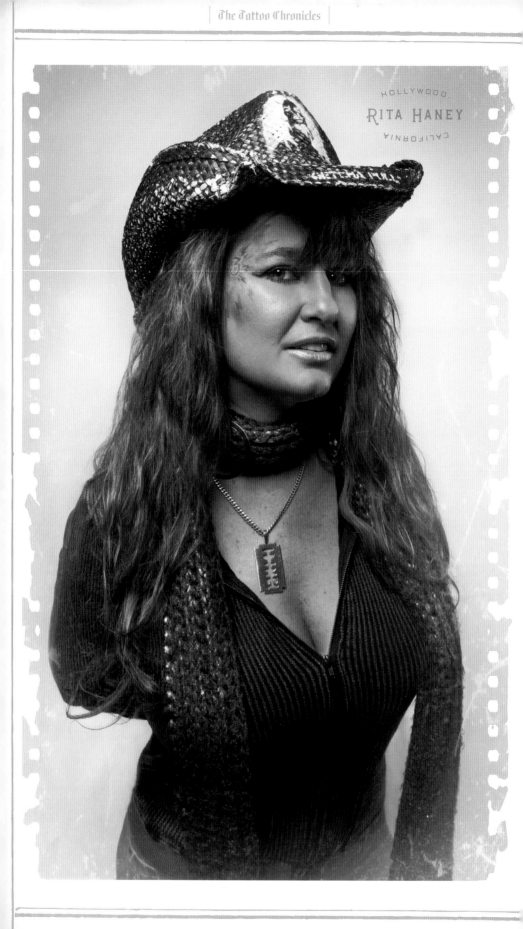

HOLLYWOOD.
RITA HANEY
CALIFORNIA

# MARIA ABARCA

October 17, 2008

My last tattoo of the day . . . Maria is one of the camera operators on the show. It's weird sometimes when I tattoo people from production—there's a completely different dynamic when we're not filming on set. I sometimes feel especially bad for the camera guys on the show, because not only are they having to hold up those heavy cameras all day, but they are also having to constantly film us, even on our "bad" days. Maria has always been so nice to me and always seemed to understand. I'm glad we made time to do this tattoo.

Maria's grandmother had an abundance of sisters who basically raised her together. The mental image of five batty old ladies yelling in French at each other in Cajun accents was amusing, I have to say. But it's easy to see how these strong women played a big part in Maria's life.

Maria's reference art came from a CHINA PATTERN that belonged to her grandmother, whom she lovingly refers to as MawMaw. The pattern was called

## Norway Rose.

When Maria got engaged, she wanted her grandmother's CHINA SET.

MawMaw refrained from giving the set to Maria, since it was so old and pieces were either missing or broken. But when Maria's Aunt Coe passed away, a peculiar discovery was made! Going through Aunt Coe's belongings, they found the identical Norway Rose set of china!

TO THIS VERY DAY, MARIA HAS THE CHINA, REMINDING HER OF MAWMAW, AUNT COE, AND ALL OF THOSE WONDERFUL WOMEN WHO MADE HER WHO SHE IS.

# STEVE HERNANDEZ

*October 20, 2008*

Steve and I have such a deep connection——I honestly enjoy the talks we have. He is always seemingly so down on life, I think mainly because he's not doing what he's meant to be doing. He is meant for something so much greater than either of us knows.

---

Every time I do a portrait, there is always a detail that ends up being my favorite part of the whole thing. Sometimes it's the way a highlight turned out on an upper lip, an ear, a brooch, or the curl of a hair. It's the little subtleties that make a difference. On Steve's portrait of Jacobo Arbenz,[12] the pattern on the tie definitely

# WON MY HEART!

---

Done with the drawing board for today, now off to pack and head straight to the good ol' airport and catch my flight to Japan for the first time! Gonna be catching up with Nikki on his final leg of the tour. I can't wait to see him and spend a week out there, even though I'm only gonna be out there a few days. I'll be able to hold him——sleep next to him... I'm hoping the jet lag isn't gonna knock the wind out of my sails once I land, considering all the ups and downs we've been going through. It's the last thing we need.

---

12 PRESIDENT OF GUATEMALA, 1951–1954.

BLOOD BOOK

XI

November

MMVIII

# AARON
## ROSAPEPE

November 1, 2008

Aaron's preexisting tattoos were impressive, a majority of them done by **STAN CORONA** AND **ERIKA STANLEY** over at Art and Soul Tattoo, in Culver City.

I remember the first time I met Erika. She was one of the bigger names in tattooing, as far as **LOS ANGELES-** based female tattooers go. I was only seventeen years old when I stepped into her shop and was completely intimidated. Erika was not only a woman, but she was a damn good tattooer! I bragged like a fool about the tattooing I was doing out of my house! I had no clue what I was talking about. And when I asked her for advice on tattooing, she told me, "You better run while you can!"

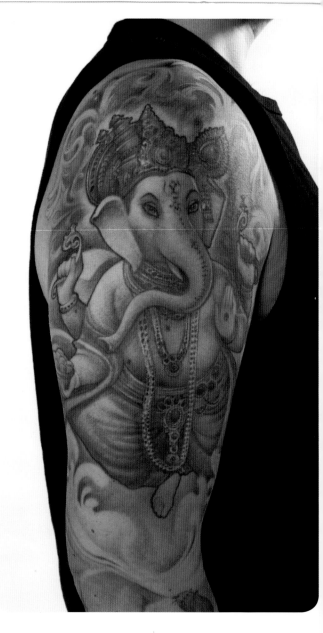

# OFFENDED,

I left with my ego bruised, but I was fueled with jealousy because I wanted to be like her.

Years later, after tattooing professionally for a while, I began getting credit for becoming a good tattooer, and ran into Erika at a tattoo convention. I approached her and introduced myself in a more humble manner.

She gave me a nice compliment on my tattooing——or at least the little she had seen. Then I decided to mention that embarrassing time when we met, how I was an overly confident idiot teenager, and how her words somehow pushed me to be the best I could possibly be.

After I thanked her for that, we laughed about the whole thing. **FUNNY THING** is that I say the same shit now when some kid comes to me and asks for advice on how to become a

# TATTOOER.

**FUNNIER THING IS** I'm now tattooing her client. Aaron has one arm done by Erika, and I'm doing the entire other arm.

# ANTIQUE ACCORDIAN

# Corvette

November 2, 2008

CORVETTE lives in New York. As the head hairstylist on Madonna's current tour, he's out on the road. Somehow a friend of a friend made it possible for him to get squeezed in.

**LUST FOR LIFE**

are the words Corvette's getting to frame his upper arm. I took the opportunity to get pretty damn elaborate on this one.

---

Corvette was quite knowledgeable about music. We talked about lots of different genres, aside from Iggy and the Stooges, and, of course, Madonna. It was so refreshing to hear what a positive person she is, according to Corvette. Madonna gives everyone a hug before she goes on stage—although he says that sometimes the things she envisions in her head and expects can seem pretty impossible.

---

I finished up Corvette's lettering and had a few minutes of downtime before Keith Flint's appointment, and found this neat travel site online. The home of the Torture Museum is in Prague! I can't wait!

# LATER...

# KEITH FLINT

## -THE PRODIGY-

I love the reference for this tattoo—a photo of a beautiful girl holding a camera in one hand, and in the other, a Polaroid of a close-up of a nipple—strategically held up over her own boob.

It creates an optical illusion, definitely the kind of thing you look at twice. Keith came up with the idea of putting a graphic image of an army tank with the words "Love Your War" on her shirt. Very cool.

Nikki told me that Mötley Crüe actually opened up for The Prodigy in Norway back in the day. They were playing a huge festival and all the kids went crazy when "Firestarter" began. Nikki said that he had never seen so many people simultaneously jumping.

Tattooing Keith was a complete pleasure. Maybe it's the accent—but there was definitely something sexy about his way. The years have been kind to him, and it's obvious that he takes proper care of himself. The tattoo we did was located on his right ribs, closer to his waistline. He had a pretty impressive collection of tattoos to begin with, and he sat like a champ for the entire tattoo.

Karoline has been working on a skull sculpture for a Day of the Dead art show. She has to design a human skull any way she wants. She came up with this beautiful baroque-inspired theme and added a stack of old books, fabric, a rosary, a cameo, a skeleton key, and a portrait of her cat, Tijuana.

During my session with Keith, she asked us what she should paint in the eye sockets of the skull. Her idea was to come up with a two-word saying. Keith came up with a brilliant concept: Don't Wake. Karoline was so pumped and agreed that would complete her **ART PROJECT.**

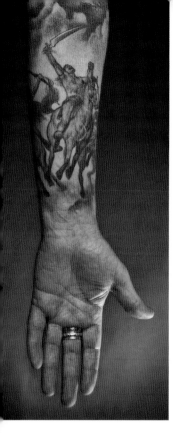

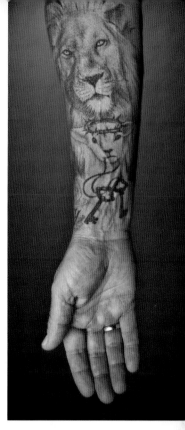

# WEYMAN THOMAS

November 6, 2008

*THE*

## HORSEMEN OF THE APOCALYPSE:

what a crazy forearm tattoo for a pastor to get.

I've tattooed Weyman before. He was referred to me by my dear friend Kenny Fong, who described Weyman as a "gnarly pastor." And that he is—well, at least in comparison to your quintessential pastor!

Weyman is working on sleeves. This tattoo consists of some of my favorite style of artwork. There are so many details that I am sure that completing this tattoo will take a little bit longer than one session.

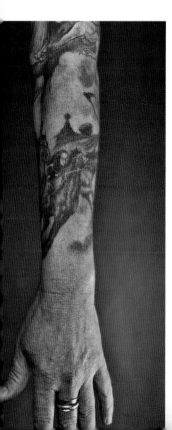

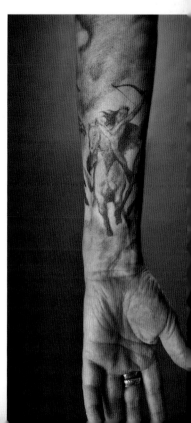

# BAM
# MARGERA

## BAM'S IN TOWN!

And with Novak——his life-long best friend. Growing up, they were both promis-ing skaters, but Novak

kept losing steam——mainly due to his constant on-and-off love affair with heroin. One positive thing that came out of that addiction, though, was *Dreamseller*, Novak's memoir about his prob-lem, which he is doing a book tour for now. Bam is in town for the Element Skateboards promotion and for Novak's book tour.

At the last minute, Bam asked me to finish off a bit of his arm with his brother's band logo, CKY, and I added some fun filigree that creeps up onto his hand——nice! I'm sure Mom is gonna love me now for sure!

Bam says he wants to go to the good ol' Rainbow with Novak after this, so here we go . . .

After today's day of tattooing,  **BAM** and I were off to the Element event at Active Ride Shop. We were greeted by pro skaters Mike V and Chad Muska once we arrived, and it was so awesome to see all the support from the kids that had been waiting patiently since

**7 A.M.**

in a line that ran down the street. What a great turnout!

But I kept looking around for Nikki——who was nowhere to be found. He has the day off from the kids——so tonight was our night. We were supposed to spend it together somehow. After calling Nikki to see where he was, it became apparent that he wasn't gonna show. I could barely hear him on the other end of the line. He was obviously in a crowded place, but from what I could gather, he changed his plans of coming out and went to the street fair with the kids instead.

———————————

I still kept hoping that he would make it to K A R O L I N E ' S

**ART SHOW**

at least——he knew how important it was to me that he be there to support my sis. No dice.

PAINTS

Karoline was so proud of the final outcome, but not as proud as I was when I saw it displayed in all its glory. Goddamn——she has no idea how talented she is!

———————————

**MAN.** It would've been nice to share these times with Nikki. I mean, it's not like I'm trying to make him choose between spending time with me or with the kids. **KAROLINE** had actually extended an invitation to the kids to come to this event last week, and I honestly thought it would've been cool to **CELEBRATE** this with the whole family. Maybe **NIKKI** WILL COME SEE ME TOMORROW. But as much as my lonely heart misses him, I highly doubt it.

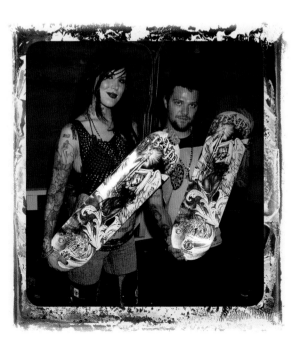

# CRYSTAL STONE

### November 11, 2008

Crystal flew out specifically from Missouri just to get this black and grey portrait of **VILLE VALO** on her forearm. As much fun as I had doing this portrait, I was preoccupied with all the turmoil with Nikki.

I think he's bummed about our **FIGHTING.** As much as I have my own part in the matter, I can't help but relate a lot of the fighting and lack of solution to the way he handles other conflicts in his life. The tour has clearly been stressful for him; I can see it affecting his moods. Like me, Nikki's overall energy tends to fluctuate depending on what's going on around him.

Not being with his kids for Christmas this year definitely causes a major shift in his attitude, but one thing I know from the all-too-familiar experience of depression, that wolf at the door, is that as important as it is to connect to your emotions, even during sad times, hanging onto dark feelings always leads to a downward spiral. Well, at least it's that way with me.

I think it's hard to be Nikki. He's got so many expectations from the world around him, tugging him in each and every direction. He's always giving of himself and making sure everyone's taken care of——a lot of the time before himself——most of the time, actually.

There's rarely any balance, it seems——and he's searching hard for it but coming up short a lot. Not enough time spent for himself: meditating, shooting photos, or whatever it is that will fill his heart. Not enough time with the kids——and never enough time to fulfill all the demands of his business——the clothing line, the two bands, the **TOURING.**

And where am I supposed to fit in the picture? And how did I **-FIT-** so perfectly into it in the beginning again? And why is finding that same amount of time we once had so impossible now?

# ANDREW
# STUART

### November 13, 2008

**STU LOVES FISHING,** which is apparent in this tattoo. Today we were able to complete the shading on this cool fish rib piece. We even got to add background. I am so proud of Stu——I have a feeling he's gonna grow to be a well-respected rocktographer.

It's funny how things work. Just about a month or two ago, I was messing around with my camera and in need of a model and Stu happened to pop by to say hi. When he said that he was down to let me take some shots of him with my camera and experiment with lighting, I was so stoked. As the pictures got progressively better, I noticed his fascination in photography growing too. The next thing I knew, he had borrowed his dad's ancient Nikon and was tagging along with me on my learn-by-trial-and-error photo shoots at the shop. Like desperate idiots, sometimes we'd stay up till 4 or 5 in the morning just trying to figure out our damn cameras.

Turns out that Slayer is in need of a candid photographer to go on tour with them and document the making of their upcoming album. Stu is going to fly out to Europe in a few weeks. His **SUCCESS** feels like it's overnight, but it's really the result of much practice and persistence. It's so rad: it's Stu's first time overseas and he's going to do what he loves!

## NOVEMBER 15, 2008

I TEXTED NIKKI, TELLING HIM HOW MUCH I MISS HIM AND HOW ALTHOUGH I WAS WORKING LATE, I WANTED TO DRIVE OUT TO HIS HOUSE AND CRAWL INTO BED NEXT TO HIM, EVEN FOR ONLY A FEW HOURS BEFORE I'D HAVE TO WAKE UP AND FIGHT TRAFFIC BACK HOME TO MAKE IT TO WORK ON TIME.

### HIS RESPONSE SHOCKED ME.

HE SAID NO. WOW. THAT HURT. ESPECIALLY CONSIDERING HOW MUCH TIME I'VE BEEN SPENDING TRYING TO PLAN THE PERFECT PARTY FOR HIM. MAYBE I'VE MADE MYSELF TOO DAMN AVAILABLE. MAYBE HE GOT COMFORTABLE. I'VE SEEN THIS MOVIE BEFORE . . .

AND MAYBE IT'S BECAUSE I'VE MADE IT SO EASY, ALWAYS MAKING THE TIME, THE EFFORT, TO COME TO HIM, MAYBE HE THINKS IT'S SOMETHING THAT'S ALWAYS GONNA BE THERE. MAYBE THE OLD SAYING "WE HURT THE ONES WE LOVE THE MOST" RINGS TRUE WITH US. MAYBE IT'S EASY TO TAKE STUFF OUT ON THE ONES YOU THINK ARE GOING TO STICK AROUND UNTIL THE END OF TIME.

YESTERDAY I MET UP WITH ALI HELNWEIN[13] TO GO OVER IDEAS FOR PUTTING TOGETHER TWELVE STRING PLAYERS AND COMPOSING A FEW MEDLEYS OF ALL THE SONGS THAT NIKKI HAS WRITTEN FOR STRING INSTRUMENTS. I KNOW NIKKI ISN'T AWARE OF HOW MUCH I'VE BEEN DOING—BUT DAMN, IT MAKES IT HURT THAT MUCH MORE.

STILL, THERE'S ABSOLUTELY NO WAY I'M GONNA LET OUR FIGHTING ABOUT SPENDING TIME TOGETHER GET IN THE WAY OF MAKING THIS PARTY HAPPEN!

WENT HOME, ALONE, AGAIN.

---

13 MY FAVORITE COMPOSER AND CONDUCTOR, WHO FORMED THE TRACTION AVENUE CHAMBER ORCHESTRA IN DOWNTOWN LA IN 2006.

# OLGA
## SAFRANOVA

### November 16, 2008

Olga came all the way from SUNNYVALE, California. She drove down with a friend to get a tattoo based on a piece by Mark Ryden across her upper back—and tattooing a Mark Ryden piece is never dull.

**November 21, 2008**

Doodling away in my office this morning, Kim[14] and I started throwing around ideas about what I could do to help support Covenant House[15]——Nikki's dedication to the *Running Wild in the Night* program has been so inspiring! Looking through some of the drawings I had already completed, she came up with a genius idea:

## SIXTY-SIX NIKKI SIXXES!

I decided I could draw sixty-six Nikkis and sell the prints to raise money and awareness for this cause. I need to start talking to an art gallery and set something up. I think Nikki's gonna love the idea!

# Michael
## Von Drachenberg

**November 29, 2008**

It's past midnight on Saturday night. I just finished tattooing my little brother——kinda late——but always worth the wait! We got a bit of a late start on the tattoo——but Michael was cool about it, as he watched me finish up one of the many Nikkis I've been trying to have ready before the upcoming event at the gallery next door.

Michael had the idea of surprising my sister with one of the sweetest ideas for a tattoo. KAROLINE'S **DAY OF THE DEAD** sculpture came out so cool——he thought it would be awesome if he had it tattooed on his forearm.

Michael is going to surprise Karoline tomorrow, and I can't wait to see her reaction.

Perfect thing for Michael, too, considering how much they have been butting heads lately. Michael and Karoline are so much alike, and it works against them when it comes to how stubborn those two can be. They always bicker about little stuff and usually end it by walking away upset, never really solving the problem. Since they are both so damn hardheaded, they haven't really talked it out. I hope this tattoo is gonna bring them together more, and in turn bring all three of us together, as well.

## TATTOOS ARE SUCH A GIFT.

Michael came with me to see what Ali Helnwein put together for Nikki's birthday after our initial meeting a couple of weeks ago. The rehearsal pretty much sold me on the idea that this is gonna blow Nikki's mind! Ali is our favorite modern-day composer; ever since I played his music for Nikki, he's been addicted to it.

Ali, along with the twelve string players, rehearsed two medleys while Michael and I watched and listened. By the time they played "Home Sweet Home," I literally was fighting back tears. It was beautiful.

I wonder if any of these players ever imagined playing a rendition of "Shout at the Devil" when they first started studying their instruments!

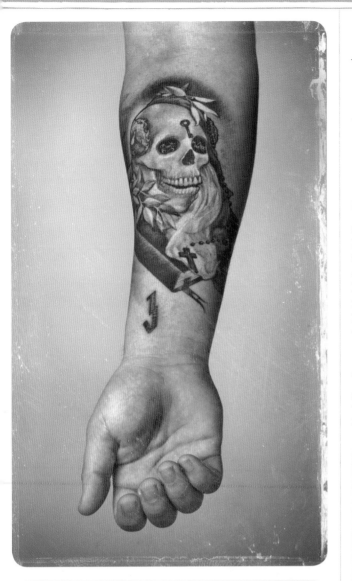

# LATER...

# DARREN MEEKS

On the first leg of the Mötley tour, on the final day of the show, Nikki gave Darren Meeks, his bass tech, the gift of a tattoo from me. Darren had been asking about getting one since Nikki and I started dating——and man, the look on his face when Nikki told him backstage last year was priceless!

Today, Darren is redeeming the gift and letting me go off on this full-color image of Shiva on his forearm.

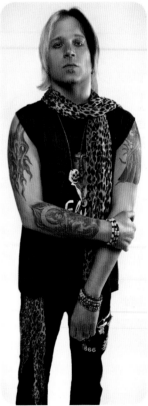

14 KIM SAIGH IS A FORMER TATTOOER AT HIGH VOLTAGE WHO WAS A CAST MEMBER ON *LA INK* WITH ME. 15 COVENANT HOUSE IS AN ORGANIZATION THAT HELPS HOMELESS TEENS FIND SUPPORT AND SHELTER THROUGHOUT THE UNITED STATES, CANADA, AND MEXICO. *RUNNING WILD IN THE NIGHT* IS THE MUSIC PROGRAM THAT NIKKI STARTED WITH COVENANT HOUSE BY DONATING PROCEEDS FROM HIS BOOK, *THE HEROIN DIARIES.*

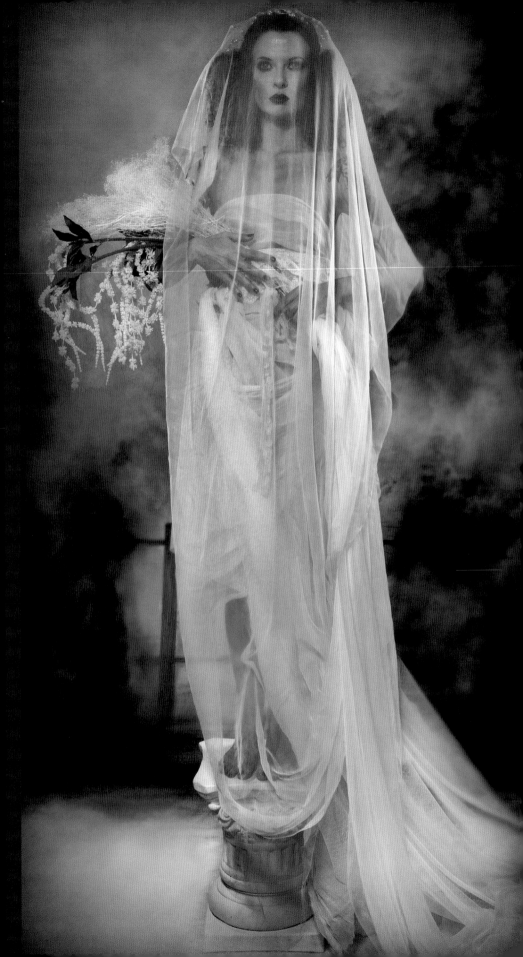

XII

December

MMVIII

December 2, 2008

COVENANT HOUSE

# 66

# NIKKI SIXXES

Feels like today came out of nowhere! I've been drawing up a storm. At 3, the gallery was full of framed Nikkis and the event was ready to go—but we were still a few drawings short! I did "SHOUT AT THE DEVIL" Nikki, toddler Nikki, mug-shot Nikki, Nikki's eye, ear, mouth, hands—and there were still more to go. This is what happens every time I take on so many projects at once—regardless of the stressful situation, I was confident the juice was worth the squeeze.

I drew furiously while Karoline made prints and Adrienne framed them—much like an assembly line.

As stressful as it got, we finally made it!

## SIXTY-FUCKING-SIX!
In the end, the turnout and support exceeded my expectations.

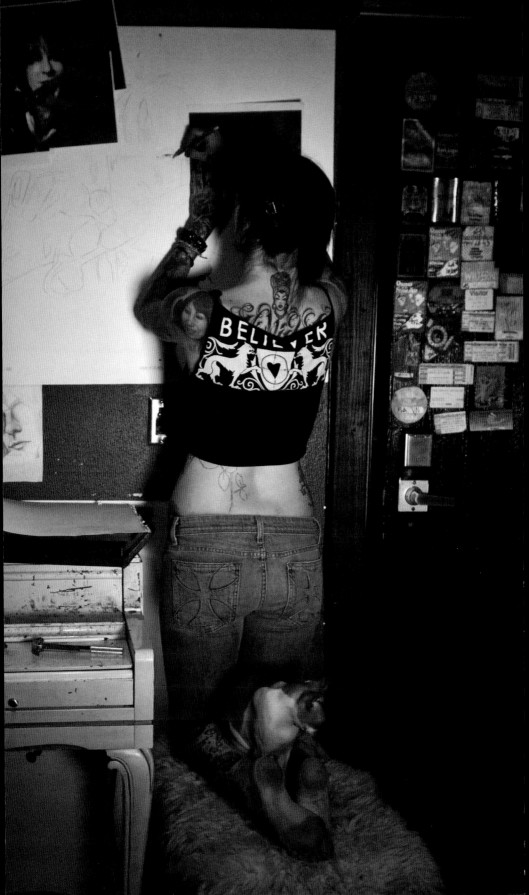

# CHARLES WINBORNE

December 6, 2008

## I WAS SO BUSY

working on session two of Tre Cool's grenades tattoo that Charles Winborne should receive the "most patient dude" award for sitting around for this tardy tattooer. Charles had been sitting

## QUIETLY

on the couch across my station for two hours——never making a peep or eye contact. Maybe he was really nervous or maybe he was just anxious——kinda like I get when I'm in large groups of people.

When Tre left, I took a seat next to Charles on the couch, and we just began to talk——and talk. Charles is a San Diego resident and an Ohio native, and he's a nurse at a hospital down south in the intensive care unit. A pinup girl was the plan for his calf tattoo——his first one. I'm not sure we really even wound up talking about the subject matter of his tattoo, because straightaway, we dove headfirst into some heavy shit. As soon as I asked him what he did for a living, I could sense a shift in his demeanor.

It's just such a heavy load to take on when you do what Charles does. He told me this terrible story about a woman——who because of a doctor's mistake, maybe——was left so brain-damaged that the family ended up having to take her off life support.

I can only imagine the expectations that weigh on the shoulders of nurses. The job requires

## PATIENCE,

focus, and love as well as being able to endure all of the death. I think he's truly sad about that woman dying. Then he said he was working this Christmas, that

he usually works on holidays. He didn't seem like a Scrooge type, but there had to be a reason for how much sadness I was sensing from him. I wondered to myself if Charles was as down as I was.

I think that he might have been——to tell you the truth.

Finally, we got to what I believe to be the source of this gloominess. Charles's mother passed away two years ago in a car accident in Ohio. Due to issues regarding the will——greed, fear, and egos getting in the way of hearts——Charles hasn't spoken

to his family since that day. And it's also why he moved to California.

## CURIOUS,

I asked questions. Don't you miss your sis? Have you told them how you feel? Will you ever? Do you miss your mom? Did you ever meet the people who, without

## INTENTION,

took her life away? And I wonder how they handled that! I bet they think of Charles's mother every day, like Charles does.

Man——our talk became more and more real while our cigarette breaks grew longer and longer. And when I ran out of smokes, we shared one of his menthols.

We both stopped thinking about his initial reason for visiting my shop today——I forgot about the tattoo altogether. We just sat listening to each other. We were the last ones in the shop.

When we finished the tattoo, he hugged me and signed my guest book——he wrote just his name and today's date.

I was so happy to have met Charles tonight. He made me

## THINK,

helped me process my thoughts. He listened and I listened. And before he jetted, I stopped what I was doing and thanked him for listening to me.

That caught him off guard—— and he thanked me back.

It's amazing to connect with someone like that.

# JIM LEWIS

## December 9, 2008

I found a picture online of the city life in Prague during Christmas——Jesus! This place is going to be a dream come true for us——snow-covered bridges and cathedrals——and dark and mysterious landscapes as far as the naked eye can see.

And I just got word that the fifty plastic pink flamingos we ordered are going to arrive in time to put them all over Nikki's lawn for his birthday surprise——yeah!!!

Now I get to focus on Jim, a psychologist from San Francisco, who specializes in working with these bigwig CEOs. You know those guys have some gnarly issues, considering the amount of shit that weighs on their shoulders.

Jim seems so centered, too. Like he's really living his life to the fullest——as if he's lived though some epic things, all leading up to this moment, where he is about to celebrate his still-successful marriage by getting his wife's portrait tattooed. It's his first tattoo.

Jim had been thinking about bringing me a gift, but at the last minute, he changed his mind, afraid that I wouldn't accept his token of appreciation.

The gift he had in mind was a ribbon that Janis Joplin had worn. He knew her back in the day, and was telling me about the time she untied the ribbon from her hair and tied his hair into a ponytail on top of his head with it. Janis laughed and laughed at how silly it looked on Jim, he said, and he's kept that ribbon ever since, as a memento of their closeness. What a unique memory. I would have treasured that ribbon as a reminder of the beautiful exchange of energy that the ribbon symbolizes, back then——and now——much like the tattoo.

I hope Jim stays in touch. I really feel like I would learn from him.

---

December 19, 2008

Dear Kat,

I just wanted to tell you what a great experience I had with you on December 9th when you created my tattoo, and that I love it! I loved our conversation and getting to know you——you are an amazing and wonderful woman and a kindred spirit.

I noticed your key collection and I wish I had asked you why you collect old keys——I find them fascinating, too. Because of this, I am sending you the enclosed key as a gift. It comes from LÄCKÖ CASTLE, one of western Sweden's greatest tourist attractions, from the estate of an old local woman whose son had stolen it from the castle fifty years ago. She had kept it put away all these years because she was embarrassed. An antiquities expert evaluated the key; it was most likely made in 1571, making it about 437 years old. Holding the key in your hand and putting your fingers through the ring is a special experience, and I hope you enjoy it as much as I have. I have also enclosed an etching of the castle that the previous owner kept——perhaps to remind her that she needed to return it!!!

——Jim

FROM THE PRIVATE COLLECTIONS *of* KATHERINE VON DRACHENBERG

# ANTIQUE KEYS

# JEFFREE STAR

*and*

# UNCLE PHIL

### December 10, 2008

Jeffree brought his uncle Phil in with him today, and it was so cool to see them interact. This is a first for us——I've never met a family member of his before.

Today, Jeffree is filling up limited space on his left leg with a portrait of his father. He brought his dad's brother, who will also get a portrait of Jeffree's dad. But the tattoos are going to be based on different photos. Jeffree's image was taken in the 1970s——looks like it could've been on his father's high school prom night——the funny suit and bow tie made me wonder.

The man in Phil's photo seriously looked like a completely different person than the guy in Jeffree's image. Phil's photo showed a man with weather-beaten skin and yellow eyes, much older and heavier. But this is how Phil wants to remember his brother.

I don't know much about Jeffree's father, but I think he died when Jeffree was really young. And I know his alcoholism was to blame. This is the reason for Jeffree's sober lifestyle.

The particular photo Jeffree chose for his tattoo had been taken during his dad's prom night.

By the looks of the ruffled shirt and swanky hairdo, I assume it was taken sometime in the '70s. Jeffree loved how young and happy his dad looked then, and said he wanted to remember him when he was at his best, instead of during his sad last days.

Phil's reference contrasted Jeffree's so much. It was as if I was doing a portrait of a completely different person. Phil had taken this photo himself shortly before his brother passed away and felt that even though the aftermath of years of alcohol abuse had taken a toll on his brother's features, that's how he remembered him.

Watching Phil's reaction to the final tattoo caught me off guard, since I was somewhat taken in by his tough-guy persona. But his struggle to hold back his tears and his long hug really hit home. Both J. Star and Phil bonded today, and when I read the guest book after they left, I was touched even more.

> " LOVE MANY. TRUST FEW. DO WRONG TO NO ONE.
> —PHIL STEININGER "

*Jeffree Star - today was the first day that I've ever felt closure with my father — thank you for that love always, tous Star*

# Nikki's Birthday Party

## December 11, 2008

WOW. From beginning to end—everything went as planned! Nikki's "Happy Birthday" serenade from the mariachi band this morning was the perfect way to catapult him into the birthday extravaganza! At 6 A.M., the kids were mischievously giggling and whispering as we woke their father up with a complete mariachi ensemble, trumpets and all! After getting over the initial shock at his loud awakening, Nikki kissed them all and headed downstairs to discover a flock of pink flamingos[16] fanned out across his entire front yard!

Before we could finish laughing hysterically at the sight, Jack-O[17] brought out a cake, complete with candles. During our birthday cake breakfast I handed him The Book, and like a kid on Christmas Eve, Nikki tore away the wrapping and began reading the first few pages. Tears rose in his eyes——the kind that let all of us know that at that very moment he felt loved.

Leaving him to enjoy the rest of his birthday morning basking in the adoration of his kids, I jetted down the highway to ensure that everything was going as planned in Hollywood at the newly remodeled Boardners. Much to my surprise, it was, which put me at ease. Finally, I would have time to make my dress and headpiece. That was the only thing that I was running behind on, but it wasn't anything a little bit of gold spray paint couldn't fix!

With everything set in place, I pulled myself together——just in time for Nikki and the family to arrive at the Castle[18] to pick me up.

From the minute we arrived, it was all hugs and birthday wishes to Nikki in a whirlwind of black and gold[19] action everywhere you looked! People were buzzing in and out of the "confessional booth,"[20] leaving behind birthday wishes for him. The Lucent Dossier[21] troupe was awesome: the aerialists spun gracefully above our heads, while the dancers breathed fire to light the place up.

When the DJ turned off the music, people began to stop talking and dancing——then silence took over the room. Everyone looked around, wondering what was about to take place——and sure enough it was cake time. But before Nikki could blow out the candles, we were surrounded by choral singers[22] in full choir attire, belting out a customized birthday song just for Nikki. Then the cake was ushered onto center stage, where Nikki, along with the help of Stormie, blew out all fifty candles!

What a wonderful introduction for Ali Helnwein and the players to take center stage and fill the room with the beautiful sounds of Nikki's music, everything from "Shout at the Devil" to "Home Sweet Home," all done in classical form, but with Ali's dark touch. The portrait of Nikki that Kevin worked on till the eleventh hour made for the perfect background to all of this.

## NIKKI WAS BLOWN AWAY!!!

I looked over at Rhian, and she winked at me. Translation: "We did it!"

In the end, my favorite moment was when Gunner took me aside to thank me for making his father's birthday wonderful.

It was sensory overload to say the least. Nikki will have to open his presents tomorrow morning when he's recharged with enough energy to be floored by the Hans Memling I got him!

All in all, it was the perfect tribute for the man I love.

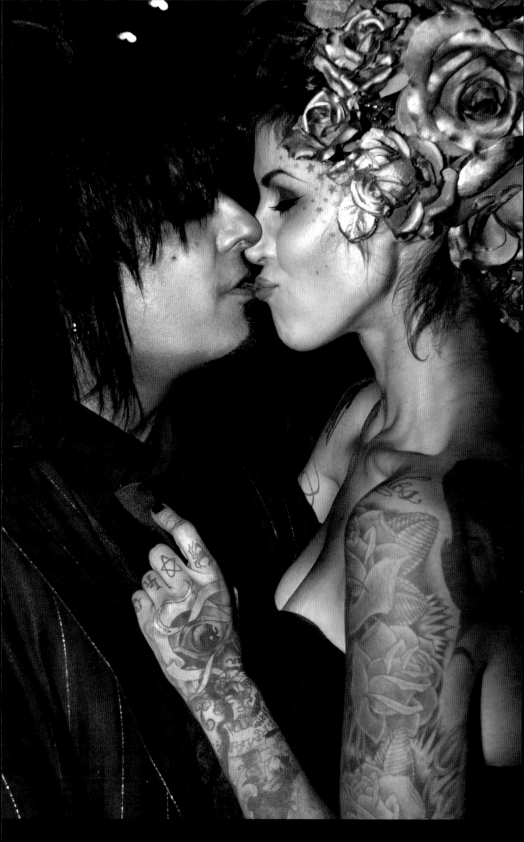

MICHAEL HUSSAR, JEFF WARD, AND DENNIS HALBRITTER HAD ALL VOLUNTEERED TO INSTALL FIFTY PINK FLAMINGOS THROUGHOUT FRONT YARD OF NIKKI'S HOUSE. 17 JACK-O IS NIKKI'S LONGTIME NANNY. 18 MY HOUSE IS A SMALL CASTLE THAT WAS INALLY BUILT FOR A 1931 FILM. 19 BLACK AND GOLD COCKTAIL ATTIRE WAS A MUST! AND AS MUCH AS THE LADIES LOVED THE OF INCORPORATING A GOLD THEME INTO THEIR OUTFITS, THE MEN ALL SEEMED TO HAVE PURCHASED THE SAME GOLD TIE FROM PARTMENT STORE! ALL EXCEPT GREG SIEBEL, WHO SPORTED A HEAD-TO-TOE GOLD LAMÉ FITTED SUIT! 20 AARON KRUMMEL ERA) AND JOHN AUSTIN (AUDIO) WORKED WITH ME TO BUILD A CONFESSIONAL BOOTH WHERE GUESTS COULD SIT INSIDE AND NIKKI A "BIRTHDAY CONFESSION." THE CONFESSIONS WERE ALL TAPED AND LATER CUT AND EDITED INTO A DVD FOR NIKKI. HE LUCENT DOSSIER EXPERIENCE CREATES WILD, FANTASTICAL ENVIRONMENTS AT PARTIES AND EVENTS WITH A WILD RANGE OF ORMANCE ARTISTS. 22 THE H. B. BARNUM'S LIFE CHOIR.

DECEMBER 14, 2008

TODAY IS THE SHOP'S XMAS BBQ-GIFT EXCHANGE-HOUSEWARMING PARTY
AT THE CASTLE. I INVITED NIKKI—AND HIS KIDS, OF COURSE. I THOUGHT
THEY WOULD GET A KICK OUT OF THIS HOUSE, BUT HE DIDN'T SHOW UP.
OUR FIGHT LAST NIGHT WAS OUR BIGGEST. MAYBE IT SHOULD BE OUR LAST.
I HAVE NO IDEA HOW TO EXPLAIN HOW IT IS THAT WE GOT HERE. EVERY
TIME IT SEEMS LIKE WE'RE THROUGH WITH THE FIGHTING, THE CRYING, THE
HURTING, SOMETHING HAPPENS—IT'S PUSHING ME OVER THE EDGE.
SO NOW THERE ARE FIFTY PEOPLE IN MY HOUSE ENJOYING THEMSELVES,
WHILE I'M STUCK HERE IN MY BEDROOM WRITING IN THIS FUCKING JOURNAL.
I DON'T THINK THERE'S A LOWER POINT I COULD HIT FROM HERE.
HE SAID HE WANTS TO TALK TO ME—WRITE DOWN THE LIST OF THINGS
HE FEELS HAVE BEEN AN ISSUE BETWEEN US. BUT THE LAST TIME WE
SPOKE TODAY HE SAID HE MAY JUST NOT BE THE GUY FOR ME—SAD TO
SAY, I THINK HE'S RIGHT. AS MUCH AS I WANT TO BELIEVE HIM TO BE MY
MATCH—LIKE IT FELT WHEN WE WERE FIRST DATING—
I THINK I'D BE LYING TO MYSELF.
HIS VOICE IS SO DISTANT—THE WALLS HIGHER THAN EVER BEFORE. HE
SAID HE THINKS HE'S JUST NOT ENOUGH FOR ME, THAT HE'S NOT GOOD
ENOUGH. ISN'T THAT WHAT PEOPLE SAY WHEN THEY WANT TO BREAK UP
AND DON'T WANT TO HURT YOUR FEELINGS?
I WISH I WAS CRYING WOLF, BUT I THINK I MAY HAVE LOST HIM THIS
TIME. NOW, IT'S JUST A QUESTION OF WHETHER
WE'LL STEP UP TO THE PLATE AND CALL IT QUITS.
I CAN'T COME TO TERMS WITH THE FACT THAT AT ONE POINT I KNEW HE
WAS THE ONE—HE REALLY WAS. HE USED TO WANT ME
AND DREAM OF ME—CONSTANTLY KISS ME.
HIS AGE HAD NEVER BEEN AN ISSUE FOR US—AND SOMEHOW
IT COMES UP—ESPECIALLY IN THESE FUCKING ARGUMENTS.
HE'S FIFTY. WHAT'S THE PROBLEM?
MAN . . . NO BACKUP PLAN THIS TIME—OR MAYBE I DO. ICELAND IS
SOUNDING MIGHTY NICE AT THE MOMENT. FUCK FIJI. FUCK PRAGUE. MAYBE
WE BREAK UP, MAYBE THE SHOW GETS CANCELED—
MAYBE I SHOULD LOOK INTO THAT.

# JULIAN GUY

December 15, 2008

This was Julian's first time to Los Angeles——he came to see me all the way from the UK. I'm trying to leave my problems with Nikki at the door and really focus my energy on this tattoo.

Julian is a new father, and he has come to honor his relationship with his own mother, who passed away two years ago. He came alone. His wife, Louise, has stayed behind to watch over their two-month-old baby, Lucius. That's one of the coolest names I've heard in a long time:

## LUCIUS.

### SOUNDS LIKE ROMAN ROYALTY!

I fell in love with the photograph that he brought as soon as I saw it: Julian as a baby boy being held by his mother. Ever since he lost her, to lung cancer, Julian has wanted this tattoo. I can see why. The image is so loving and nurturing. Both Julian and his mom's eyes are focused on something outside the camera——it's almost as if they're staring into the future. Julian's mother was a

## NATURAL BEAUTY—

with a strong face, lost in thought. Julian told me what an empowering woman she was, full of ideas and opinions, and I believed him.

This tattoo ended up taking up a majority of his forearm. We framed both the top and bottom with

## Filigree Accents.

We had plenty of time to talk, and when I asked about his mother, he was happy to speak about her and his love for her. He described an extremely healthy person——a vegetarian who exercised and never smoked, which made the lung cancer even tougher to understand.

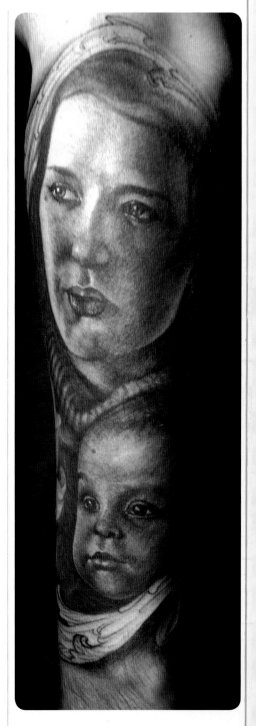

# JIM ROTA

## (FIREBALL MINISTRY)

### December 16, 2008

Jim Rota has such a great mind. Outwardly, he looks like this biker dude, always wearing his leather vest——even to weddings! But inside, he's so compassionate. I end up venting to him in one form or another when I tattoo him. Nikki and I have really been going through the ringer lately, and I haven't really talked to anyone about the whole thing. It's like all of these emotions I've been having——feeling like there's been a loss of love in the relationship——have made Nikki pull away from me. I'm always trying to work my shit out on my own, but it's so damn easy to talk with Jim. As much as I know I shouldn't share some of my personal shit with people, I can't help myself with him.

While I was finishing up some shading on his arm, we got serious. Karoline was working in her office, within earshot, and after hearing Jim and I dive into some of the serious issues Nikki and I have been having, Karoline said, "How 'bout those Dodgers, eh?"

Clearly insinuating that I've said too much—— and it pissed me off.

"What the fuck is that supposed to mean?" I asked. She rolled her eyes at me.

The situation was awkward to say the least. Jim and I stopped talking——for a second anyway. Then Jim began to tell me about how and why his relationship with his ex-wife ended. Being married, being in a band together——basically always being together pretty much took the life out of the relationship.

Now that he is dating Melinda, it gets tricky when he wants to stay in his creative zone with his buddies when they're in the studio working on a new project. But if he's working on his music, that can be a problem after Melinda comes home from a long day at work. And naturally, she wants to have "Jim time."

That can easily turn into resentment unless both people work to balance it, and it doesn't take a rocket scientist to figure that one out.

My session with Jim really made me rethink some of the situations with Nikki that I've overreacted to. I don't want Nikki stopping what it is he's creatively hopped-up on to be with me.

**I DON'T WANT NIKKI TO EVER RESENT ME.**

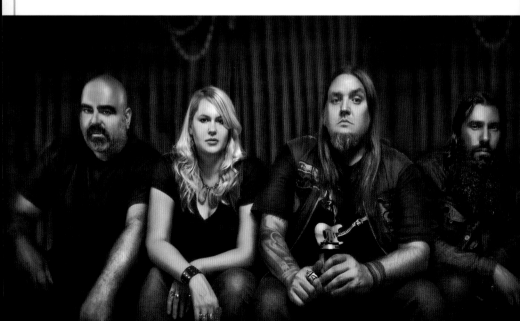

DECEMBER 17, 2008

NIKKI DOESN'T WANT TO GO TO PRAGUE. I GUESS HE'S
HAD A CHANGE OF HEART. HE TOLD ME, "THE LAST
THING I WANT TO DO RIGHT NOW IS GET ON A PLANE
AND FLY ANYWHERE."

———————————

AWESOME. MIGHTA BEEN GOOD TO KNOW THAT BEFORE
GOING THROUGH ALL THE TROUBLE OF BOOKING FLIGHTS
AND HOTELS. BEFORE ALL OF THIS EMOTIONAL
INVESTING.

———————————

MAYBE I SHOULD GO ANYWAY. I LIKE FLYING SOLO.
I'M GOOD AT IT. I'VE HAD A LOT OF PRACTICE.
HMM. ALONE ON CHRISTMAS IN PRAGUE, WISHING MY
BOYFRIEND WANTED TO BE THERE WITH ME. FOR SOME
REASON, THAT DOESN'T SOUND LIKE AN "AWESOME"
VACATION ANYMORE . . .

———————————

BETTER IDEA: LET'S JUST BOOK THOSE TEN DAYS
SOLID WITH TATTOOS—I WANNA GET LOST IN WORK.

## December 18, 2008

I n bed at the Castle—alone again, but it's all right. After the evening I had at Nikki's, I actually looked forward to coming home to Ludwig, my bed, and my journal.

Nikki's at his house, of course. And I know three of the kids went with their mom to Mexico, and his youngest daughter will be leaving tomorrow as well to spend this year's holiday with her mom. I know how much this bums Nikki out, and how much he values his time with them, so I wanted to give him his space so he could give them his full attention. I had a bag full of things to do—journals, laptop, the Edward Steichen photography book Jeff gave me—so I could just hang out and Nikki could have one-on-one time with his little girl before she went to sleep. But I was also looking forward to spending some quiet time with him, especially with all of the tension surrounding our trip to Prague. I even made sure I was looking extra-cute—try to dazzle him maybe . . .

Upon arrival, I could tell by the sound of the television upstairs that he and his daughter were watching a movie. I put my stuff down on the kitchen table and made my way upstairs to say hello. They were in the middle of watching *Mamma Mia!*, so I politely told him I'd be downstairs.

Finally, when he came down, he was uninterested in anything having to do with me, and slumped into a chair. It was so clear that my presence irked him. At no time did he even mention anything about the way I looked.

We've been at our worst this month—and the confusion is beginning to be replaced with—shit, I dunno.

Whatever it is, it ain't good.

We've been failing to get back to the "good ol' days"—back when we were "happy." He seems so drained—so defeated. And as much as I know he loves me, talk about breaking up has been coming up more often. I guess it's safe to say Prague is officially canceled. As much as I need the break and as much as I truly believe our relationship needs it, too, it ain't happenin'. Maybe next year.

But why am I so determined to not give up on us? I just don't think calling it quits is what my heart wants.

Without him even saying it, I can tell he hasn't been all that into me coming over the past few nights. And regardless, I've been making the trek out there, F I G H T I N G the exhausting traffic after my equally rigorous hours at work. For me, it's important to try to spend time together as a couple, even if it's just sleeping next to each other. I've been doing all of the driving in this relationship. And it's not so much the drive that's the problem. It's the way it makes me feel when I'm making most of the effort. I started thinking if I were to stop going out there every day after work,

I just don't think I'd see Nikki at all, to be honest. This makes me feel unimportant. It's been quite the struggle keeping positive when he says things like, "Everyone hates me," "I'm not good enough," "I ruined Christmas . . ."

I was determined to help Nikki turn it around—replying only with words of encouragement, love, and support. All of which he quickly knocked down with what seems to me is just indulgent self-pity. I really think that's where I go wrong—the only person that can turn Nikki's feelings around is Nikki—not me.

### SMILE. DEEP BREATH.

Without making things any more awkward or forced than they already were, I told him I just came by to say hello—and will leave now to give him his space.

I should have trusted my gut instinct and just stayed home.

I sucked it up, got in my car, and bawled my eyes out the entire drive home.

Now I should try getting some sleep, considering how important my morning meeting with two of the world's largest perfume houses is gonna be.

## December 19, 2008

Somehow I woke up this morning feeling positive. I spent four hours at the perfume meeting, sat in more traffic to make it back to the shop in time to film, and by the end of the day I felt like I

# KICKED MAJOR ASS.

*That I Did.*

---

Kirk texted me earlier this morning inviting me to the final Metallica show tonight at the Forum. I'd never seen Metallica live, and I definitely needed to get out and do SOMETHING fun, so I took him up on his offer. By the time Rhian and I made it down to the arena to meet up with Kerry, Ayesha, Stu, Kristen, and Rita, there was only four or five songs left of the set. And it was fucking amazing! Two hundred thousand people all there having just as good of a time as I was.

---

I ran into Darren, Nikki's bass tech, so it wasn't long before I started getting the guilt-trip texts from Nikki. There was no way he could bring me down tonight——I wasn't gonna let that happen, I was determined to stay positive. I can't believe I stayed the entire remainder of the show! When's the last time I got to do that? Afterward, we socialized backstage

# AND LAUGHED A WHOLE LOT.

I so needed this. Tonight, I felt fun for the first time in a long time. AND MAYBE EVEN A LITTLE SEXY,

# TOO!

---

| F1218 | LOG 9 | R | 6 | COMP | EF1218 |
|---|---|---|---|---|---|
| EVENT CODE | SECTION/AISLE | ROW/BOX | SEAT | ADMISSION | EVENT CODE |
| $ 0.00 | LOGE | EAST | | 0.00 | CN 07728 |
| | | KROQ PRESENTS | | | PP 181 |
| SECTION/AISLE | | | | | SEC |
| LOG 9 | | METALLICA | | | LOG 9 |
| PP 13X | | WWW.METALLICA.COM | | | 429FOR |
| ROW SEAT | | | | | ROW |
| R 6 | | THE FORUM | | | R |
| 429CFOR | | NO RECORDERS/AUDIO/VIDEO | | | C 0.00 |
| 17DEC08 | | THU DEC 18 2008 7:00 PM | | | 6 |

ticketmaster

get tickets at ticketmaster.com

7850925533108

December 20, 2008

# I HAD A LONG TALK WITH RHIAN TONIGHT.

I was so desperate to try to figure out what it is I'm obviously doing wrong in this relationship. I tried to be as unbiased as possible as I conveyed our litany of troubles we've run into time and time again. And I tried to make Rhian understand how the accumulative "little things" had been making me feel so damn neglected, really. It didn't take a fool to see how much of a communication breakdown has been taking place between Nikki and me. I knew that the fights we've been having are wearing him the fuck out. And this hasn't made me feel all too willing to share with him when I am having these feelings. It's like, if I were to bring my problems to his attention, he would instantly get on the defense——and too paranoid to start another argument, I started to really bottle up these feelings. This is the feeling of loneliness that's hard to explain. And Nikki looked at me like I was crazy when I told him about it. "I don't understand how you feel alone," he had said, looking at me like I was a freak for feeling this way. Why couldn't he have just held me, and reassured me that I wasn't alone——instead of pushing me even further away?

After she listened patiently in my kitchen, she had me write down a list of thoughts to keep in mind when it comes to the relationship. She strongly suggested that once my thoughts were organized, I should share them with Nikki. Rhian and I came up with this.

## IN ORDER TO MAKE MY RELATIONSHIP WITH NIKKI WORK:

### I.

I need to understand that parents should be home every night and see their kids go to bed in order to have a stable and healthy household——therefore in order to see Nikki I should spend four nights a week at his house. I need to accept that Nikki has love for me, but not the time for me. UNLESS, I go over there four nights per week.

### II.

We should set aside official "date nights" and plan on returning home to the kids after.

### III.

I need to recognize my role in Nikki's life and his kids' lives. If the shoe was on the other foot, and I was a single mom, I'd be going home every night, and if I decided to introduce a man I was dating to the kids, he would automatically become somewhat of a father figure, whether I liked it or not. If I'm not present, that's the role I'm creating. If I want to be more present, I need to be more involved with his kids. Nikki has never had a "mom" role in his life, but I have, and I understand that by not committing to his kids, I have not committed to him.

### IV.

If I continue the mindset of "I just want a boyfriend," that is a virtual impossibility. If I just wanna be his "girlfriend," then I'll have to settle for crumbs in perpetuity——the solution is to jump in with both feet.

### V.

BOTH of our families are equally important and should be equally involved and invited to events, like Thanksgiving, Christmas.

# THE GOOD NEWS:

there is no loss of love between us. This, Rhian said, is apparent.
Then she asked the important question here: are you ready?
Well, am I ready?

She's right. This is a decision that I could be very well dealing with the rest of my life with Nikki. And even though it sounded like a whole lot to take in, I felt as if a load had been lifted once we broke it down that way. A solution didn't seem so unattainable. Now it's a matter of sharing this with him and hopefully moving forward.

## December 21, 2008

Talking to Nikki this morning was the best thing I could have ever done. Rhian's suggestion to share my collected thoughts made it easy to relate all the things that have been bothering me and also admit all the things that I was doing that weren't helping our situation.

I was obviously being far too emotional than I needed to be, taking everything so goddamn personally. If Nikki was too tired to make an effort to come out to my place, then maybe it's simply just that. It doesn't mean that he loves me any less. My overanalytical mind makes it hard not to overthink such unimportant things. If Nikki finds himself inspired by a

# PHOTO SHOOT

and forgets to call, that doesn't mean I am no longer fascinating to him. When things don't feel as romantic as they used to, maybe that means that we are growing comfortable in a good way, and doesn't mean we are growing apart. A lot of the way I handle things has a lot to do with perspective.

## NIKKI WAS SO RECEPTIVE,

and he told me I blew his mind with my changed perspective on the entire matter. He admitted to feeling a bit suffocated, not just by me, but by all the people around him.

I told him I thought it was immature on my part to have expected a fairytale ROMANCE of a RELATIONSHIP. To be honest, when I really break it down I can see how much I don't even want that.

# I WANT A RELATIONSHIP
## WHERE WE CAN GROW TOGETHER AND MATURE.

It took a lot for me to push aside my pride and admit the way I was handling things wasn't the healthiest.

Nikki and I decided this year for

# CHRISTMAS

we would exchange letters from one another instead of doing the whole extravagant presents thing. I love reading the things he writes. We usually read to each other from our journals,

and I think taking the time to write something heartfelt to one another and read it on Christmas was going to be the best gift and a great way to start over. Prague isn't going anywhere and neither is

# NIKKI.

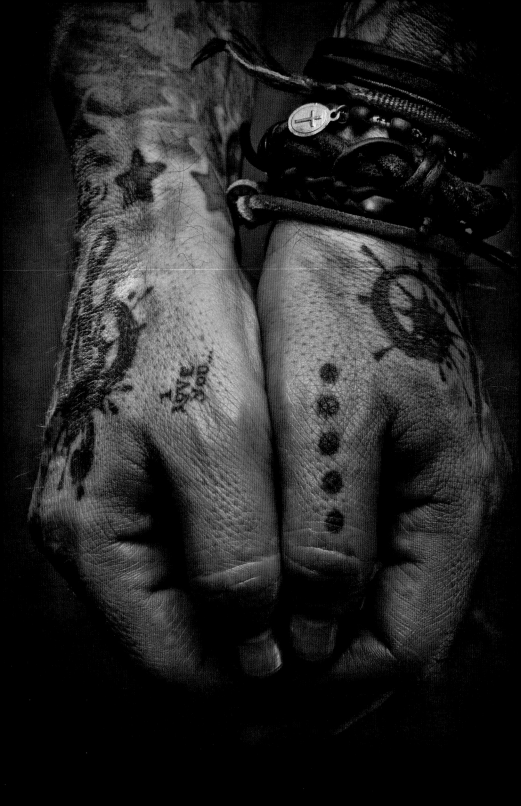

# Christmas Day, 2008

## CHRISTMAS LETTER FROM NIKKI

**DEAR KATHERINE,**

So I sit here on Xmas Eve, the house is empty (Mochi and Fluffers don't count). The fire is crackling at my feet, and of course I'm thinking of you. I say of course, because that's what I do, I think of you, all the time.

It seems like years ago that we first met eye to eye, even longer since we first started texting, years all rolled into a blink of an eye. A wonderful journey it's become, and continues to be. Yet. And I do say yet, it seems to have blown by so fast. Wasn't it just yesterday that we were getting all giddy about the thought of posting a picture of us together online? Santa Barbara, room five? Tattooing in that hotel while you were on the vampire movie set? And all the sea horses in the ocean?

Do you remember our first kiss??? I do. I think of it. Sometimes I can feel it, so warm that first embrace, the butterflies, the first thoughts of love . . . Wow, it's all I can say, fucking wow, babe. You've changed my life, for the better, no matter what. I grow from knowing you. I love from knowing you, and I live better from knowing you . . . I wonder sometimes if you know how much I feel love when I love you? It must be hard to imagine so much love, I can't even put it into words . . . The words (I love you), sound too plain, too short, too little, yet I haven't found bigger words . . . So I say it, over and over to you. Maybe that will make the words bigger? Like when I type in all caps. Hahahaha . . .

You have turned me on in so many ways, in my heart and my body, but also my mind. All the art we discuss turns me on, not unlike your smile, and your body. We are amazing together, nothing compares to us together, we have the power to move mountains together, but the only thing I want to move is your heart. I want to make it jump, and skip a beat every day. I want you to feel me, my heart. I want you to know, how much I loveeee youuuu.

This is our first Xmas together, it won't be our last. Someday, this too will seem like it was years ago and at the same time, went by in the blink of an eye, a flash of light . . . And I want it to be known that (that flash in the sky was my love for you, Katherine) . . . I do so love you.

MERRY XMAS, MY LOVE.

NIKKI, 2008

DECEMBER 31, 2008

EVERY MORNING NIKKI TAKES THE KIDS TO SCHOOL. THERE'S A
WOODEN SIGN ON THE GRASSY HILL AT THE END OF THE STREET,
AND NO ONE KNOWS WHY THERE ARE FOUR DOTS PAINTED ON THE
SIGN. AT ONE POINT, ONE OF THE KIDS MADE A RULE THAT IF YOU
LOOK AT THE FOUR DOTS WHEN YOU'RE STOPPED AT THE LIGHT, YOU
WOULD GO BLIND. THE NEXT THING YOU KNEW, NIKKI STARTED TO
REFER TO HIS FOUR KIDS AS FOUR DOTS, EVENTUALLY INSPIRING
HIM TO GET FOUR DOTS TATTOOED ON HIS HAND DURING ONE OF HIS
BREAKS FROM TOUR. TODAY, NIKKI WANTED TO GET THE FIFTH DOT
ADDED TO THE ALREADY EXISTING FOUR ON HIS HAND. THE FIRST
FOUR DOTS OBVIOUSLY REPRESENTED THE KIDS, BUT THE FIFTH
REPRESENTS JACK-O, WHO HAS DEFINITELY EARNED HER PLACE IN
NIKKI'S HEART. COINCIDENTALLY, JACK-O HAD SECRETLY GOTTEN ALL
FOUR KIDS' INITIALS, G, S, D, F AND AN N FOR NIKKI TATTOOED
ON HER HIP IN HOPES OF SURPRISING NIKKI. I WAS BLOWN AWAY,
BECAUSE NOT ONLY WAS THIS A GESTURE OF DEDICATION TO THE
FAMILY, BUT IT WAS JACK-O'S FIRST AND ONLY TATTOO! SHE DOESN'T
KNOW HE'S DOING THIS FOR HER TODAY, AND I CAN'T WAIT FOR HIM TO
SHOW HER. SHE'S GOING TO FLIP OUT FOR SURE.
IT FELT SO GOOD TO TATTOO NIKKI—IT FEELS AS IF WE ARE FALLING
IN LOVE ALL OVER AGAIN—I THINK THE CONVERSATION I HAD WITH
RHIAN REALLY HELPED. AND EVERY TIME I'M ABLE TO GET SOME
ALONE TIME WITH NIKKI AND TATTOO HIM, IT BRINGS US SO MUCH
CLOSER TO EACH OTHER.
AS WE START THIS NEW YEAR, I WANT TO STOP WASTING TIME. I WANT
TO START LETTING MYSELF BE HAPPY, AND HAPPY WITH NIKKI—AND
GET BACK TO HOW WE USED TO BE.
THAT'S ALL I WANT.

BLOOD BOOK

I

January

MMIX

# Robert Carito

## January 3, 2009

Robert flew in from New York to get a tattoo of Sisyphus on his chest. For Robert, the story of Sisyphus is a metaphor for life's constant, never-ending struggle.

---

Robert's outlook on life was so inspiring. We were discussing the comments made by the Pope comparing homosexuals to terrorists in his recent speech——it's unbelievable. What the fuck is wrong with humanity?

---

I thought Robert's heartening response was amazing, especially considering that he himself is Catholic——and gay. He said, "I forgive him not because he deserves it, but because that's what my God teaches me to do."

*Beautiful.*

# RYAN WILGUS

## January 5, 2009

You can't find a sweeter guy than Ryan. Last month, he drove out from Vegas to get a portrait of his father. Today, we're adding his mother. He's been waiting to complete both portraits before revealing them to his parents——what an awesome surprise!

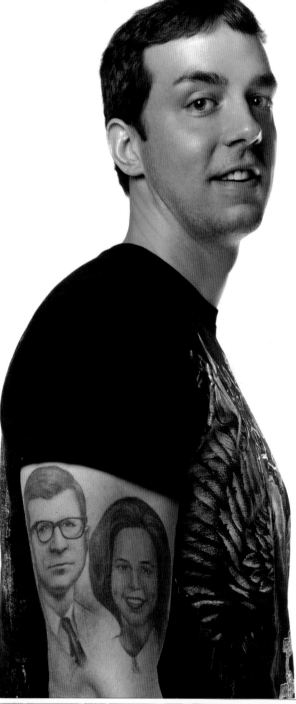

# KAROLINE'S BIRTHDAY

## January 8, 2009

Tonight I'm taking Karoline to the Magic Castle for a birthday party for our immediate family——Nikki and me, Dad and Sharon, Michael and his girlfriend, and her close friend Asylum. You really have to be a member to go there, but Frank Iero from My Chemical Romance is a magician as well as a musician, so he got us in. The party is going to be in the Houdini Room, where they have Halloween séances to contact Houdini. Tonight, though, we're going to have a private dinner and watch a magic show. I'm so excited to give her her present——I got her every board game we used to play together, from Scrabble to Candyland.

# ☠ Lemmy ☠
# KILMISTER

## (Motörhead)

### January 10, 2009

Earlier today, I got a text from Lemmy asking if I could squeeze him in for a tattoo session tonight. He said he was happy with the outcome of the last tattoo we touched up on his arm, and was looking forward to giving the tattoo on his other arm an update as well. I was looking forward to spending time with him off camera, unlike the last time, when I tattooed him for the show.

He had just returned from touring, and I was desperate for human interaction with someone I could relate to, so I agreed to work on him.

If someone had been keeping tabs, Lemmy would've scored the most "cool points" with me tonight. It feels like I haven't had any kind of stimulating conversation with anyone in a long while. He referenced half of my favorite authors——Poe, Bukowski, Lovecraft——during our conversations, and really impressed me with his vast knowledge of **LATIN TERMINOLOGY AND WORLD WAR II FACTS**.

Fascinated by the collection of oddities in my office, Lemmy strongly urged me to one day visit his place, convinced I'll be blown away by his collection of "stuff."

I don't doubt how impressive it possibly is for one second, but tonight, after his tattoo was complete, we aimed for the Rainbow instead and landed there in perfect time to grab a quick bite to eat before my trek to Nikki's. He'll probably be sleeping by the time I get there, and I'll miss our usual reading session before goin' to bed. But that's okay——those books aren't goin' anywhere.

# BOOKWORMS,
the two of us. My newfound hunger for informative self-help literature

was something that I can only blame Nikki for. It all started with *The Four Agreements* by Don Miguel Ruiz. On a drive back to his place, I noticed he had the audiobook playing in his car. I ended up reading not only *The Four Agreements* but also the rest of the library of these wisdom books by the same author. Reading the same books, whether on our own or together in bed, quickly became one of our fave pastimes.

Next was Ruiz's *The Mastery of Love*. We each had our own copy and still would take turns reading chapter after chapter together, jotting down key notes pertaining to our own individual problems, highlighting sentences or quotes that really spoke to us, and later talking and reflecting.

One night, at the end of one of these "reading sessions," we laughed together, saying, "God! If fans knew how nerdy we were, **THEY PROBABLY WOULDN'T THINK THIS WAS VERY ROCK 'N' ROLL, WOULD THEY?!**"

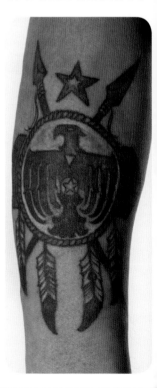

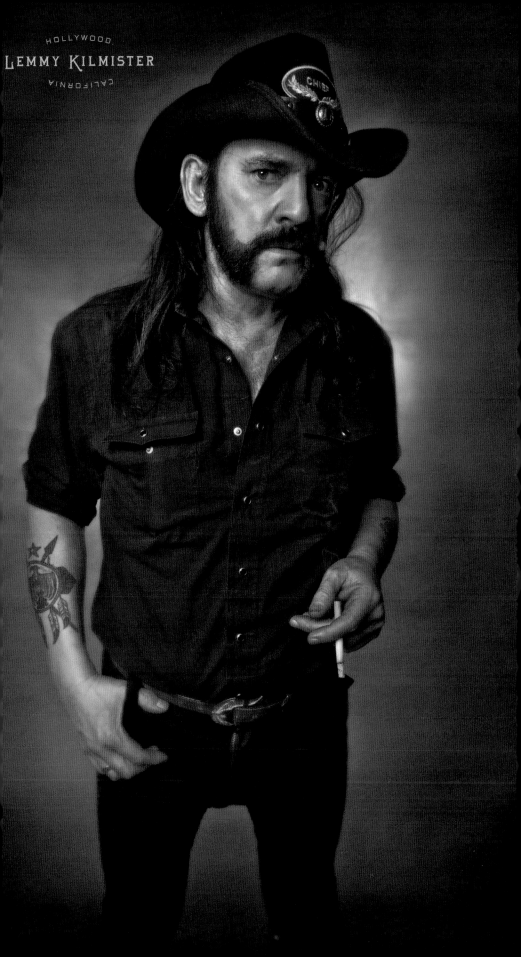

# Caleb Followill

## (KINGS OF LEON)

### January 13, 2009

Earlier this week, Brent Bolthouse set me up with Caleb to tattoo him before he starts touring this month. After much texting back and forth with Caleb, we were able to narrow down what he wanted.

Like many people, Caleb and his brother made the mistake of getting a drunken drive-by tattoo when Caleb was sixteen. But it was an easy fix. What was once a much clearer tribalesque lizard on his left shoulder is now cleaned up. I did a freehand Sharpie sketch of roses to set the stage for a successful cover-up on Caleb's old tattoo.

# GLEN BARNES

### January 14, 2009

Matt Skiba and Danny Lohner came by for a quick visit, which gave me the perfect chance to show Danny the Edgar Allan Poe painting that has recently taken up most of my interest, let alone any spare second I've had. I'm just a few coats of glaze away from finishing my first official oil painting. Danny is over the moon about it. Dealing with the recent death of his mother hasn't been the easiest thing for him, so I was happy to see the Poe painting bring a real smile to my neighbor's face.

Although I don't yet know Danny all that well, considering I just moved into his neighborhood, I have a pretty good feeling about him

and could tell by the incessant flow of conversation that Danny and I were gonna be good friends.

Anyhow, our chatting session was cut short by my final appointment of the evening: Glen Barnes and his soon-to-be son-in-law. Before I could stretch my hand out to introduce myself, he asked for a hug and turned down the handshake. Awkwardly, and in front of Matt and Danny, I hesitantly but quickly gave Glen the coldest hug imaginable. It wasn't because I dislike hugs——or even dislike touching people——quite the contrary. I consider myself a highly affectionate person, hugs being one of my favorite exchanges of energies.

It's just that much scarier for me to hug a client prior to getting to know them. The overly assertive mannerisms of Glen, although unintentional, came off as a warning sign. I assumed I had already started to disappoint Glen, beginning the process of dashing a fan's preconceived fantasies about me. Even though I know all of these assumptions are probably just in my head, it can be hard for me to ignore those feelings. That's usually when my anxiety kicks in.

---

Matt and Danny decided this was the perfect time to exit the scene, and I started the set-up process for Glen. Lemmy was very adamant about giving me a "gift" prior to my departure on my **BOOK TOUR—** and tonight was that night where I promised I'd come over. So there was no room for dillydallying on my final tattoo of the day. I had

up Glen's portrait tattoo earlier that day, and the stencil was placed

were all mourning their loss——each handling it so differently.

His death had been fairly recent——the result of a terrible car accident. One day, after school, Dalton asked his father about the Jewish religion. A friend at school had invited him to temple, and like most curious kids, he wondered what it was all about and wanted to go. He insured his father that in no way was he turning his back on his Christian beliefs.

Glen said he felt hesitant about approving his son's request, but after talking with the other parents, and arranging a ride to and from temple, he allowed it. The parents had promised to bring his son back in one piece; something none of them even fathomed would backfire.

Glen would have gladly given the boy a ride if he hadn't already had obligations to his sheriff duties that evening. So off they went, and different to what had been promised, the boys were driven back by his friend's older brother, who had just turned sixteen years old that week and had just acquired his

DRIVING PERMIT.

The boy went too fast around a corner, like I'm sure many of us have done during those first weeks behind the wheel. But this corner got the best of them, catapulting the vehicle, along with the three boys inside of it, into the side of a hill.

Back at Glen's house, a mother nervously waited for her son's return. They hadn't heard from a single soul as to the whereabouts of their son. Fortunately, or maybe unfortunately, working at the sheriff's department comes with certain benefits, and Glen heard about

just where I like it on my station so Glen and I could jump right into the tattoo.

The photo's simplicity was a clear indication that the tattoo would most likely not take much longer than an hour and a half if everything went as planned. Quickly I learned the young boy in the picture was Glen's deceased son,

DALTON.

I also gathered Glen was a sheriff. This detail made the gun he had been wearing on his hip just a tad bit less intimidating. But one thing that'll guarantee uneasiness on my end is a loaded gun, and despite his official status, I was much happier when Glen was thoughtful enough to place the gun across the room with the rest of his stuff after unloading it.

Tattooing chests makes the tattoo process so much more intimate.

(A) It forces artists' and clients' faces to be much closer than normal.

(B) You can speak lower since you're that close. I mean, you could whisper, and it wouldn't be a problem hearing each other.

(C) It forces me, as the artist, to hover over the client, who's lying down, so oftentimes elbows touch abdomens, arms touch other arms, and so on.

According to Glen, Dalton had been a happy, open-minded kid who had plenty of friends. Loved by everyone, at home, church, and school. He wasn't even in high school yet when he passed away. Glen, his wife, and Dalton's sister

the accident on the radio: "Three boys in near fatal accident off the 210 freeway. One of them pronounced dead."

Glen's heart immediately sank with the idea of the one dead boy being his son, but all the information given was that two of the victims were being helicoptered to the nearest hospital——and the

# UNLUCKY

one was given the code for the coroner. It didn't take much to do the math once Glen and his wife arrived at the hospital, finding the two boys who survived accompanied by their parents.

Glen paused, and then pointed to the gun across the room, asking, "You know how many times I wanted to put my mouth around that thing and pull the trigger?"

I couldn't even imagine that type of loss.

"Do you think having a daughter helped to keep you from doing something like that?" I replied.

Glen's honesty made me appreciate our conversation that much more. He told me how his wife of over two decades had a hard time with it. And after all those years, the death of a child could take the remaining feelings of love in the relationship——and dispose of it so easily. Resentment. Blaming. Reminders. I've heard about this kind of stuff breaking families apart.

## "YOU STILL IN LOVE?"

Glen tried to answer with a lie, probably what he has to do a majority of the time just to not deal with reality. Kinda like when someone asks you, "How are you?" and inside you know you wish you could disappear, but saying words like, "fine" or "pretty good" take a whole lot less energy. Before he could complete his autopilot answer about the loss of love in his marriage, he cut himself off and said, "Ya know what? No, we are not in love." And sometimes, those few words of truth can be liberating. I mean, rarely do people feel comfortable enough to truly be themselves, to call it how it really is——cry if they need to, accept the truth, and not be ashamed of it.

**BUT I THINK THAT'S THE THERAPEUTIC GIFT OF TATTOOING.** For the most part, people's tattoo process requires the input of no one else except themselves. Its final outcome benefits no one other than the person getting it. It's a completely indulgent form of pampering yourself in the most positive way possible.

But back to the idea of being in a marriage lacking the most important facet to a relationship: love. His heart spoke honestly when Glen acknowledged the loveless relationship his marriage had become after Dalton's death. They only wanted the best for one another, but fond regard and romantic, enduring love are two very different things. Their love did not survive their tragedy. When I try and put myself in their position, it's easy to see how those feelings might need to be erased. How difficult it must it be to look at each other's faces and not be reminded of him. How painful each milestone event must be——and their daughter's upcoming wedding will be one of those times. How hard is it for Glen to come to terms with the fact that at one point the idea of wrapping his lips around the barrel of that gun and pulling the trigger felt like the answer?

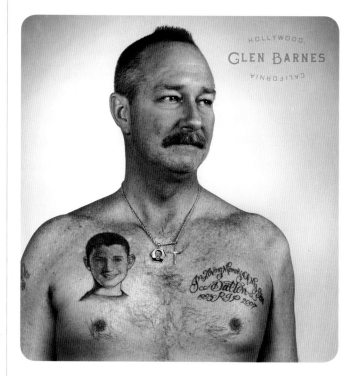

HOLLYWOOD
GLEN BARNES
CALIFORNIA

# KATIE FAULKNER

## January 17, 2009

Rewind to several months past. I DISTINCTLY REMEMBER A

# PORTRAIT OF A PRIEST

among the rest of the tattoo requests that had been stacked in piles on my desk. The vintage image, perfect in every way, was most likely from the 1940s or 1950s——and I knew I had to tattoo it. I must have added at least

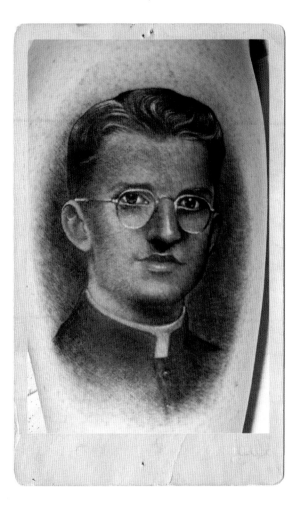

five stars to the approval, in hopes Karoline would call the client back and make it happen!

Fast-forward to today, and here it is! Katie flew from Seattle to get this black and gray portrait of the priest, who also happens to be her father.

———

Katie's an audiologist——an ear doc! How ironic that today she got tattooed by probably the world's most deaf tattooer.

———

I felt bad at the end of our session, when I realized I had monopolized a majority of our conversation with questions about hearing. My hearing has been rapidly worsening, particularly in my right ear, making every day just a little more frustrating than the day before. The doctors blame it on the constant buzzing from my tattoo machines being so close to my ear. They've also said that it's irreversible. I could wear earplugs or some kind of fancy "filters" custom-made to fit my ear——or not.

I opted for the not. I can't not listen to people; it's such a crucial part of my job.

———

Well, when the doc said it was irreversible, that was a few years back. Katie told me that an extensive amount of stem cell research had been done since then, and they may be onto something.

———

## HOW EXCITING!

What if I could hear a question asked from just a few feet away without having to say, "Pardon?" or looking up at the painting that looms over my station, Beethoven's giant smirk taunting me, as if to say that of course I'd be the one to become deaf, considering how much I love that deaf motherfucker!

———

## Meanwhile,

it's Dave Grohl's fortieth birthday party at Medieval Times tonight. I'm feeling pretty under the weather, so I guess there will be no jousting for me tonight.

———

## LORD KNOWS

I need the rest in order to feel 100 percent before my book tour for *High Voltage Tattoo* kicks off in Hollywood in five days! And my book goes on sale in

# THREE!

# JORGE ROBLEDO

## January 23, 2009

A few weeks have passed since our last session, and Jorge has returned, as punctual as last time and ready to finish this portrait of his father. I'm in town for only a couple of days——and I'm in the middle of the launch of my book, and I've got to get ready to head out on tour across the country with Nikki.[23]

Anyway, this was Jorge's second attempt at getting the portrait of his late father tattooed, and from what I gather, about two years ago Jorge got a poorly done rendition of this amazing photograph. But he wasn't happy with the result and covered it up with a Japanese-influenced half sleeve.

Today, it's my turn to attempt at doing the photo justice, this time on his chest. I can see how an in-experienced tattooer could have bitten off more than he could chew trying to tattoo this specific image. The lighting was challenging, and executing the tattoo too light or too dark would be pretty hard to avoid if you didn't know what you were doing.

That's the problem I've noticed with some of the overly ambitious new tattooers, who tend to take on portraits and end up messing them up. A pinup girl is one thing——a portrait of someone's family member is another. If a tattooer is off by just a few millimeters on the lips of a portrait, for instance, it changes everything. The final product will not translate if it is not as accurate as it should have been. I question the tattooers who would flatter themselves by taking on such a huge responsibility——because it is a huge responsibility. It is selfish to present yourself as someone with the capability to accurately transfer an image in hopes of "practicing" on someone. I remember always wanting to tattoo portraits and also knowing my limits as a tattooer, so I held off on taking on anything I couldn't do 100 percent right——and it sucked. I turned away lots of "fun" projects back then, sticking to practicing Gil Elvgren pinups until there was a clear resemblance between the artwork and tattoo. There was no gambling with taking on a pinup girl as opposed to a portrait of somebody's loved one. If you're off by that millimeter on the lips, the final outcome will still be recognized as a pinup girl.

Live and learn, I guess. Unfortunately, for folks like Jorge, he had to live and learn someone else's valuable lesson. Thankfully he was able to cover up the old tattoo.

It's a shame that Jorge's first attempt at getting

this tattoo was a disappointment, but I am glad that I had the chance to get to know him the second time around! Talking with him during these two sessions has been nothing short of fun!

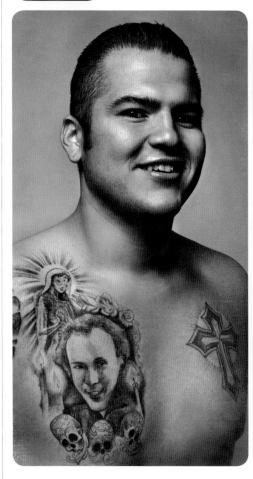

23 NIKKI WAS OUT ON THE ROAD FOR CRÜE FEST 1 AT THE SAME TIME AS MY BOOK TOUR. WE MADE OUR TOURS COINCIDE SO THAT WE COULD SPEND MORE TIME TOGETHER.

# LATER...

# JERED WEAVER

J ered is a starting pitcher for the Anaheim Angels. Much like all the basketball, hockey, and football players I've had the chance to tattoo, Jered was intimidatingly tall! Naturally, this means a pretty long arm— convenient for us, considering Jered wants to get not only two portraits of his parents but an elaborate background, as well.

BLOOD BOOK

II

February

MMIX

FEBRUARY 3, 2009

## MÖTLEY CRÜE

UP UNTIL THIS TIME IN MY LIFE, I HAD NEVER GONE LONGER THAN FIVE DAYS WITHOUT TATTOOING. AT TIMES, NOT TATTOOING FEELS LIKE WHAT I COULD ONLY IMAGINE AN AMPUTEE MUST FEEL LIKE. AN EXTENSION OF YOURSELF, LIKE A PART OF YOURSELF, AN ARM, MAYBE A LEG—YOU'VE ALWAYS HAD IT, AND THEN ONE DAY IT'S GONE. IN THE MORNINGS, YOU GO TO REACH FOR SOMETHING ON THE TABLE, EXPECTING YOUR FINGERS TO TOUCH WHATEVER IT IS THAT YOU'RE AIMING FOR, ONLY TO MISS IT BY A LONG SHOT, FORGETTING THAT YOU NO LONGER HAVE YOUR HAND OR YOUR ARM.

THESE ARE THE THINGS THAT YOU COULD EASILY TAKE FOR GRANTED EACH PASSING DAY—THINKING THEY AREN'T GONNA BE GOING ANYWHERE. IMAGINING YOUR LIFE WITHOUT YOUR ARM OR WITHOUT THE CAREER YOU'VE HAD A MAJORITY OF YOUR LIFE, OR EVEN WORSE WITHOUT A LOVED ONE YOU'VE WOKEN UP TO EVERY DAY FOR THE PAST FEW DECADES MAY SEEM LIKE AN IMPOSSIBILITY. BUT FOR THE FIRST TIME IN MY LIFE, TATTOOING ISN'T HERE TO SAVE ME FROM MYSELF, AND THIS IMPOSSIBILITY FEELS MORE REAL THAN EVER.

AS MUCH ENJOYMENT AS IT BRINGS MEETING FANS ON THIS BOOK TOUR AND SPENDING TIME WITH NIKKI HERE AND THERE, I DO MISS MY OLD COMPANION—TATTOOING. I MISS THE CONNECTION I FEEL WHEN I TATTOO, AND THIS MAKES ME WANT TO GO HOME SO BADLY.

## February 14, 2009

# LAST VALENTINES' DAY,

before Nikki and I had started dating, I was sitting in the bathroom of my old apartment, feeling crushed by my then boyfriend's lack of efforts in making this forced holiday somewhat "romantic." I had asked one thing from my sweetheart, and that request was a simple Valentine's card. I didn't care if it cost $2.99 and he bought it at a liquor store, or if it was a folded piece of red construction paper cut into a heart with a scribbled message——hell! I would have settled for a receipt with a heart-shaped grease stain on it at that point.

Instead I got nothing. I sat in that bathroom——it would've been just too pathetic to cry in front of him, and it probably wouldn't have made a difference anyway. I remember holding my phone in my hand, thinking my telepathic powers might kick in at any moment, and somehow send my lonesome vibes out into the universe, and maybe get a text, or a call that would change how neglected I felt.

Weirdly enough, my phone buzzed with a message from Nikki, who at that time was just a friend, wishing me a happy Valentine's Day.

I couldn't help but wonder if Nikki was sitting in a similar setting, feeling and thinking the same way I was. Somehow I found comfort in that thought.

# NEW ORLEANS

## February 27, 2009

Nikki calls FEBRUARY 27 our "LOVE DAY." The first time he told me he loved me was shortly after we officially began our relationship.

Everything happened so quickly. That first kiss, then a week spent dancing around the "L" word, leading up to this particular day. I drove to meet him at Anarbaugh, an Indian restaurant near his place. I rushed through the usual traffic, hungry to be around him more than for the actual food.

They seated us in a booth, and he sat next to me instead of across the table. It was as if there was no way of getting close enough to each other. We joked about getting surgery to join us together like Siamese twins out of a circus sideshow——and how happy that would make the two of us.

I experienced all the nerves and wonderful feelings that take over during the first few months of discovering and getting to know someone. We told each other about the chains of events that made up our days——we were both so fully intrigued. He looked at me like I was a Christmas present——anxious to hear whatever I was rambling about.

Then he started listing what he considered to be his downfalls—— or at least the things people in

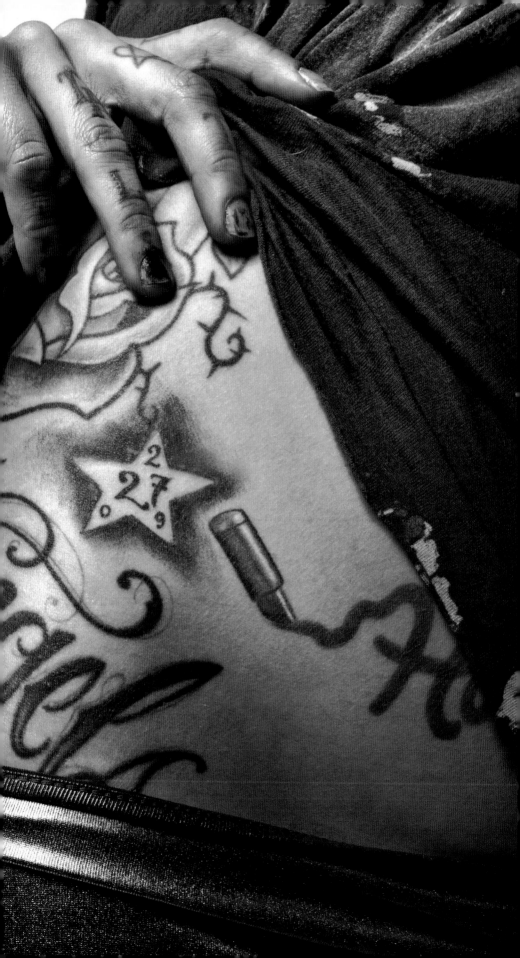

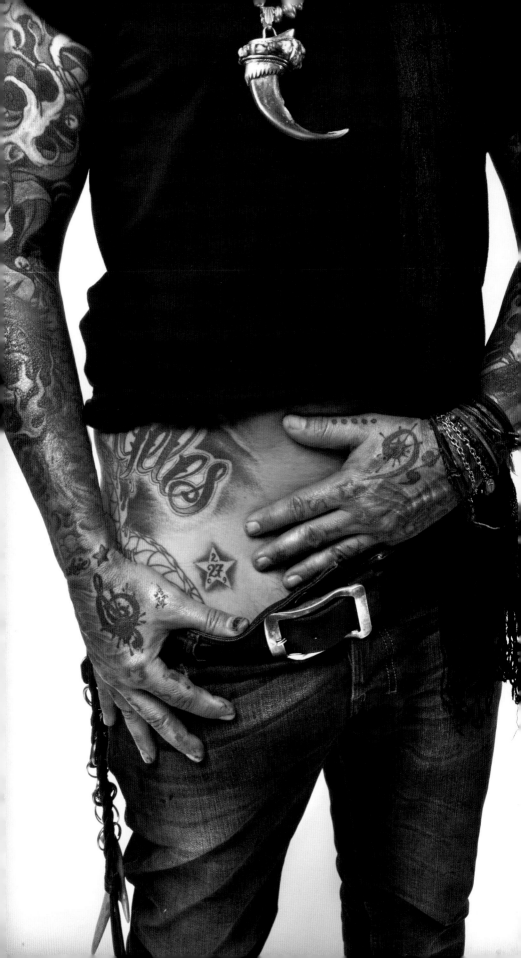

his past relationships found to be "annoying."

I thought those things didn't sound like downfalls at all, and thought everything he said was interesting and funny. Everything seemed like something else we had in common. Regardless of his self-proclaimed baggage and issues, I was falling deeper for this man.

I already knew I fell beyond the point of no return with my heart——I mean, it had only been five days into this companion-ship, but I could have said that ten seconds after he kissed me for the first time.

Whenever he'd put his arms around me——whenever he'd hold my hand——it just felt so natural. There's no other way to describe this complete sense of comfort, the sort of familiarity one might only expect to feel with someone they'd known from childhood.

First he leaned over to make fun of the way I was eating. I guess he thought it was funny that I try to eat everything like a taco. Then he leaned over again and said something else. Outta all the times my hearing failed me, this was the worst thing not to hear.

"Pardon?" "What did you say?" "Nothing."

I finally convinced him to repeat whatever it was that he had attempted to whisper into my ear.

He said, "I said, I love you."

Every time we reminisce about that evening, we laugh, finding humor in the fact that we're both deaf as doorknobs!

So he dubbed that day our "love day." February 27.

Today, one year later, I'm on my book tour, and he's on his tour. He played tonight in Lafayette, a few hours away from my hotel room here in New Orleans. He'll be tired by the time the tour bus pulls up; I'll be up waiting until he comes rushing through that door

with his luggage. I've also planned a really great surprise for him; I had to enlist my friend Roxy's help in order to pull it off in such short time.

My book signing had gone well and ended earlier than I expected, leaving me with a few hours to try to get a tattoo to com-memorate the year anniversary of "love day" before Nikki gets to the hotel.

Roxy used to live in New Orleans and knows anyone who's anyone——especially in the tat-too world. I figured she'd be the perfect person to refer me to a tattooer who'd be not only a good tattooer, but more importantly, available on such a late notice. She got me an "appointment" with her tattooer friend at a shop about ten minutes away. The only catch was that, like most good tattooers, he had already been booked. Lucky for me, he had promised to make my quarter-sized tattoo a possi-bility after his last appointment, around 11 P.M.

That would only give me a limited time prior to Nikki's arrival——and I really wanted to make this tattoo a surprising success.

I killed some time walking the streets and discovering little dive bars and knickknack stores along the cobblestone roads. I had never been to New Orleans before—— and breathing in the Louisiana night air was as romantic as the idea of my tattoo.

# AT 11 P.M.,

I found the shop Roxy was talking about. It was apparently closed for business by the look of the place, but the light on the inside told me I was on time.

By process of elimination among the tattooed boys that were lingering around the facility, I figured out that the curly haired, hat-wearing skater bloke was Randy, the guy who had agreed to tattoo me.

It's often awkward when I attempt to interact with some tattooers, and this time was just like the others. Ever since the success of the TV show, a lot of tattooers haven't really shown too much love——and I consider myself smart enough to know when and where I'm not welcome. Randy's name had rang a bell when Roxy told me about him, but I didn't have a clue what his deal was——I just figured he was a good tattooer who'd do a decent job.

I wanted a small outline of a star with a simple 2. 27. 2009 in black tattooed on my hip. Any tattooer could have done it jus-tice. Meanwhile, I was growing impatient while this guy dilly-dallied, casually chomping away on fried chicken and chatting. Try-ing to cut to the chase, I reminded him how important it was that I get this tattoo soon since I had a time crunch. And then, catching me completely off guard, he grew some balls and blurted out what he had sheepishly been avoiding: "I work with the guys down in Miami[24]——and I don't wanna risk the opportunity to work there by tattooing you."

He was still eating his chicken, while I firmly but pleasantly ex-plained that he could save his apologies because I had less than half an hour left before the car-riage turns into a pumpkin here.

I wasn't going to get into dis-cussing my time on *Miami Ink*. So I hurried back to the hotel room, desperately trying to fix myself up to be somewhat presentable, and to set up what little tattoo equipment I had packed for the

**24** IN 2005, I JOINED THE CAST OF *MIAMI INK*, A TV SHOW ABOUT TATTOOING. TENSIONS ROSE, AND I EVENTUALLY HAD TO GO MY OWN WAY. UNFORTUNATELY, THERE WERE SOME BAD FEELINGS LEFT BEHIND.

possibility of tattooing someone on this two-month book tour.

Well, I would have to tattoo myself—something I haven't done since my early tattoo days. The main difference now is that the real estate available on my body for a new tattoo has become quite limited, especially since I'm right-handed and only have access to half of the empty spots with a decent enough reach to still pull off a good tattoo. But if I wanted a tattoo, that was the answer.

I decided to make the best of the situation. My tattoo setup was a go, and I transferred the stencil of the star tattoo onto my right hip, right next to my New York Dolls-inspired Hollywood tattoo.

My tattoo machine sounded so much damn louder than normal——I was sure the hotel room next to me was going to file a complaint——but fuck it.

I kept on trucking. When my

# PHONE

lit up with a text from Sully, Mötley's manager for this tour, with a five-minute warning of Nikki's arrival, my heart was beating one hundred beats per second.

So close to being done! I reached the finish line and I was done! I washed my new tattoo, which by the way, was a total pain, and was now stinging like a motherfucker.

And the moment he came in was really romantic, just like in the movies . . . The door knob slowly turned, and I could hear the rummaging of luggage and muffled voices on the other side. Then the door opened slowly, and Nikki, my love, stood there fatigued from the concert and the drive. But his eyes were just as bright and shiny and as full of love as that night at the Indian restaurant.

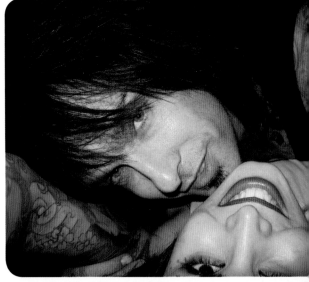

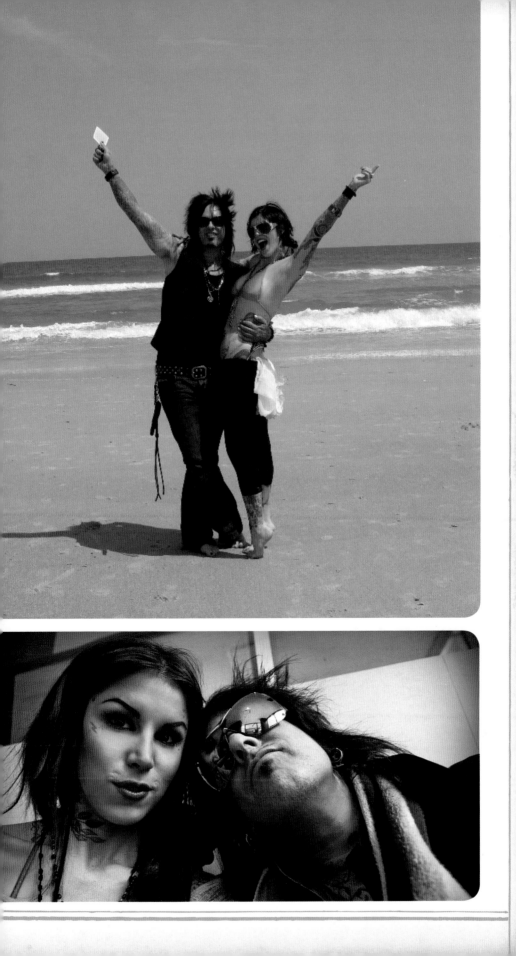

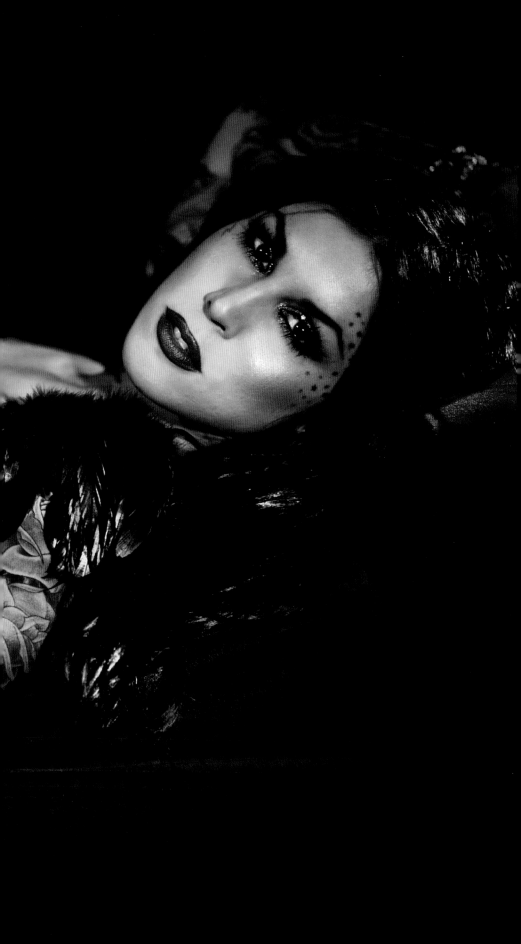

## February 28, 2009

# BREAKING UP

with someone seemed like a cake-walk compared to having to break the news to Hannah and Kim[25] that the network decided not to pick up their talent agreement for *LA Ink*. After looking over the results of test groups and numbers, the network decided to take the show in a different direction, much to my dismay. And regardless of my efforts in trying to convince them different, I was left with a choice——do the show without Hannah and Kim or not do the show.

# FRUSTRATED.
# CONFUSED.
# TORN.

And above all, I was left clueless as to what I should do.

I asked Nikki his opinion, like I usually do, especially when it comes to difficult crossroads such as these. Because of his business experience and his way of doing things without ever compromising his integrity, his words are important to me.

He told me about a similar situation he encountered with the band. One of the guys was struggling with personal demons, and it was bringing the rest of the band down. Eventually, there was talk of replacing him, and while Nikki struggled with the situation, he stepped back and thought to himself: "These are things I cannot control. They are out of my

hands, and I can either continue doing what it is I do (even if it's without an original member) or pass up the opportunity to keep on doing the things that make me happy."

# GOD!
## WHAT WOULD I DO WITHOUT THIS GUY?!

IT WAS CLEAR THAT AT THAT POINT, I had done whatever I could have to try to keep the girls, but Nikki was right——it wasn't my choice, and if I could have changed the situation I would have. But I can't.

# TAKING A STANCE AGAINST THE
# NETWORK

would only hurt me, Corey, and the shop——and it wouldn't change the reality of the situation. All I can do is be honest and tell Hannah and Kim just that. Hopefully, they'll understand how much it hurts me, too.

FIN

---

25 HANNAH AITCHISON AND KIM SAIGH WERE NOT ONLY A PART OF THE ORIGINAL CAST ON *LA INK* FOR THE FIRST TWO SEASONS WITH ME, BUT ALSO FEMALE TATTOOERS WHO I HAD ADMIRED EVEN PRIOR TO KNOWING THEM PERSONALLY.

BLOOD BOOK

III

March

MMIX

# Philadelphia

E PLURIBUS ✩ UNUM

### March 8, 2009

# HAPPY BIRTHDAY TO ME.

Karoline and Michael flew out, knowing how much I missed them while I was away on my book tour. They were honoring my birthday wish this year: to spend the day with my family. Michael had never been on the East Coast before, and it feels like eternity since I've seen Karoline, so I'm really glad that they are here.

It may just be another day, but I'm feeling pretty lonely. It's strange to think that between the Mötley shows and my book signings, this entire tour revolves around being around thousands of people, yet the last thing I've had too much of is alone time——you can still feel so solitary in a room full of many. That feeling is becoming all too familiar nowadays.

When Nikki and I first compared each other's tour schedules, we knew there would be a good amount of time spent apart, but looking on the brighter side of things seemed far more helpful than complaining. We kept saying, "Well, at least we'll be near each other" or "it could be worse, we could not see each other for months straight." This is all true. At least we're in the same time zone for once.

The last birthday that I really enjoyed was when I turned twenty-three. Rhian threw me an outrageous party, complete with a Dolly Parton impersonator who sang "Happy Birthday" at midnight, a cake with black and gold icing, and go-go dancers in silver bikinis and full-blown KISS makeup. My family was there, all my friends were there, and even Kore Flatmo[26] attended.

I think this is what Nikki was talking about when he had told me all the birthdays prior to his fiftieth were a far stretch from "fun," those times when he was away from the ones he loved the most. I miss him so much, but it helps to have my sister and brother here. And my book signing was amazing——tonight's event was one of the best so far. The staff was thoughtful enough to welcome me with a birthday cake, but as I blew the candles out in the stockroom of that book store, melancholy thoughts wrapped themselves around me. I breathed in, and for a moment I felt kind of pitiful. But then I completed the exhale and let another thought emerge. Looking up from the slice of store-bought cake, I thought: this could very well turn into the best birthday I'll ever experience, if I let it——so why shouldn't I?

My brother and sister were beaming at me as the bookstore employees I had met only moments before clapped and cheered, as excited for the signing as they were to celebrate my birthday with me.

How I was lucky to be there at that very moment...
TODAY I TURNED TWENTY-SEVEN,

27

and it was the best birthday I could have had.

---

26 ONE OF THE ONLY TATTOOERS OUTSIDE HIGH VOLTAGE THAT I STILL REMAIN CLOSE FRIENDS WITH, KORE FLATMO IS BY FAR MY NUMBER ONE FAVORITE TATTOOER AND AT TIMES HAS BEEN CONSIDERED A MENTOR TO ME.

## March 9, 2009

I think Nikki felt bad for not being able to be with me yesterday. It's not like the tour manager said, "Oh, its Kat's birthday! Let's make sure to play three hours away in Hershey, Pennsylvania, instead of hangin' out in Philly to wait till she's done with her book signing so our bass player can be happy!"

I was so excited to go and see him——but honestly, after three hours in the car, by the time our driver caught us up with Crüe Fest, Michael, Karoline, and I were grateful for any time outside a moving vehicle.

During the ride, I kept getting texts from Nikki saying, "Let me know when you're getting close, babe." He was up to something. As soon as we pulled up, Nikki reached for my hand, telling me to

# SHUT MY EYES

so he could take me somewhere special and unknown. Thrilled to be near him, I held his hand in mine, shielding my eyes with my free hand.

## WHAT A COOL SURPRISE.

Nikki had spent his day setting up his dressing room as a birthday den for me——mood lighting and all. Glittery streamers hung from the ceiling, and star-shaped confetti had been sprinkled on the floor, leading to what looked like an altar draped in velvety curtains and lit from inside. There on the altar sat a birthday cake with a personalized

# BIRTHDAY WISH.

Nikki's effort to make my birthday wonderful left me speechless. But I couldn't even hug him to thank him because he was jumping up and down like an eight-year-old, just pointing at a box on a table, repeating over and over, "Open your present!"

Under all the wrapping was a custom-made silver jacket with fringes long enough to hit the floor when I walked! There was no way this special piece could be an Agatha Blois knockoff. No sir, this was the real deal!!

"I've been planning this for months now, babe," he said, and I finally got to throw my arms around him, silver fringe rustling all around us.

## WHY DID I FEEL LIKE THE LUCKIEST GIRL

in the world? Not only did I get to celebrate an amazing birthday last night but again today——this time with Nikki and my family!

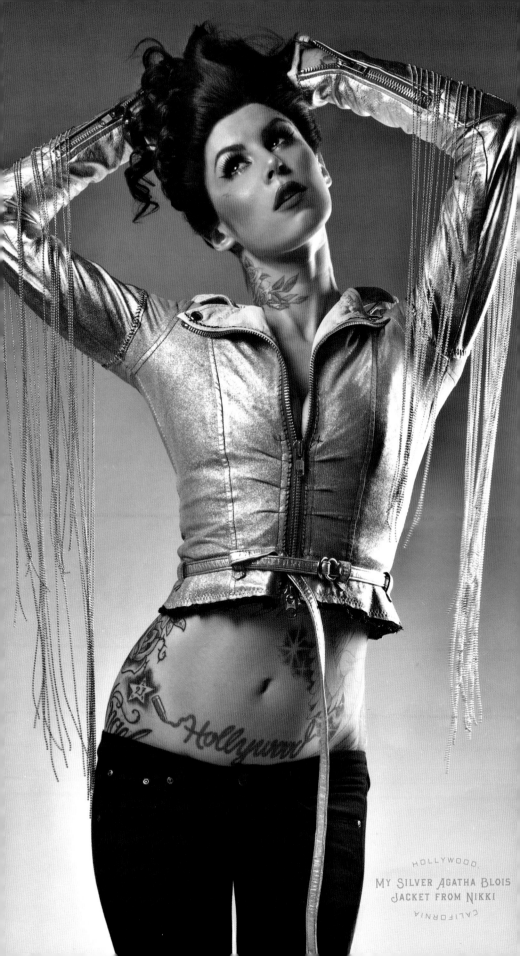

MARCH 11, 2009 — NEW YORK

MY DEAREST MR. BLACK,

I AM RUSHING AS FAST AS HUMANLY POSSIBLE TO FLY

BACK INTO THE CITY OF ANGELS—HOME.

AS MUCH AS I KNOW YOU LOVE NEW YORK, I'M GLAD

WE DON'T LIVE ON OPPOSITE COASTS. SUCH A SHORT

TRIP COMPARED TO ALL THE TIME SPENT IN THE

AIR—BUT INSTEAD OF STAYING OVERNIGHT, I'D MUCH

RATHER NOT MISS ANOTHER CHANCE TO GAIN ONE

EVENING'S WORTH OF SLEEP, AND MAYBE, JUST

MAYBE—JUST MAYBE, SPEND THE REMAINING HOURS

OF WHAT'S LEFT OF THE NIGHT IN THE FAMILIAR

WARMTH OF YOUR ARMS . . .

MAYBE—JUST MAYBE, A HARDWORKING, TIRED, AND

LONELY GIRL LIKE MYSELF MIGHT GET LUCKY ENOUGH?

—MRS. BLACK[27]

27 NIKKI AND I WERE IN THE HABIT OF WRITING LITTLE LOVE NOTES IN WHICH MR. AND MRS. BLACK WERE OUR EQUALLY ENAMORED ALTER EGOS.

BLOOD BOOK

IV

April

MMIX

# JAMIE
## THOMAS

April 1, 2009

I hadn't seen Jamie since we photographed him for my book last year, so I was looking forward to catching up. One obvious change: Jamie's hair. He went from having long, flowing locks like Jesus to a simplified

## BUZZ CUT.

I barely recognized him.

---

At the eleventh hour, Jamie changed his mind about what he wanted T A T T O O E D — appropriate, since it's April Fool's Day. So we shelved the idea of putting the portrait of his mother on his chest, for the time being, and tackled the beginning of Jamie's

this time with a far more intricate tattoo than the lion we'd done last year on the right side.

---

The artwork Jamie brought was inspired by old engravings of

images—a beautiful composition of a far more angelic Saint Michael than the traditional image people usually ask me to tattoo. Jamie had used the image for the graphic on one of his skateboards that he gave to the shop, and it now graces our walls along with the rest of my board collection.

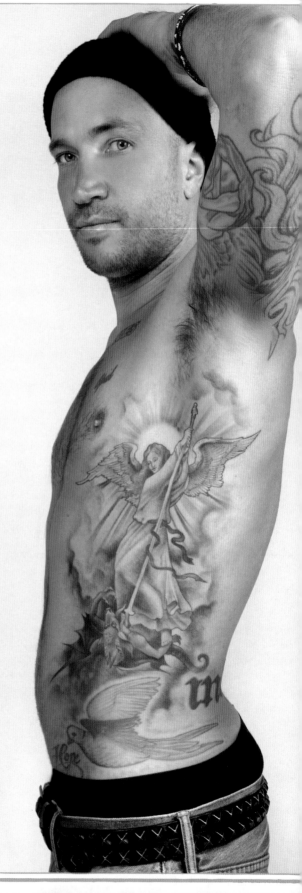

Our conversation gravitated toward the subject of love, and how

and his wife met in particular. I'm a sucker for love stories and always notice the shift in tone in a man's voice when he's reminiscing about the beginning moments of a relationship.

---

When he talked about his better half, it was as if he was talking about his best friend. Twelve years into the relationship and Jamie's still on fire for her. His sense of

𝕻𝕽𝕴𝕯𝕰

when it comes to the qualities he sees in her, how eager he is each day to tell her how beautiful she is, and the way that he loves her unconditionally was inspiring.

---

Talking with Jamie reminded me how much I'm still in love with

And I can't fathom the idea of not waking up to each and every single wrinkle on his face, every issue that comes along with the package, every good and bad quality——and everything in between. I meant it when I told him I want to grow old with him. That he is my other self, my best friend. I meant it when I told him that there is absolutely no backup plan here. Not like every other RELATIONSHIP—— including my MARRIAGE—— no plan B.

# *LATER...*

# SKIP WILLIAMSON

Had to take care of so much shit today——all show-related. I feel like I totally got my brains bashed in today after dealing with it all. Phone conference, after meeting, after e-mails, after more meetings! Too many chiefs in the teepee!

---

I was supposed to take the day off, but my neighbor Danny had asked me a while back if I could squeeze his buddy Skip in for a tattoo——for some reason it had to be today. It wasn't the best timing. We were all still trying to recover from the trauma of witnessing a FATAL CAR ACCIDENT LAST NIGHT that left two, maybe three innocent bystanders dead in front of the shop door. The police had cordoned off the block, including the area in front of the shop, and we had spent a few hours together talking about the traumatic experience of being so close to death before we were allowed to leave.

---

Still, Danny is a friend, and he was very insistent about the date, so I wanted to do this favor for him. Skip's concept was clean and simple: a bold, **BLACK TRIANGLE WITH A "3"** in the center, placed on his forearm. I wondered about the symbolism, particularly because Danny had been so clear that today was the day this had to happen.

---

DANNY had texted saying that he would accompany Skip to the appointment. Well, Skip was on time, but Danny didn't show up till we were well into the beginning stages of the tattoo. The three-inch tattoo didn't take very long, and most of the conversation was overpowered by opinionated talk about music—— and Danny's crazy rants, once he arrived. *LA Ink's* show runner came by halfway through to talk to me about the changes the network has been trying to force down my throat. It's funny how all these matters seem so "urgent" when it's convenient for them, with no consideration for Skip, who was forced to endure the conversation. That's the hardest part about doing the show. The producers care about the show, not about tattooing. How can I expect them to understand how sacred tattooing is to me? I just wish they'd show it more respect. For me, tattooing will always come first——before the show, before all the lawyers, the contracts—— and especially before all these damn meetings! When I apologized for the interruption, Skip was so cool about it, probably because he knows what it's like to work on sets with directors, producers, writers, and the whole shebang that comes with a production company. We didn't even get to the meaning of his tattoo until well after we were done and he was bandaged up.

I asked him what his deal was with **THE NUMBER 3,** considering my fascination with NUMERICAL SYMBOLOGY. The number 3 in particular is the most obsessed-over number; they've actually named the obsession for it as triphilia. I also discovered just recently that

# NIKOLA TESLA

had arithromania——basically a compulsion to count his actions or the objects around him——and triphilia. He often walked three times around a building before entering it, and toward his last days, records show that he would only allow things around him to occur in numbers divisible by three. His housekeeper always knew to bring stacks of eighteen napkins during each of his meals——or he wouldn't be able to eat in peace.

———

Rita Haney has triphilia, too. I tattooed that same number on her temple, with lightning bolts shooting out across her face—— all in increments of three. She also was the thirty-third person I tattooed out of the four hundred during my attempt at the Guinness World Record.

———

What I came to find is that Skip isn't so much a candidate for diagnosis but someone who is deeply grateful and appreciative for just being alive. For him, the number 3 represents three things: **MIND. BODY. SPIRIT.**

———

He told Danny and I what happened on today's date exactly **25** years ago. His story sounded more like a crazy movie than something that had actually happened——but it had.

# SKIP,

his girlfriend, and a few other friends drove a pick up truck out to the woods for a weekend of camping. His buddy drove, and Skip and his girl rode in the back, on the bed of the vehicle. When a van full of aggressive characters started tailgating their truck, everyone's comfort level went from a fun high to a frightening low.

———

They had no idea why they were being stalked, and Skip and his friends held on for their lives as their driver tried to escape these predators. Finally, cornered and scared, they tried to flee the scene on foot.

# THE PSYCHOTIC LUMBERJACKS

jumped out of their van, and pointed at Skip and his friends, threatening to kick their asses and rape their girlfriends.

———

Despite all the commotion, Skip's girlfriend was swift enough to escape the situation and fled by foot to the nearest form of population in hopes of finding a helping hand——and thankfully she did! Someone at a nearby business

let her use the phone, and she frantically called the cops and an ambulance.

Meanwhile, at the scene of the crime——who knows what was happening to Skip's friends. But what Skip does remember are the few moments shortly after he jumped off the bed of the truck and tumbled onto the ground—— finding himself underneath the attackers' van. He had no chance to get himself out of this position before the van started driving and his life was on the line. Skip said he could see the differential under the vehicle move like a clock,

coming closer and closer to his head, eventually driving over him and puncturing a perfect hexagon-shaped three-inch hole into the top of his skull. He was in a state of shock, but he managed to free himself and began to run. With warm blood spurting out of the hole on the top of his head, Skip only made it a few more feet before collapsing.

Luckily the police and an ambulance were only a few miles away. When the attackers heard the sirens they all jumped in the van and took off. When Skip was put into the ambulance, he could

sense the urgency of the paramedics; he was going in and out of consciousness, but he heard them say, "We've lost him, we've lost him!" He couldn't talk or move but was thinking, "Please keep trying, because I can hear you." A long minute later he heard them say, "We have him back!"

Skip died twenty-five years ago today. He also miraculously came back to life. Today, he has made peace with whoever these violent criminals were. They were never caught. Who knows? Maybe Skip was fated to endure a true act of dying to appreciate today.

# KEVIN LLEWELLYN

## April 2, 2009

I remember the first time Nikki took me to a romantic weekend getaway so we could unplug and relax in Santa Barbara. It was maybe two weeks into our relationship. I had never done something like that before——it was so awesome. We spent over an hour trying to find a video place that had *Immortal Beloved* for sale. Nikki wanted to watch it with me because he knows how much I love

### BEETHOVEN

and how much I talk about that movie. After finally finding it, we hurried back to our bungalow and were busy lighting candles and making the room as romantic as imaginable before we started the movie when my phone rang. It was my dad.

I told Nikki I would step into the other room to take this call. Dad and I chatted only for a few minutes. He wanted to see how I was doing.

When I was done and went back in to start the movie with Nikki, I figured I should grab pillows from the bedroom for us and was taken aback by what I discovered on our bed. During my phone call with Dad, Nikki had written me a love letter on my pillow——my first love letter from him——and the first of many little thoughtful things to come that weekend.

I remember the first time I showed Kevin this pillowcase. I kept it neatly folded in one of my special boxes in my office. I had pulled it out to show him after retelling that story one evening.

Today, before we got started on his tattoo, he mentioned something that really caught my attention. He said, "I've been thinking about that story you told me of the love letter on the pillowcase Nikki gave you. It felt so powerful holding that thing in my hands when you showed it to me that day, and every once in a while I think about it and how amazing it is. I wish I could meet a girl that would inspire me to do that for her."

Kevin's comment touched me and reminded me how lucky I was to have Nikki in my life.

I've been a fan of Kevin's

# PAINTINGS

for quite some time already, and after getting to know him over his recent late night visits to the shop, we decided to collaborate on a tattoo. It was like the time I tattooed Michael Hussar——a rare moment where I find myself becoming very SELF-CONSCIOUS around an artist I admire. When I tattoo artists and tattooers who I respect and admire, I develop a heightened awareness of my art and what I'm doing.

Kevin told me that he'd wanted to get a tattoo from me for quite some time. Today, he brought in a mini-library of reference art as well as a switchblade and a real

# HUMAN SKULL

that was most likely used at one point as a medical reference and was now gonna be our "model" for the main subject of the tattoo. Kevin had envisioned the skull wearing a halo of switchblades over its head like a crown of thorns. After working and reworking rough drafts of the line drawing together, we realized if this tattoo was going to fit the area that stretched from his wrist to his elbow, we were going to have to come up with a different shape. The "crown of thorns" idea was making the overall shape far too horizontal, and lengthening the design vertically would be the answer. Finally, we developed a line drawing that the both of us were excited about and fit

perfectly, scratching the halo idea and incorporating the

# SWITCHBLADE,

piercing the top of the skull and peering through the bottom.

I had hoped to impress Kevin with the tattoo——and in the end, he was so giddy and excited that that no amount of money could ever match the payment of Kevin's gratitude.

# BRANDON COX

### April 3, 2009

Several months ago, I tattooed a portrait of Brandon's son on him. Today, Brandon returned for a tattoo I've dreamed of doing for a long while now: a rendition of the Caravaggio painting *Doubting Thomas*. Brandon dedicated his entire left ribcage to this tattoo.

I've been lucky enough to tattoo plenty of Caravaggio-inspired pieces over the years——the *Medusa*, *St. Matthew and the Angel*, *Judith Beheading Holofernes*, *St. Jerome Writing*, but never this one. Brandon told me the inspiration for this tattoo was derived from one of his favorite scriptures, John 20:29—— "Then Jesus told him, 'because you have seen me, you have believed; blessed are those who have not seen and yet have believed.'"

This painting depicts the story of Jesus shortly after the resurrection, where he shows himself to the disciples who have been in hiding. Thomas is skeptical, refusing to believe Jesus has miraculously risen from death, wounds and all. To prove himself to Thomas, Jesus tells him to feel the wounds for himself. Caravaggio captured each subject's emotions in such an expressive way. Jesus pulls aside his garments to reveal the deep wound on his ribs. Dumbfounded, Thomas sticks his finger in the open wound.

Brandon wanted to get this tattoo specifically in this location because it's in the same location as Jesus's wound. He wanted the tattoo to remind him to believe during moments when he doubts his own faith.

# JEFFREE STAR

April 8, 2009

## JEFFREE WANTED

# "*Redrum*"

across his lower abdomen——an appropriate choice for a tattoo to match the rest of his slain Beauty Queens collection.

I gave the tattoo an etched texturing, so the tattoo appears to be carved into his belly.

We both gasped in awe at the sight, which anyone with one good functioning eyeball could read from across the street: "MURDER." It read so clearly. We laughed out loud before Greg bandaged it, and our social hour came and went.

**ANOTHER DAY AT THE OFFICE . . .**

# LATER...

## CEDRIC Bixler-Zavala

### (THE MARS VOLTA)

This is the second time I get to tattoo Cedric. I am so excited, more so even than the last time, when we did the portrait of Joan Crawford in *Straight-Jacket*. This time, he's here to get a portrait of comedian Andy Kaufman.

When the last Mars Volta record, *Frances The Mute*, came out, Nikki and I had only been dating for a few months. I remember taking a drive through the windy roads of Mulholland. It didn't bother me that I was late for an appointment. I didn't have a care in the world, as we held hands and drank each other in. I asked him if he'd ever heard the Mars Volta, explaining my recent obsession with the new record, and insisted he listen to these six tracks,[18] which segued into each other, making the album one long (not long enough, in my opinion) song. He genuinely listened to the music——and like me, became a fan right away, scouring through any sites to find more of where this music came from. It was weeks before Nikki would listen to anything else.

At this exact time in our relationship, Nikki had been busy recording a new album himself and rehearsing for not only Mötley, but Sixx: A.M. as well.

Around the same time, I had just started James Michael's[29] angel sleeve——and clearly remember him telling me, "I don't know what you got Nikki listening to, but in the studio this week, his bass playing has never been better." That flattering remark made me blush! Turning Nikki onto the Mars Volta record meant I had in one way or another affected his life in a positive way——and that mean so much to me.

Each night we'd meet up after my long days filming and Nikki would play me whatever rough cut or demo he'd recorded or read me the lyrics to the new songs, winning my heart over each time with his drive and his passion for what he was creating.

## *Nothing*

is a bigger turn-on than seeing your mate on fire, productive, excited about something. I don't know if I ever had a chance to feel so inspired in my past relationships. Nikki made me feel like I should question whether I had actually ever truly been in love. I mean, I thought I was in love at those times, but maybe I just didn't know any better. I was sure this was true love. This was love in the most natural way, inspiring in the most encouraging way, the kind of love that almost makes you impatient to be a better person——because you really want to. It was a love that came with

respect for one another and admiration——and that to me was so

## FUCKING SEXY.

I told him that. One day driving home from work, I texted him: "Being with you makes me question all my past relationships. This is true love, and no one's ever made me feel like this until I met you."

The next day he showed up so giddy he could hardly contain himself and played me a rough demo of one of the new songs on the *Saints of Los Angeles* record. Nikki called the song "Animal." He had used what I had told him and put it beautifully into a lyric:

*"Feels like thunder when we're slowly digging in. Makes me wonder, about the lovers that have been..."*

I was flattered, impressed, and felt so close to Nikki that day.

Those little things he'd do to make me feel so adored and so important. It felt comforting to reminisce the sweet times and share with Cedric how much both Nikki and I appreciate his music and how happy we both were that they won a Grammy[30] this year. In return, it felt really good to know Cedric noticed a mention of Nikki's congrats to them in a recent interview——and to hear Cedric tell me the same story everyone in our age group confesses: about the time they had to sneak their copy of *Shout at the Devil* back in the day, because if

were to find out...

---

28 CASSANDRA GEMINI I, II, III, IV, V, AND VI  29 JAMES IS THE LEAD VOCALIST FOR SIXX: A.M.  30 EVEN THOUGH MÖTLEY CRÜE LOST THE GRAMMY TO MARS VOLTA, WE BOTH FELT THAT MARS VOLTA REALLY DESERVED IT.

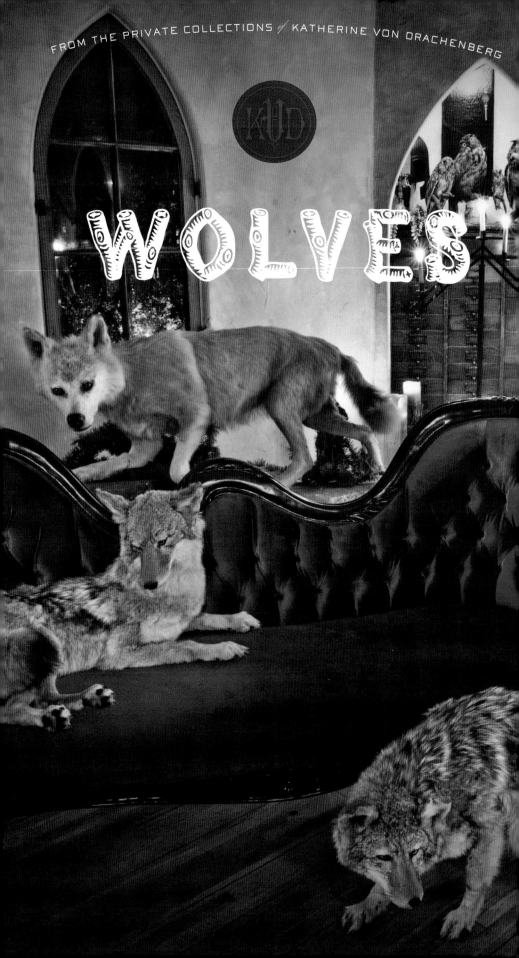

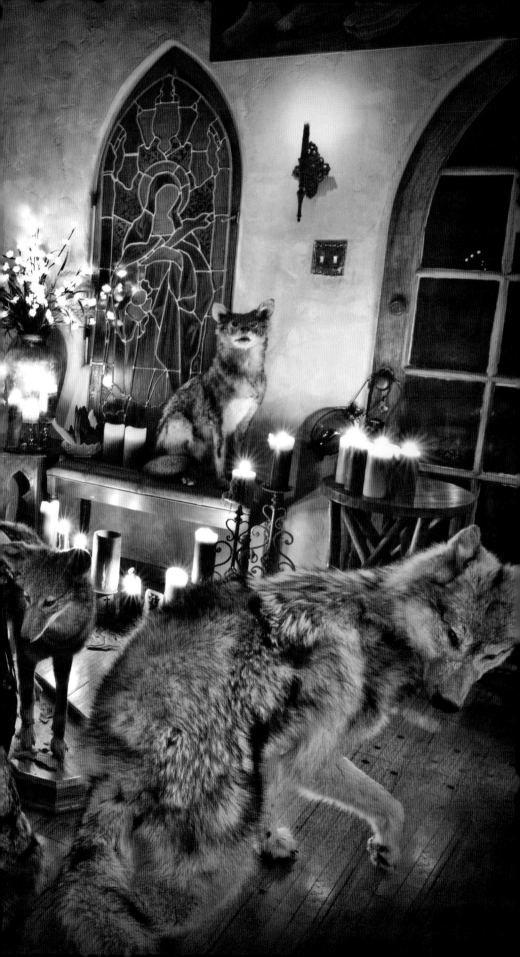

# CHUCK WOODY

April 11, 2009

**CHUCK LOVED HIS DOG**, Jimmy, so damn much that this portrait on his calf is his first tattoo and, according to Chuck, will be his last. Chuck and Jimmy did everything together, even win bets! Their friends and neighbors would bet as to whether Jimmy the Dog could jump barriers—walls, gates, fences, hedges as high as eight to ten feet. Every time, Chuck and his dog companion walked away with the money.

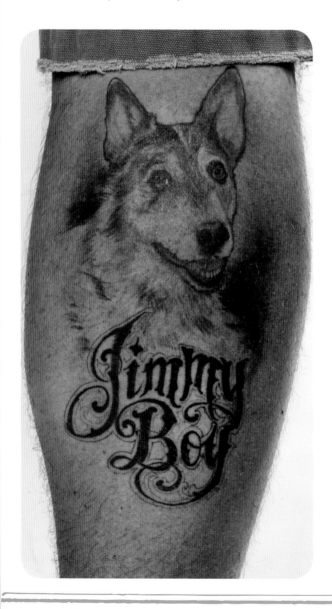

# Revecka NGUYEN

April 17, 2009

"

When I was growing up, Mary was a figure in my life, and even though today I'm not Catholic, I'm still very spiritual. What Mary stands for is so powerful because she is such a strong historical female figure. Although the Sacred Heart is a piece of art that I find beautiful, I wanted something a little different, so I turned it into a locket.

——Revecka Nguyen

"

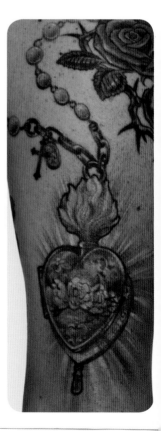

# WEYMAN THOMAS

## April 25, 2009

Weyman's been taking magician classes at the Magic Castle in his spare time, so every time he comes in for his appointments with me, we start our sessions with a magic trick. Today we chipped away at completing his sleeve by adding a St. Michael to his biblical-inspired theme.

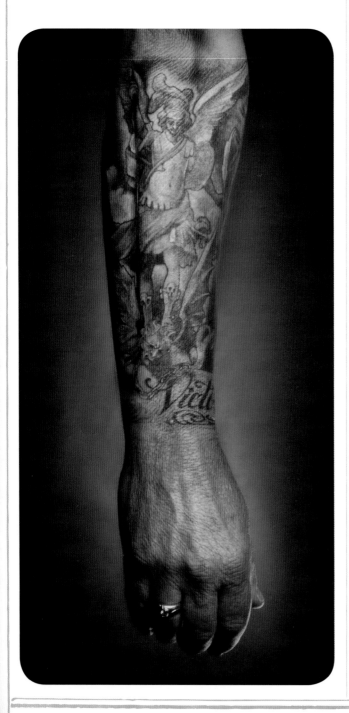

# L A T E R

# JAMIE THOMAS

What a funny coincidence. First, Weyman Thomas, now Jamie Thomas—both getting different renditions of St. Michael. Even though the two have never met, they are both some of my favorite people to tattoo. Both have lions tattooed on them by me, both have strong Christian beliefs, and both were here today.

# HEIDI WRIGHT

## April 27, 2009

Heidi's simple kanji tattoo on her ankle took about a good ten minutes to do. While I worked, she explained that she was an animal communicator. First she worked for the police department, then her career shifted, and she learned how to be in tune with what animals were thinking and feeling.

I've never really believed in

# ANIMAL PSYCHICS,

probably because I'm one of those people who has to see it to believe it. Last year, I had bought another sphynx cat, thinking Ludwig would appreciate the company, especially since I had a lot of traveling to do at the time. I named the new golden-eyed kitty Agatha, after my dear friend. Naturally, everyone who'd come over would lend all their attention to the baby girl—she was so lovable and sweet, and tiny!

Maybe the change in Ludi's surroundings caused a shift in his behavior. Aside from the addition of Agatha to our little family, maybe my ex-boyfriend's departure had something to do with it. Ludi had really taken a liking to him.

To top all of it off, my mom was staying with me, since my sis and I had finally convinced her to move back to the United States from Tijuana. It probably didn't help any that my mom openly favored Agatha's company over Ludwig's, either.

So, it began...Ludwig started meowing all day long. I mean, every fucking waking moment—and loud! I did everything possible to end the constant yelping,

especially once his meows became raspy, practically like barks. He was hurting himself and almost lost his voice altogether.

I fed him, filled his water bowl, changed the temperature in the pad, petted him, bathed him, didn't bathe him, took him to the vet—everything!

It was not only frustrating, it was worrying. My best friend at the time recommended I call this pet psychic in Las Vegas who had worked miracles on her shoe-thrashing feline. You call this

# LADY,

you let her know where you live, as well as your pet's name, age, breed, and of course, the problem.

A few days later, after she has "communicated" with your pet, she calls and tells you what the story is. It was hard to swallow but

## I WAS DESPERATE!

The psychic wound up telling me that Ludwig was upset that I didn't let him outside and that I needed to maybe get a leash of some sort and take him on daily walks. After I jotted down her name and the address to send the $75 check to, I hung up with a good amount of disappointment. I mean, could you imagine my ass walking Ludwig, the hairless cat, on a leash down the streets of

# HOLLYWOOD BOULEVARD?

That mental image was laughable at best.

So the crying continued, until my mother moved out and took Agatha with her, since she was so fond of her company—and guess what? Ludwig stopped **FUCKING CRYING!**

# Ludwig

is an attention whore, simply put. He prefers to be the sole focus of my attention at all times. That's probably due to the fact that when I brought Ludi home with me for the first time, it was the day after I left my husband. It was just Ludwig and me. On the nights when I cried myself to sleep, Ludwig would sleep even closer to me, as if he knew I needed that extra love. When I'm feeling gloomy, he'll put his face right next to mine—and like this funny little snuggly sponge, he soaks up the negative energy and I can't help but smile.

Heidi met Ludwig soon after her tattoo was complete and bandaged up. She said, "He loves you and is the jealous type."

She was right about that.

"He's also telling me that this morning you didn't pay attention to him," she continued. "And that really upset him."

# OKAY...

I don't know about all that...

"I see a stretch limo? Ludwig really wants to be taken for a ride—a limo ride to be exact."

Well, if this is true, Ludwig's gonna have to suck it up and settle for my little compact car, because I can't stand stretch limos!

Who knows if Heidi is really talking to these animals or not.

In any case, she was over the moon about her new tattoo—but, I think, even more excited to have met my cat.

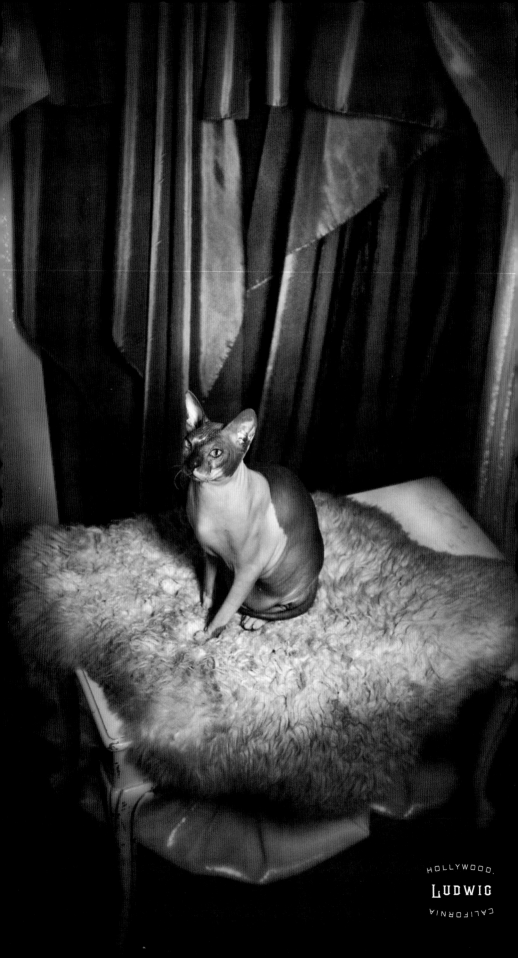

V

May

MMIX

# Tom Judd

May 4, 2009

I approved this tattoo with casting a while back solely because it was Salvador Dalí—inspired art. I love Dalí. I've always been a big fan of his work, even more so because of the love story of Salvador and his wife and muse,

Dalí once said, "I love her more than my father, more than my mother, more than Picasso, and even more than money. Now I want just two things: to love Gala, and to learn how to die. So I touch her ear lobe and turn it into my Aladdin's lamp. Straight away, in harmony and all at once, all the peak visual moments of my life loom before me. It's Gala who discovers and brings me all the essences, which I then turn into honey in the busy hive of my mind. Without Gala, the world would have no genie: Dalí would not exist."

Tom and I connected instantly. He had brought in a sketch to better give me an idea of his vision for his tattoo, and I thought he must be an artist because his drawing had style, composition, and overall skill. Sure enough, he is an illustrator working in the animation world.

I loved Tom. His words with me while the cameras were off busy filming someone else's story were so fucking real. It's amazing how much the camera robs us of the "magic" when it comes to tattooing. As intimate as the process can be sometimes, it never fails to cause a noticeable shift in conversation once those cameras are pointed in your direction. No wonder I get so disappointed with a lot of the final cuts of the episodes, when the real stories seem so watered down compared to reality.

"Avida Dollars." Those were the words he wanted to use to frame the Dalí-inspired skull tattoo on his upper back. We added stacks of dollar bills protruding from the skull's clenched jaw.

Avida Dollars was a nickname given to Dalí by a surrealist peer of his during the peak of his success. It's an anagram of Salvador Dalí and also Spanish for "evil for dollars." Although the nickname was most likely given in a spiteful manner, Dalí fell in love with the meaning behind it and kept it. Benefitting financially from his art didn't bother him so much, either——and he was quite good at that, so the meaning in all actuality suited him.

Tom chose this tattoo because it relates to where he's at with his career. Dalí had to deal with a lot of criticism, which can be expected once an artist attains any measure of success. I know exactly how Tom feels——and I remember getting to the exact same place where he is now. At what point does an artist let go of the many expectations forced upon him and stop feeling guilty for being successful?

At what point did Salvador Dalí embrace his success and learn that making money off his many endeavors didn't detract from his talents? If money is the means to do what you love, then money can be seen as a form of freedom. And if marketing yourself, whether you're a painter, a musician, or a puppet maker helps you share your gift and abilities with the rest of the world, then so be it.

For me, coming from nothing makes it a whole lot easier to appreciate each and every little

# LUXURY

I'm able to experience.

Man! I hope I get to see Tom again. He inspired me, and made me remember that my insecurities are only fears that I've allowed to distract me from my true purpose here: to take each and every single opportunity to create, learn and teach——and above all, to learn to stop doubting myself——and my art.

This was by far my favorite Salvador Dalí tattoo that I've ever done.

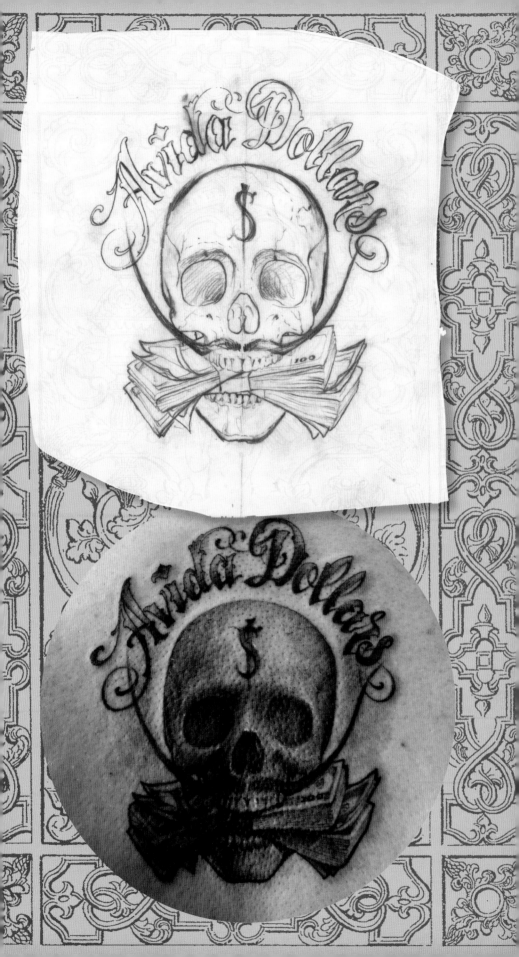

# Shawn Chan

## May 5, 2009

The wedding photo of Shawn's parents is probably one of his family's most prized possessions. The image has no monetary value, but the fact that it made it out of the Cambodian concentration camp with his family during their escape decades ago makes it priceless.

---

Shawn's story shocked and moved me. After he was born, in the "reeducation" camps set up under Pol Pot, his parents and sisters managed to escape. They were totally stripped of all of their belongings, but they kept baby Shawn safe the entire time. Shawn's mother, who had been only sixteen when she married Shawn's dad, clung to the photo as a reminder of their earlier lives, determined to take it with her wherever they wound up.

---

We tattooed the wedding

# PORTRAIT

on Shawn's chest. Because he is so tall, the tattoo easily measured eight by ten inches, a large space to cover compared to the average pec! But that only meant I had more room for detail——and there definitely was no shortage of that. For the final details of the tattoo, I spent a good amount of time on the wedding dress and headpiece alone.

As we chipped away at the tattoo, Shawn told me about the night his family escaped. A group of prisoners had gathered and plotted out their escape. Because they were trapped in a confined area surrounded by land mines, the only way to do it was to have one person volunteer to lead the way out. You'd do it by carefully putting one foot in front of the other, because each step meant the risk of a fatal explosion. Everyone else would watch the volunteer and try to memorize the exact same trail of "safe" zones to follow. One by one, they'd follow the leader until they reached a nearby forest.

---

Luck was on their side that night, and Sean's family cleared the minefield with no casualties.

---

Shawn's sister, barely more than a child herself at that point, was the one who carried baby Shawn that night. It's so amazing—— she saved his life and probably wasn't even aware of what was really happening around her.

---

The photograph that sits framed above his mother's mantle serves as a reminder of what the true meaning of family is, and it will now forever be displayed proudly on Shawn's chest for the entire world to see.

---

When we were finally done, I showed him his new tattoo in the reveal mirror, and at this point, Shawn's excitement over his tattoo was interrupted by his mother and sister entering the shop. They were equally eager to see the tattoo. Even though his mother isn't a fan of tattoos, I was confident this one would strike a chord in a positive way.

When they made their way past the lobby of the shop to Shawn, I could see him get a little nervous. I knew how much this tattoo meant to him and how important it was for his mother to love it, too. I introduced myself with a hug; I felt like I already knew them after everything that Shawn had told me about them. They were so beautiful. His mom reminded me of my own——petite, with curled dark hair and eyes that sparkled even more when she smiled.

---

The two women looked at the

# TATTOO.

Shawn waited for their reaction——their eyes started to shine with tears. I watched as Shawn told his mother how much he loved her as they embraced each other.

---

You can't fake this kind of stuff. You can only be thankful to be a part of it.

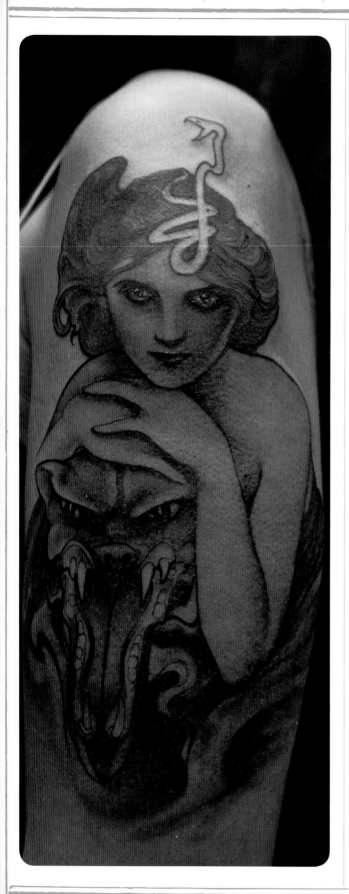

# CASSANDRA FONTE

May 6, 2009

I WAS SO PUMPED ON THIS ALPHONSE MUCHA tattoo that I drew the final line drawing up last night. Cassandra has flown in from Connecticut for her first out-of-state trip by herself. How neat! When clients come in

# SOLO,

I feel much calmer because I know the session will be far more intimate, with no obligation to try to entertain their sidekicks.

---

There's a unique connection I can instantly feel with certain people. It's usually there from the moment we meet, and I felt it strongly with Cassandra. My instinct told me Cassandra was different from other people——broken in some way——and most likely depressed like I was. Lately, it's been nothing but a constant battle with this lingering depression for me. Some days are easier than others, and although yesterday felt like some kind of a breakthrough happened, I'm not going lie and say I'm Sally Sunshine all of a sudden. THESE DEMONS are a lot tougher than I am at times.

---

I wanted to ask Cassandra if she also ever felt totally alone in a room full of people, but then I thought better of it.

Cassandra was just as beautiful as one of Mucha's illustrations of women. She had such an exotic look. I was thoroughly impressed by Cassandra's collection of preexisting tattoos of Mucha girls, which she had all over her body, and I was also intimidated to be tattooing next to those renditions——but of course those fleeting moments of insecurity dissipate as quickly as they appear. They have to, or else you could never do your job.

———————

I tattooed for several hours on her upper arm. She stayed relatively quiet while I worked steadily, never once complaining about the pain or ever showing any signs of being affected by the needle——or me.

———————

And that was fine. I think I just maybe wanted to feel a connection with someone who I could possibly relate to. Maybe I was just looking for these "signs" in Cassandra and seeing an underlying sadness that wasn't there. Maybe I just imagined that she has also felt completely isolated and shut down, like somebody flipped a switch from "on" to "off." Maybe I've removed myself so far from normal social reality that I've started believing my faux reality and projecting it onto others. It's not okay that I can only look forward to my tattoo appointments and my journaling as my only source of

## "*Friendship.*"

I think something's wrong with me, and that everyone can see it. I think those around me see how much I've isolated myself from the outside world and how it's changing me.

There's a reason why my phone doesn't ring unless it's something work-related——or it's my sister——which for the most part is also always work-related. I can't remember the last time someone asked me how I was doing and actually meant it. And why should I blame them? The failed attempts at getting me to participate in a social environment would get pretty fucking old after constantly getting turned down. And who wants to talk about work anyway? I just don't really have much else to talk about, in all honesty. And this is all because I've made it this way.

———————

What a relief it is Cassandra isn't telepathic! She can't read minds——and she's not reading my journals, so that makes me safe. The fraudulent happy face is convincing enough for now to get me and Cassandra through this tattoo——and this whole day altogether.

———————

As I finish the tattoo and take a photograph, I feel so happy that despite all the despondency, I am still able to feel something——pleasure in the work.

———————

I always say tattooing saved my life, providing me with all the opportunities to get me to where I am. Today it saved me from myself. Sometimes, if it's quiet for too long, it's easy for my mind to steer into these feelings of longing. I feel pretty alone a whole lot. And I recognize when I'm avoiding dealing with my gloom by distracting myself with tattooing, work, taxidermy, candles, and whatever other "fascinations." But recognizing and taking charge are two different things.

———————

After we were done, I gave Cassandra a ride to her hotel, which I never do, since it goes against my rule of not socializing too much with a client.

———————

## MY GUT FEELING

was that it was okay, and I'm glad I did it. Cassandra had not only gotten a neat tattoo, but she was able to experience a lotta "firsts" on this trip. When I saw how glad she felt to be riding in my car with me, it made me rethink some things. If a total stranger somehow feels honored to be around me, then maybe I should recognize that and put myself out there with the rest of the world——and maybe make a friend or two.

———————

Cassandra thanked me as I dropped her off, and I did the same.

# Kristina Rhodes

## May 7, 2009

**PATTERNS OCCUR AND REOCCUR—**
personality traits, characteristics . . . Family patterns can easily be mistaken for mere coincidences, but I've seen so many people repeating the things their parents did, because their parents did, and their parents before them did and so on.

It's easier to think of your parents as role models who lead by action than to see them as imperfect humans——often trying their best but making mistakes. If we were taught to learn from our mom's and dad's mistakes, instead of mimicking them, I think we might have a chance at halting the less-than-healthy patterns. That's what I saw in front of me with Kristina and her daughter, and it gives me hope.

## THE IMAGE OF HER

# HANDS

making a heart shape made such a cool tattoo to celebrate breaking this pattern.

Kristina's mother had her at the too-young age of sixteen, and when Kristina herself got pregnant at sixteen, Kristina's mother helped her raise her daughter. Despite the disappointments that came with being a teenager with a baby, Kristina raised her daughter with nothing but love.

You don't have to be a parent to foresee the obstacles a teenage mom would face or to understand why parents would want their children to make the right choices.

I remember after I had dropped out of high school when I was a freshman: only two weeks into the year, and it was more important to me to be tattooing than to be sitting in class. My dad was so disappointed, because he'd wanted a life for me that was so different than the one I was determined to create for myself.

In the hopes of making my father happy, I reluctantly attempted to go back to school, but by the time I tried to sign up for the year, too much time had passed, and the only public schooling option left me at the doors of the independent schooling education program for the city of Redlands.

All the normal public school kids referred to this as the school for losers, delinquents, and of course, the

# PREGNANT GIRLS.

I can see their elitist, negative point of view, but at least these losers were trying. I, on the other hand, had written off school all together.

But before I gave up on that place, I did make friends with a few of the pregnant teenagers struggling to continue their educations despite changed circumstances. There was one girl who was already on her second child and hadn't even hit her senior year.

I had barely turned fifteen, and it was obvious to me that getting pregnant robbed you of the freedom you were meant to enjoy at that age. No parties, no going out to the mall with your friends if you can't find a babysitter, no fun jobs——no time.

Like Theodore Roosevelt said, "Do what you can, with what you have, where you are." They were just kids raising kids——who in turn have a higher chance of doing the same and so on. That thought saddens me. But what I see in front of me shows that there is always hope.

Kristina's daughter, who sat across from her during her tattoo today, recently celebrated her sixteenth birthday without a simultaneous pregnancy. Kristina has no regrets about her choices in life, especially having a child when she was that young. Instead, there's a strong sense of pride in her daughter, who was smart enough to listen and learn from her mother's experience and create a new future for herself.

# Dorys Aranavia

## May 9, 2009

**DORYS BROUGHT HER SISTER ALONG FOR MORAL SUPPORT** as we completed her portrait of La Doña, Maria Felix, an icon of Mexican cinema. Her features are very striking, which made for an equally striking tattoo.

It was so neat to see the two sisters interact during the tattoo session. They reminded me so much of Karoline and me. They work together in the garment industry——they laughed a lot and completed each other's sentences.

Karoline was in her office as I tattooed. I looked up and watched as she typed out e-mail after e-mail, made phone call after phone call, and scheduled and rescheduled my life. It's so easy to get sidetracked by all the work I have going on, to forget to take a deep breath and a closer look at the hard work she puts in eight days a week——and the unconditional love she offers me——all because she really cares.

# LATER...BUZZ *and* KELLI THOMAS

Don't give up, it takes a while
I have seen this look before
And it's alright
You're not alone
If you don't love this anymore
I hear that you've slipped again
I'm here 'cause I know you'll need a friend

And you know that accidents can happen
And it's okay,
We all fall off the wagon sometimes
It's not your whole life
It's only one day
You haven't thrown everything away.

-Sixx: A.M., "Accidents Can Happen"

The last time I tattooed Buzz, he told me about how much Nikki's book had helped him with his sobriety. He really related to Nikki's battle with addiction to heroin. He was so scared to tell me that since then he had relapsed and found himself back at square one.

---

When we first met, he brought the missus with him, and she tagged along today, as well. He is getting a portrait of her, quite large, across his belly. The portrait is an homage to his wife, because through thick and thin she has displayed nothing but support and tough love for him. Although he fell off the wagon, she stuck by his side, suffering right alongside him, just waiting and hoping to be able to see brighter days like today.

---

I have plans to go hang out later at Funny Farm, so even though I usually don't do this sort of thing, I promised Buzz I would get his copy of *The Heroin Diaries* signed for him.

---

I knew Nikki would write down some words of encouragement that would make a much bigger impact than anything I could ever say.

---

Buzz took a look at his new tattoo in the mirror and thanked me. The tattoo would be a daily reminder that there are things to look forward to——that there are such things as true, unconditional love.

**May 11, 2009**

# I'M BACK IN N.Y.

again——this time to shoot the new print ads for the two

## FRAGRANCES.

I'm so glad Sephora agreed to go with the idea I had for the

## SAINT & SINNER

## CAMPAIGN.

For Saint, they spent over five hours covering up all my tattoos with the tattoo concealer we came up with a while back. It was so strange to see myself without any tattoos—— I barely recognized myself! The final images are gonna come as such a shock to everyone—— especially my dad!

---

May 11, 2009

Kat,

Inspiration comes in many forms.
People. Places. Experiences. Kelli's
portrait looks just as beautiful as she is.
You have inspired me to go home, clean up,
and rock out some cool tattoos.

Thanks for *everything*.

We'll see you again real soon!

And please let Nikki know he could not have
sent a better message.

XOXO BUZZ

# JESSIE JOE STARK

## May 14, 2009

### ANOTHER REFERRAL FROM
### BRENT BOLTHOUSE!

I was a bit late to our appointment since the morning had been taken over by meetings with my business manager and the unexpected phone call from Nikko Hurtado[31] telling me he was reluctantly going to have to take a pass on doing the TV show. I'm bummed that he decided to take a pass on the chance of being a good representation of tattooing, especially because he is such a master of color portraiture and realism. But I don't think it's a mistake if that's what his heart is telling him to do.

Thank God for my meditation sessions with Nancy; if it weren't for those moments of relaxation and breathing, there'd be no way to compose myself.

## I SAID MY
## MANTRA

and took a deep breath, trying to leave my problems at the door so I could go and spend some time with Jessie Joe. She turned out to be the spitting image of her father, Richard. Nikki's always referred to Richard as one of his closest friends, and the last time I saw him was at Nikki's fiftieth! I could instantly tell Jessie Joe was a cool gal——she reminded me a lot of Storm.

31 NIKKO, A TATTOOER, IS FAMOUS FOR HIS MASTERY OF COLOR PORTRAITS AND REALISM, AND HE WAS INVITED TO BE A CAST MEMBER ON *LA INK*.

Jessie Joe had a style all her own and was comfortable in her skin. She wanted to get a simple tattoo on her wrist, just a graphic black silhouette of a bird in flight framed by a perfect circle that incorporated her siblings' initials inside of it.

---

Brent showed up to be a part of the process right before we finalized the artwork. It was so cool to chat with him. And I don't believe it was a coincidence when I found out he had learned Transcendental Meditation from Nancy, as well, considering how he, like Matt Skiba, has that cool and calm quality about him!

Although it only took ten minutes, the tattoo was quite painful for Jessie Joe, so I'm sure she was thankful that it went so swiftly.

---

Before we bandaged her up, I got a call from Nikki——and I swear! We have some weird telepathic vibe going on——we're going through some similar stuff right now.

---

I guess one of his bandmates has been causing unnecessary drama last minute before he heads out on the road again. I know the amount of stress this puts on Nikki——especially only moments away from leaving for the European leg of the tour. It's like trying to replace a cast member on such short notice.

---

I've been trying to get Nikki to go see Nancy. He's already a fan of meditation and he'd probably learn a lot from her, too. Regardless, it was comforting to be able to laugh off both of our situations

# TOGETHER.

# Charles Winborne

### May 15, 2009

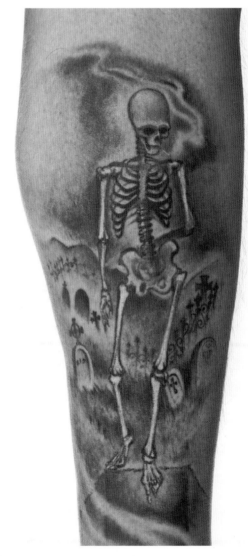

I've been looking forward to seeing Charles again since his first appointment months ago, when he drove down from San Diego and ended up claiming a place in my heart after our late night talkfest.

---

I drew out his tattoo idea last night: a skeleton walking into its own grave, arms behind its back, its head facing down, a cigarette in its mouth, with smoke bellowing out and above the whole design, and I added an entire graveyard in the background. And so we began . . .

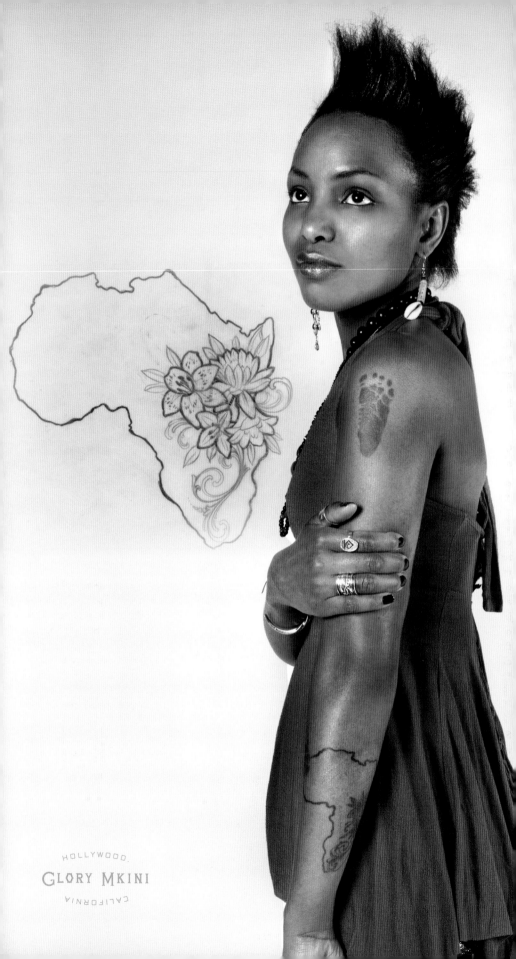

# GLORY MKINI

## May 18, 2009

I've become pretty close with Aaron, the director of photography on *LA Ink*. We've had some good conversations as friends off camera. He had been telling me about Glory, one of his ex-girlfriends and the footage he filmed to document her family's history.

Glory is from Tanzania, the main subject of her tattoo. She's got a

SCAR

on her arm that, coincidentally, resembles the shape of Africa. My mission today was to add simple contour outline around the scar, and a bouquet of flowers placed just where Tanzania would lie on a map of Africa. The little red flowers were a nostalgic reminder of the years she spent living in

TANZANIA.

She said the flowers were everywhere and dotted the land around her mother's house.

Glory lives here in the United States now. She came from a big family: three brothers and four sisters, including herself. All of her sisters died of AIDS, and although her brothers are still alive, they have the disease as well. Glory has also lost two aunts, an uncle, three cousins and a stepbrother to AIDS, making her the only female survivor left in her family.

Glory told me that the people treat AIDS victims in Tanzania the same way in which the Bible describes lepers. People there are not educated about what the

## DISEASE

really is, what it does to your body, and most importantly, how to protect yourself and those around you. No one talks about it——and again, living a life in the track of fear and denial makes it even easier to infect each other.

At one point, Glory went to find her brother Ray, one of the many who'd contracted AIDS. Unable to cope with the inevitable, he removed himself from his surroundings and hid from everyone.

"I refused to lose one more family member to AIDS," Glory told me. So she accumulated as much savings as possible, and with the financial support of friends, Glory's plan of heading back home to Tanzania in search of her brother was well underway. She was determined to find him to get him proper health care and

LOVE

so he wouldn't feel like an outcast. She was tired of all the death in her family and wanted this time to be different. She was so brave—— for all she knew, her brother could have been long gone. She

## STRUGGLED

to find him, scavenging the streets and alleys asking everyone, anyone if they'd seen her brother. After spending a week searching the bus station in town, she found her long-lost brother sleeping on the floor of a one-room shanty. Glory took her brother to the

## HOSPITAL,

where the doctors confirmed that Ray had AIDS. While she can't save him from the disease, she can help him live the rest of his life more comfortably.

I've been fortunate to have had little to no experience with this sort of thing in my personal life, but the years of tattooing the arms of clients who've endured the unimaginable have taught me something. And an awareness of all of these hard realities serves as a regular reminder of how

WONDERFUL

the good moments in life really are.

# CHARITY JONES

## May 19, 2009

Charity is only thirty-three years old——and what a first impression! I couldn't think of a single guy who wouldn't easily find her attractive; her sassy smart-aleck wit only added to her overall refreshing personality. But as perfect as someone might seem externally, there is always the likelihood of inner shadows and darkness and insecurities. You wait long enough, and what's underneath the skin will ultimately emerge . . .

The painting that Charity brought in for reference showed a woman with two diametrically opposed halves. One half represented the plastic surgery addict, complete with a Botox needle at the lip and a piece of silicone escaping from the loosely stitched incision on the breast cradled in her hand. The other half would be best described as Mother Nature——organically beautiful, with tousled brown locks of hair cascading past her shoulder. Instead of an implant, this half of the figure cradles a newborn.

It took me a while to understand why Charity had chosen this piece. I suppose the message was obvious, but it was less obvious to me why she'd choose this subject matter to take up a good amount of her upper back. Maybe it was my lack of experience in the whole plastic surgery department that made me naive enough to believe that Charity's physical loveliness was as much a gift from a God as from a physician. Or maybe it just goes to show that she had done her research and really chosen the best doctor.

Growing up in Chicago, Charity considered herself a "fat kid." Kids can be so cruel, and constant ridicule goes a long way to breaking down our self-esteem. Charity grew up, managed to shed the weight, and made her way to California——the land of the "beautiful people," where levels of perfection can be unrealistic.

After undergoing multiple breast enhancements on top of a lengthy list of other surgical procedures, Charity found herself obsessed with being fit, symmetrical, wrinkle free, and perfectly tan. As a woman, I can understand how we can feed off of the physical idealism that surrounds us on billboards and in magazines, television, and movies, making it all too easy to focus on all our imperfections every time we look into our own mirror. We're bombarded by these false idealizations everywhere we go. Of course, Charity's learned concept of perfect was unattainable.

She couldn't accept herself, because she didn't feel her beauty inside——and not feeling it, she had surgery again and again to try to find it outside herself.

For me, I can definitely be my own worst critic——and I usually am. After all, I'm the one who sees my reflection when I get out of the shower, when I undress at the end of my day, when I try on clothes. Still, it baffled me to hear Charity talk about how many times she has submitted to the

# KNIFE

in search of beauty.

At one point, I found myself getting frustrated with her, wishing she could see how beautiful she truly is. Our conversation made me laugh and think, and I really enjoyed Charity's company. There was nothing not to like! After Charity's many visits with plastic surgeons, I wonder if there was a point where she felt like she had taken it too far?

There's a place inside all of us that begs to feel sexy and loved—— but no amount of surgery will ever get that for you, because you have to find it within yourself. I hear myself starting to sound like a

# CLICHÉ,

but it's the goddamn honest truth.

What do we stand to gain from the Botoxed face that

# CONCEALS

the clues to our ages? When did being older, wiser, and more experienced stop being sexy?

# JASON ZUHLKE

May 20, 2009

"Consider it pure joy, my

## BROTHERS,

whenever you face trials of many kinds, because you know that the TESTING OF YOUR

## FAITH

DEVELOPS PERSEVERANCE.

## PERSEVERANCE

must finish its work so that you may be mature and complete, not lacking anything."

—James 1:2—4

That's the Bible verse Jason quoted during our conversation today. And when I really think about how much that verse pertains to the reason Jason is getting this tattoo, it also applies to pretty much everything that's happening around us. Jason and I talked about how looking back at all of the hoops of fire we've had to jump through in order to

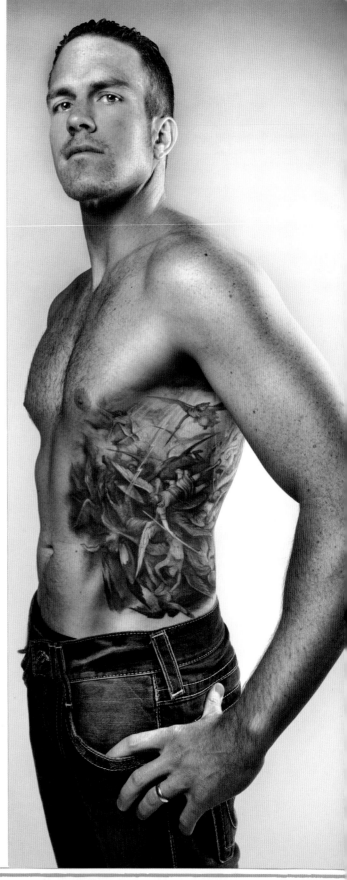

get us where we are now in our lives is something to be thankful for, really. He put it best when he said, "It's through suffering we are able to learn perseverance and build character." I ended up jotting down his quote on a piece of paper I hung in my office near my station.

Tattooing Jason felt like it was life changing. The first three- to four-hour session on this Gustave

# DORÉ

interpretation of a heavenly skirmish was a great introduction to what I can see growing into a deep and profound friendship. This type of artwork is one of my favorite styles to tattoo. And out of all the tattoos we filmed for the show this season, Jason's massive rib piece is by far the most impressive one I've been lucky enough to do. Doré did a series of illustrations inspired by *Paradise Lost*, John Milton's seventeenth-

century epic poem about the fall of Lucifer. The tattoo is based on a detailed scene depicting Michael casting Lucifer out of heaven and banishing the rest of his clan of

# FALLEN ANGELS

while glorious rays of light beam down through the ethereal cloud-filled skies. The main light source comes from above, and as your eyes make their way down this beautiful engraving, the atmosphere grows increasingly darker and more forbidding. Layers of shadows create depth throughout the entire composition; these were brought to life with the involved amount of detail put into each feather on each wing of each angel.

Jason spoke my language. I knew we'd get along, once he told me he was a police officer. Hell, I knew we'd get along when he had walked in the first time with that wonderful Doré print.

I love cops. In my opinion, police officers are one of the most undercredited, underpaid, underappreciated working-class jobs out there——especially those officers that are out there with the right intentions, truly there to protect and serve.

I always wonder how much therapy a police officer needs in order to deal with the unceasing

# ADVERSITY

that comes with the gig. How does someone go to work each day, witness traumatic experiences, make life-threatening choices, then go home to the wife and kids and be a loving husband and father? Or

# WITNESS

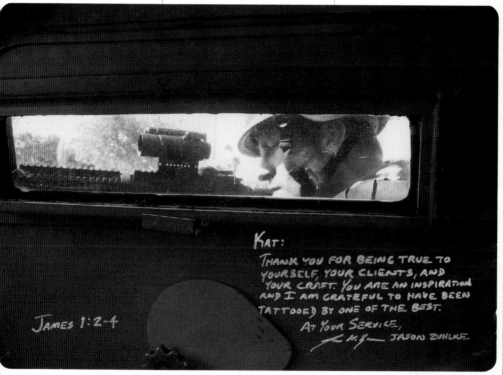

JAMES 1:2-4

KAT:
THANK YOU FOR BEING TRUE TO YOURSELF, YOUR CLIENTS, AND YOUR CRAFT. YOU ARE AN INSPIRATION AND I AM GRATEFUL TO HAVE BEEN TATTOOED BY ONE OF THE BEST.
AT YOUR SERVICE,
— JASON ZUHLKE

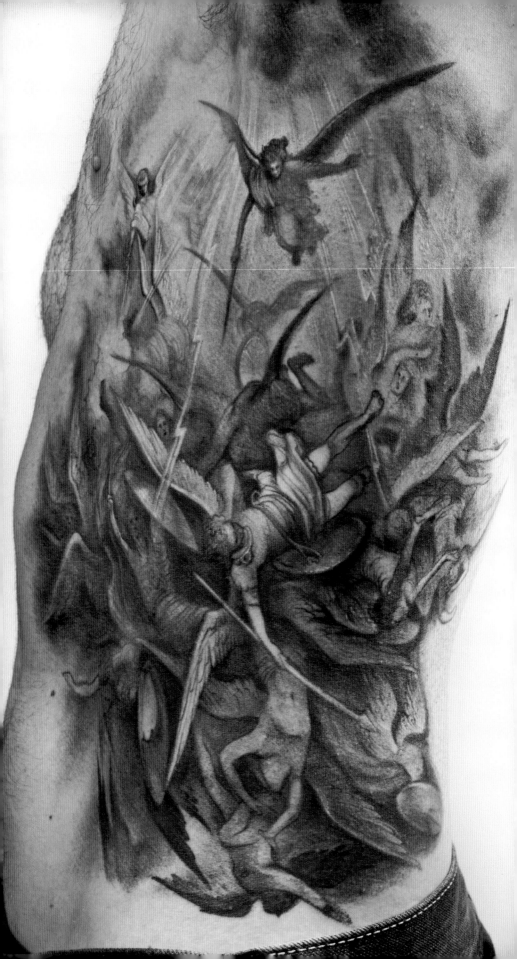

crime and slaughter and not be affected? Or take on the responsibility of justice and handle it?

The good ones, like Jason, do somehow. And he loves his job. He told me so.

Then he told me about a domestic dispute call he answered. "Those are always scary," he said. "You never know if someone's on drugs or how they're going to react in such a heated moment when a cop shows up at their door looking to 'solve' the problem." At the scene of the crime, he found a young woman who had been brutally battered. The culprit had fled the scene, allowing Jason the opportunity to talk to her. Sometimes, that's all people really need.

Years later, at an event, Jason ran into this woman. She approached him, and he remembered her. Time had clearly treated her and her daughter kindly. No bruises, scars, or black eyes this time. She thanked him for the few moments he had taken to sit with her that day, which was actually the last of many times her husband had hit her, as well as the last time she let herself be hurt physically at the hand of any man.

During those years following that nightmare day, she had taken control of her life——left her husband, went back to school and like a modern-day fairy tale, turned it all around.

Jason probably helped change that woman's outlook on men in general, not to mention her view of herself. These are the simple shifts in our world, in our lives—— just a few seconds spent selflessly

helping another person can really change everything.

This story led us to our main topic of conversation: Jason's belief that all things happen for a purpose. In the past, the idea of things happening for a reason seemed like such bullshit to me. I resented the concept and refused to believe knowledge should be gained from something like an abusive relationship, an untimely death, or any of the other difficult things that people go through. The idea of "looking at the big picture" felt like a betrayal, and the idea of an all-knowing "God" allowing such terrible things to happen sounded like a bad joke.

But over the past year——over the past years——through my own life experiences and through hearing about my clients' life experiences, I'm starting to come around. I can't pawn off tragic moments (and good ones, too) to mere coincidence. Things do happen for a reason. I understand now that it's just that most of the time, looking at the grand scheme of things is practically impossible when you're in the middle of it. But later on, we can start to see how the pieces fit together, how the most painful emotional

# WOUNDS

can lead us to the most dramatic awakenings.

LIKE DIVORCE. Emotionally draining, heartbreaking. When I was going through my divorce from Oliver (and it was much simpler than some of the divorces I've seen friends endure), it was nothing short of horrible. I lost several friends, along with

the house I'd paid the mortgage on for the entire three years of the

# MARRIAGE,

as well as many more assets. Telling my dad was a whole other monster, and the memory of seeing my ex-husband cry the way he did still makes me cringe today.

At the time, it was so hard to step back from it all and envision a resolution. But once I worked through a lot of those issues that come along with a separation like that, I learned so much more about myself. I was able to look at deeply rooted issues that I had pretty much blocked out of my mind and refused to address. I was able to start identifying the

# DEMONS.

And once I identified them, I could start thinking about how to exorcise them.

We were so intense in our talk that the hours flew by quicker than I wanted them to. He had so much to say, and I tried to do more than listen. I tried to really hear what he was telling me.

Our ability as human beings to endure the unimaginable is very possible. And to get up afterward and lead productive, fulfilling lives is, too. Coming from a man who underwent Chinese torture at one point during his military training, Jason's outlook on patience and will was nothing short of inspiring. He was put before me for a reason——not just the tattoo—— and I'd be a fool not to pay attention to it.

# Illuminated Globes

BLOOD BOOK

VI

June

MMIX

# Pearl Aday

June 19, 2009

It was so good to see Pearl today. Haven't seen her in quite some time, since she's been on the road with Scott. Pearl had been right a year ago, when she thought she spotted a perfect match with Nikki and me. She was right when she said she saw cupids and that we would make each other happy.

Because we do.

Pearl explained to me the origin of her idea for the lettering, "Little Immaculate White Fox" that we tattooed on her today.

It was in the early spring of

# 1975.

When Pearl's mother, Leslie, was well into her pregnancy with Pearl, she received a phone call late at night from her best friend, Marti Minter Bailey. Marti had called to say that she had just woken from a dream about her baby. "She has blonde hair and blue eyes, and in the dream she was wrapped in white fox fur, laying at the base of a tree in the forest. She's known as Little Immaculate White Fox."

But Leslie's gut feeling throughout the entire pregnancy was that she was having a boy. Pearl actually has the diary her mother kept while she was pregnant. In it, Leslie constantly refers to Pearl as "he," saying things like, "He kicked a lot today," or, "I can't wait until he gets here." So after listening to Marti's dream, she kindly replied, "That's so beautiful, but I'm having a boy."

It was only a few hours after the call that Leslie went into labor and was rushed through a snowstorm to the nearest hospital, in Kingston, New York. She gave birth to a blonde, blue-eyed baby girl, who she named Pearl, after her dear friend Janis Joplin.

Pearl jokingly told me, "I guess Little Immaculate White Fox was too long to write on the birth certificate! But I've always been known (unofficially) by the dream-baby name."

Pearl's cherished that story her whole life. She sees it as her first true name. So Pearl decided to name what she calls "her first baby"——her first album——*Little Immaculate White Fox.* I can only imagine all the hard work that goes into creating an album, especially for the first time——and this was a celebration of Pearl's recent completion of it!

I've been thinking a lot lately about life and love and purpose and the reason that things happen the way they do, even if we don't understand it at the time. I've been learning so much about the world and myself, about people and the ways that we relate to each other, and hurt each other even when what we want to do is reach out with love.

Everything that I've gone through has got me here today. The pain I went through with Oli led me to take a strong look at myself. I got sober soon after. A year and some change after my divorce, I met Nikki and fell in

# LOVE.

We could relate to so much of our past. There is a certain appreciation I gained for a relationship that consists of respecting one another.

I remember Nikki asking me during our first months of dating, "Where were you twenty years ago?" joking of course, but insinuating the obvious. My response was something along the lines of, "Well, Nikki, I was six years old at that time. We probably wouldn't have had too much in common, and I'm sure my father wouldn't have approved!"

We both laughed.

Everything happens for a reason . . .

July 23 2009          Los Angeles

Kat,
I can't thank you enough for my beautiful tattoo. I am in love. I'll always think of you when I see my spirit name. Cheers, love, sock, always, "Little Immaculate White Fox."
                    Pearl Aday

I had to go through a miserable divorce, as well as some not-as-bad relationships along the way to become who I am now. As did Nikki.

Our past relationships were just band rehearsals for the actual big show...

Now he is on his way to

# RUSSIA,

and while I want him here with me, we both have responsibilities, and that isn't possible. But what is possible, I understand now, is us together, making it work one step at a time.

FIG. 1

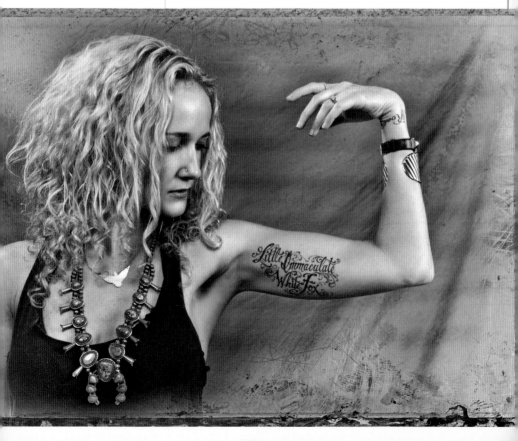

HOLLYWOOD.
KAT VON D
CALIFORNIA

# June 28, 2009

It's Sunday, my usual day off——and I'm doing the usual——being a workaholic. Not much has changed in that department.

I had one appointment, a woman who had a pretty small tattoo that needed to be touched up. It was the ROMAN NUMERAL

on her ring finger, a matching tattoo she shares with her husband. This number has become a noticeable recurrence for them. She was not only born on the second of the month, but they were married on the second of February, the second month of the year. Reminded me of Angel Portillo and his "22"——funny how these numbers seem to pop up in people's lives over and over again.

Nikki leaves to go back on the road day after tomorrow, so these next two days are pretty much all we have left. There's a noticeable change in Nikki that's taken place ever since we had that talk around Christmas, when he got back from Europe. I think it was an eye-opener to say the least. These last few months have been like getting to know each other all over again——we're both really trying to listen and understand——to think about each other's needs better before reacting and getting into same fight after the same fight. It's made it so much easier to be open with each other. It's like all the barriers are coming down, and we're both really present. Especially after tonight.

We went to see Johnette play, and Nikki held me so close to him, with those loving arms. His hand cradled my hand against his heart as she sang. I fought back tears for the love we have; we've fallen in love again, but this time on a higher level.

sang "When I Was a Fool" tonight, and I never heard the lyrics as clearly before. The song was about her walking past a magazine stand, seeing the young, fresh faces of cover girls——and how she would no longer be the

who'd be tied down by the ideals and expectations of today's world.

And oh! How she sang——and what a feeling of pure liberation as I listened and I squeezed Nikki so close . . . I'll never hear that song

the same way——I know Nikki knew what I was thinking at that very moment, because he whispered, "Thank you," into my ear.

Today was a wonderful Sunday, I must admit, probably the best day I've had in six months. There was no impending doom looming over my head when I woke up this morning next to my sweetheart. There was no anxiety or paranoia when I tattooed today——and redid the Roman numeral II. It just felt so right to do the II——somehow it just made me feel even closer to Nikki. And there was no lingering sorrow when I whispered back, "I love you," into Nikki's good ear, and took that single moment to

him in like I always do when he's that close to me.

My tattoo session today really gave me something. I mean, my client has a life that is a million times more complicated than mine, yet she seemed so calm, so in love. Making that faded tiny II on her wedding finger bright and clear again shows her commitment to her husband. And in asking me to do the tattoo, she taught me a lesson of love without even knowing it.

# Acknowledgments from the bottom of my heart

Elizabeth Sullivan — for still believing in me and in this book.

Johnette Napolitano — for setting the perfect example of everything I'd like to be.

Karoline & Michael Von Drachenberg —

Without You — I'm Nothing.

Emily — for being my everyday reminder to live in love.

High Voltage Tattoo crew — for completing the family I always wanted. Por Vida!

Lemmy Kilmister — Als ihrer Freundschaft, Liebe, und Wahrheit.

Nikki Sixx — everything happens for a reason.

Nancy de Herrera — for teaching me the wonderful gift of meditation. "All You Need Is Love".

Kevin Llewellyn — for your art, your heart, and your true friendship.

Will Staehle — for once again, bringing life to this book.... surpassing all of my wildest dreams.

For the continuous amount of unconditional love, support, help and patience, I must thank the following:

Adrienne Ironside, Bam Margera, Jim Rota, Sandra Dark, Brent Bolthouse, Matt Skiba, Danny Lohner, Dr. Drew, Ken Jamplin, Mike "Rooftop" Escamilla, John Austin, Aaron Krummel, Brad Lyon, Warren Favala, the Official Kat Von D Fanclub, and of course Mom and Dad.

Fin.

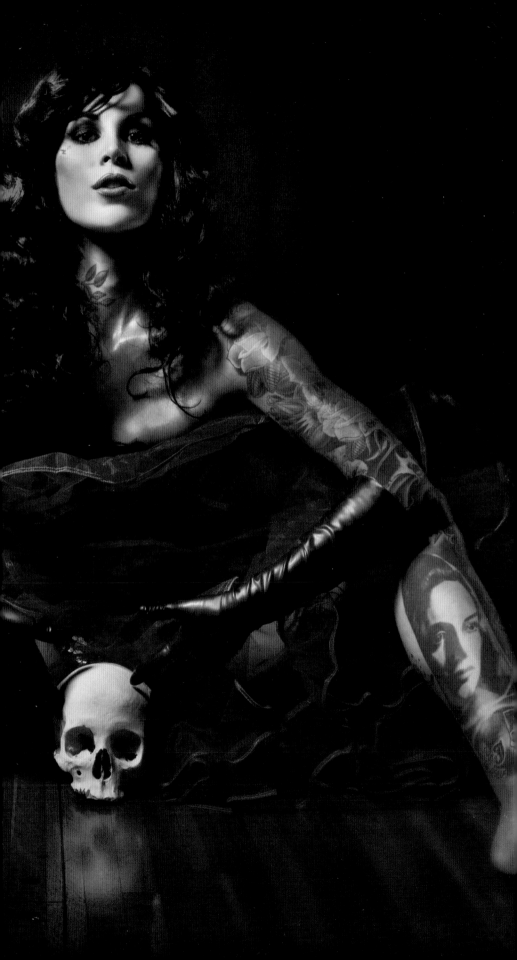

A YEAR OF TATTOOS

FAREWELL